Other Publications:

Planet Earth
Collector's Library of the Civil War
Library of Health
Classics of the Old West
The Epic of Flight
The Good Cook
The Seafarers
The Encyclopedia of Collectibles
The Great Cities
World War II
Home Repair and Improvement
The World's Wild Places
The Time-Life Library of Boating
Human Behavior
The Art of Sewing
The Old West
The Emergence of Man
The American Wilderness
The Time-Life Encyclopedia of Gardening
Life Library of Photography
This Fabulous Century
Foods of the World
Time-Life Library of America
Time-Life Library of Art
Great Ages of Man
Life Science Library
The Life History of the United States
Time Reading Program
Life Nature Library
Life World Library
Family Library:
 How Things Work in Your Home
 The Time-Life Book of the Family Car
 The Time-Life Family Legal Guide
 The Time-Life Book of Family Finance

PHOTOGRAPHY YEAR

1982 EDITION

BY THE EDITORS OF TIME-LIFE BOOKS

770.5

① 2 copi.
③ 1982

TIME-LIFE BOOKS, ALEXANDRIA, VIRGINIA

② ①

The Library of Congress Catalogued The First
issue of This Serial as Follows:
 Photography year.
 New York, Time-Life Books.
v. illus. 26 cm. annual.
1. Photography — Yearbooks. I. Time-Life Books.
TR1: P8819 770'.5 72-91518
ISSN 0090-4406 MARC-S
Library of Congress 73(2)

ISBN 0-8094-1695-6
ISBN 0-8094-1693-X (retail ed.)
ISBN 0-8094-1694-8 (lib. bdg.)

ON THE COVER: An unusual nude study and a transparent model of a new instant camera from Polaroid are representative of the artistic and technological achievements in photography in 1981. The picture of densely tattooed males juxtaposed with an undecorated female torso is the work of an emergent Japanese photographer, Masato Sudo. Polaroid's Autofocus 660 Land Camera has a built-in electronic flash that supplies enough light both indoors and out to brighten subjects that would otherwise be shadowed.

Contents

Time-Life Books Inc.
is a wholly owned subsidiary of

TIME INCORPORATED

FOUNDER: Henry R. Luce 1898-1967

Editor-in-Chief: Henry Anatole Grunwald
President: J. Richard Munro
Chairman of the Board: Ralph P. Davidson
Executive Vice President: Clifford J. Grum
Chairman, Executive Committee: James R. Shepley
Editorial Director: Ralph Graves
Group Vice President, Books: Joan D. Manley
Vice Chairman: Arthur Temple

TIME-LIFE BOOKS INC.

MANAGING EDITOR: Jerry Korn
Text Director: George Constable
Board of Editors: Dale M. Brown, George G. Daniels,
Thomas H. Flaherty Jr., Martin Mann, Philip W. Payne,
Gerry Schremp, Gerald Simons
Planning Director: Edward Brash
Art Director: Tom Suzuki
 Assistant: Arnold C. Holeywell
Director of Administration: David L. Harrison
Director of Operations: Gennaro C. Esposito
Director of Research: Carolyn L. Sackett
 Assistant: Phyllis K. Wise
Director of Photography: Dolores A. Littles

CHAIRMAN: John D. McSweeney
President: Carl G. Jaeger
Executive Vice Presidents: John Steven Maxwell,
David J. Walsh
Vice Presidents: George Artandi, Stephen L. Bair,
Peter G. Barnes, Nicholas Benton, John L. Canova,
Beatrice T. Dobie, Carol Flaumenhaft, James L. Mercer,
Herbert Sorkin, Paul R. Stewart

EDITORIAL STAFF FOR PHOTOGRAPHY YEAR

EDITOR: Thomas H. Flaherty Jr.
Senior Editor: Robert G. Mason
Picture Editor: Richard Kenin
Text Editor: Roberta R. Conlan
Researchers: Sara Schneidman, Susan V. Kelly,
Donna J. Roginski
Copy Coordinator: Anne T. Connell
Art Assistants: Carol Pommer, Robert Herndon,
Cynthia Richardson
Picture Coordinators: Renée DeSandies,
Donna Quaresima
Editorial Assistant: Carolyn W. Halbach

Special Contributors
Michael Blumenthal, Stanley W. Cloud, Don Earnest,
Maitland Edey, Aimée L. Morner, John Neary, James A.
Randall, Charles C. Smith, Gene Thornton

Editorial Operations
Production Director: Feliciano Madrid
 Assistants: Peter A. Inchauteguiz, Karen A. Meyerson
Copy Processing: Gordon E. Buck
Quality Control Director: Robert L. Young
 Assistant: James J. Cox
 Associates: Daniel J. McSweeney, Michael G. Wight
Art Coordinator: Anne B. Landry
Copy Room Director: Susan B. Galloway
 Assistants: Celia Beattie, Ricki Tarlow

*Consultant: Mel Ingber, a freelance writer on
photography, was the consultant for "The New
Technology."*

Correspondents: Elisabeth Kraemer (Bonn); Margot
Hapgood, Dorothy Bacon (London); Susan Jonas, Lucy T.
Voulgaris (New York); Maria Vincenza Aloisi, Josephine
du Brusle (Paris); Ann Natanson (Rome). Valuable
assistance was also provided by: Gail Cameron Wescott
(Atlanta); Helga Kohl (Bonn); Enid Farmer (Boston); Jo
Anne Reid (Chicago); Bing Wong (Hong Kong); Susan
Peters (Los Angeles); Trini Bandres (Madrid); Laura
Lopez (Mexico City); Miriam Hsia, Christina Lieberman,
Cornelis Verwaal, Tina Voulgaris, Gretchen Wessels (New
York); Peter Ward (Ottawa); Dick Rose (Phoenix); Eva
Stichova (Prague); Mimi Murphy (Rome); Janet Huseby
(San Francisco); Eiko Fukuda, Katsuko Yamazaki (Tokyo);
Traudl Lessing (Vienna); Bogdan Turek (Warsaw).

For information about any Time-Life book, please write:
Reader Information, Time-Life Books,
541 North Fairbanks Court, Chicago, Illinois 60611.

Fresh approaches to traditional subject matter and methods produced exciting work throughout the photographic world in 1981. A major trend developed as photographers turned back to a wide range of old hand-coloring techniques; the result was an array of novel images, incorporating tints that were sometimes moody—and often whimsical. Another important trend was the burst of activity in the classic realm of portraiture.

Quiet, yet sustained efforts to apply innovative ideas to old themes turned up everywhere. Each of the four photographers selected this year as a Discovery, for example, has attempted to treat some traditional area of photography in a strikingly new way. One, taking as his subjects a woman and a group of artfully tattooed men, produced a set of elegantly composed nude studies. Another photographer chosen as a Discovery has a unique approach to the traditional subject of landscapes: He treats all the elements in the landscape as controlled vibrations. A third put together a body of work that contains an assortment of landscapes graced with curious found objects and portraits posed and propped in equally odd and delightful ways. The fourth worked in one of the oldest artistic realms: the still life. Using a variety of items, many of them bought at a thrift shop, she created a series of rhythmic, romantic color images that are distinctive manifestations of a classic theme.

In the technical arena, 1981 was a year of important advances. Two manufacturers of film—Agfa-Gevaert and Ilford—started worldwide distribution of a versatile new film that produces black-and-white prints from negatives that can be processed like conventional color film. The Polaroid Corporation introduced a pair of new instant cameras with major improvements in both flash and film; although the cameras are clearly cousins of earlier Polaroid models, their new features have greatly increased the satisfaction of many instant photographers—especially those making portraits in uneven light. Another adaptation of an established process came from Eastman Kodak. Using a process employed in film for its Colorburst instant cameras, Kodak introduced a simple, convenient, one-bath process for making quality color prints in the home darkroom.

One technical achievement announced in 1981 aimed at nothing less than a photographic revolution. In early autumn, the Sony Corporation held press conferences in Tokyo and New York to promise a filmless electronic camera for delivery sometime in the future *(page 138).*

The Editors

Trends/1

Trends/1

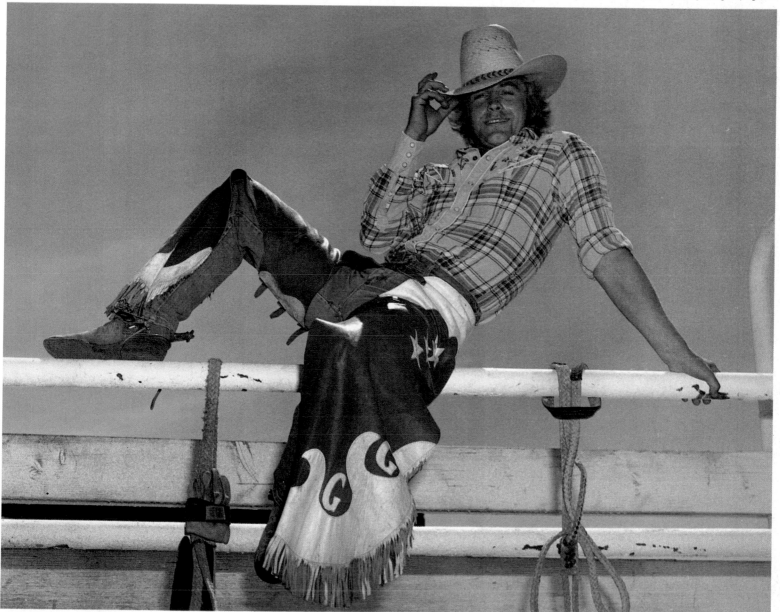

Susan Felter's pinup-like portrait of a jaunty rodeo rider in crimson chaps is an example of her inspired near-parodies of the Marlboro cigarette-ad stereotype. It reflects what she calls "the myth of Western Machismo, tarnished by seedy reality." Felter, a Californian, is one of the photographers whose growing interest in portraiture is described beginning on page 30.

Portraiture's Challenge / SUSAN FELTER: *Roger Cummings, Bull Rider,* 1979

Tints and Hues That Alter Nature's Own

Rejecting notions of artistic "purity," contemporary experimental photographers find a new freedom of expression in old techniques of adding color by hand

Some art photography purists of a certain generation still look askance at the practice of coloring photographs by hand. For them, it conjures up visions of the mass-produced, hand-colored photographs that were popular at the turn of the century or the tinted studio portraits of the 1940s. An increasing number of photographers, however, are now experimenting with various methods of adding color to their images, either during the printing stage or afterward — and they frequently use techniques that date back as far as the birth of photography itself.

This resurgence of interest in hand-coloring — strongest in the United States but international in scope — has been confirmed as an important new photographic movement by a number of recent exhibits and publications. Two major surveys of the field opened in the spring of 1979 — one at the Philadelphia College of Art and the other at New York's P.S. 1, a leading exhibition center for avant-garde art. In December 1980 the Los Angeles-based *Picture Magazine* devoted a special issue to hand-coloring, and many of the photographs featured in that issue appeared the following spring in an exhibition at the De Saisset Museum of the University of Santa Clara, a show that included 82 works by 15 contemporary photographers. Then, in the summer of 1981, the San Francisco Museum of Modern Art presented an exhibition entitled "The Markers," featuring photographs that were drawn and written upon as well as colored by hand.

The diversity of flavor and technique in hand-coloring is tremendous. It ranges from the hazy romanticism of Belgian photographer Hubert Grooteclaes *(opposite)* to the sharply defined, boldly colored images of Carl Kurtz *(page 18)* and Katherine Fishman *(page 22).* Many current practitioners play fast and loose with nature's color scheme: Personal artistic expression takes precedence. Alice Steinhardt *(page 20),* like many of her colleagues, started to experiment with paint and colored pencils applied over black-and-white prints after she had become disenchanted with color film. "I felt limited by having no choice in the colors presented from life," Steinhardt says. "I was interested in controlling the total effect of color and design."

Although the movement is now considered avant-garde, hand-coloring itself originated soon after the introduction of daguerreotypy in 1839. Two methods of coloring were devised: gold-toning, in which the silver-gray daguerreotype plate was immersed in a chemical bath to give it a warmer tone; and tinting, in which dry artists' pigments were carefully deposited on the fragile surface of a daguerreotype plate that had been coated with an adhesive.

In the 1850s the daguerreotype process gave way to the negative-positive process, but toning and tinting continued to be widely used. With paper prints, a much wider range of effects became possible. Some toners endowed prints with an overall bluish or greenish cast useful for moonlight effects and seascapes; others imparted a warm sepia hue suited to portraits and sunlit landscapes. At the same time, a wide range of dyes, oil colors, pencils and pastels gave the colorist more control over the final result. And toward the end of the 19th Century, a new ap-

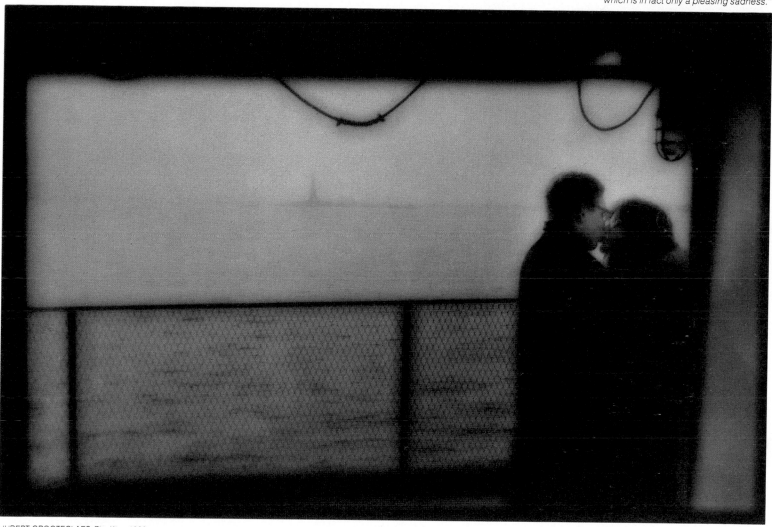

HUBERT GROOTECLAES: *The Kiss,* 1980

These richly colored ivorytype miniatures are typical of 19th Century efforts to imitate painted portraits by hand-coloring photographs. After the paper prints were colored, they were waxed, squeezed face down onto hot glass and backed up by white or ivory-tinted paper.

proach emerged. Instead of imposing color on images, such techniques as carbro color and the gum-bichromate process actually produced the image from pigment during the printing stage.

A degree of artificiality was manifest in all of these methods. Nonetheless, colored images came to enjoy such popularity that mass production methods were introduced. During the early years of this century, pictorialist photographers turned out thousands of hand-colored photographs, primarily for use in home decoration. One prolific practitioner, Wallace Nutting, hired an assembly line of nearly 200 women to add colors to prints of his peaceful landscapes and well-ordered interiors. While a given image might be reproduced hundreds of times, its hues would vary with the adroitness of its particular colorist.

Widespread hand-tinting continued in commercial photography until color film came into its own after World War II. As an art form, however, tinting and other additive processes fell out of favor relatively early, at least in the United States. Before World War I, photographers in the circle of Alfred Stieglitz had used various manipulative processes to enhance their photographs. But the next generation of art photographers criticized any kind of hand work on photographic images, on the ground that it violated the purity of the photographic process, spawning a bastard art, neither photography nor painting.

This disdain for hand-coloring continued for several decades, but the bastard art began regaining adherents in the mid-1960s. According to Karen Truax, a contemporary practitioner of hand-coloring who has spent several years researching its history, one of the earliest signs of this comeback was posted by Harold Jones, then a graduate student in art history and photography at the University of New Mexico. Like most of his teachers and peers, Jones had been leery of hand-coloring photographs. "There was something about it," he recalled later, "that seemed photographically unclean." Eventually, however, Jones decided to override his self-imposed scrupulousness. He declared his independence from photographic orthodoxy by using green vegetable dye to color a cow in a black-and-white print. His impulse, it seems, was widely shared. Soon many photographers were demonstrating more interest in "making a picture"—as New York photographer Dan Weaks puts it—than in just taking one. Harold Jones's commitment to altering photographs has grown as well. "There is something to the simple act of drawing that attracts me even more now," he comments. It is not a manifestation of disrespect for the photograph. It is a heightening of the photographic.

Toning and tinting remain the most common methods used to add color to a photograph. Karen Truax made "Painted Woman" *(page 24)* by iron-toning a black-and-white print, which gave it the bluish cast visible in most areas, then painting some areas of the print with transparent and opaque oil colors in order to achieve a bold, brassy effect. Gail Skoff achieved a more subtle and mysterious

In this 1911 Wallace Nutting print entitled "The Coming Out of Rosa," shades of pink were applied by hand to each flower on the rose-covered trellis. Photographs like this were hand-colored by the thousands and were hung in many American homes in the early 20th Century.

effect by applying softer, more delicate tints to a purplish-brown, selenium-toned print *(pages 26-27)*.

Some new colorists, such as Christine Osinski and Jane Tuckerman, use other old processes as well. Osinski employed the gum-bichromate printing technique to create the hauntingly evocative modern still life on page 21, and Tuckerman's pastel interior *(page 29)* is an example of carbro printing that has been brightened with watercolor.

For the most part, these methods require both precision and vast reserves of patience. Seta L. Injeyan, for example, created an impossible image of huge fish swimming through the air *(page 19)* by starting with a photographed landscape printed on transparent acetate. Then, using tiny brushes or cotton swabs, she painstakingly hand-painted the fish onto the acetate. Dan Weaks achieves the elegant chiaroscuro of his images *(page 16)* by manipulating the darks and lights through a series of positive and negative prints. On the final print he uses a combination of toners and dyes, finishing with abrasion toning, a technique in which powdered pigments are rubbed into a print after its surface has been roughened with fine pumice. Katherine Fishman, for her part, works eight hours a day for two to three weeks to finish such intricate and detailed prints as "Polka Dots," and Connie Ritchie spent 40 hours coloring the fantastic cityscape on page 28. Yet these photographers consider the rewards to be well worth the effort. "It can get tiresome and tedious," says Bill Turner, "but I'm hooked." So are his many colleagues, who feel that the marriage of painting techniques and photographic imagery enables them to get the best of both worlds.

*The soft tones and muted colors of this
enigmatic illustration of a magazine story were
obtained by a combination of old processes,
including abrasion toning, a technique Weaks
learned from an old German photographer
whom he met while living in South America.*

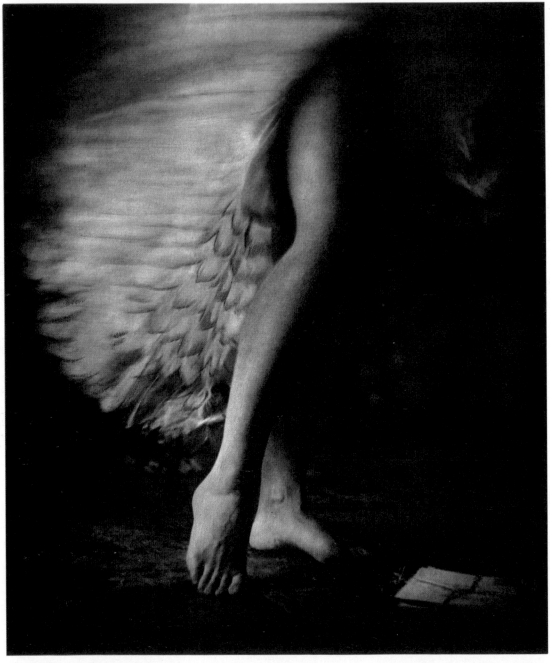

DAN WEAKS: *Seductions of a Different Kind,* 1980

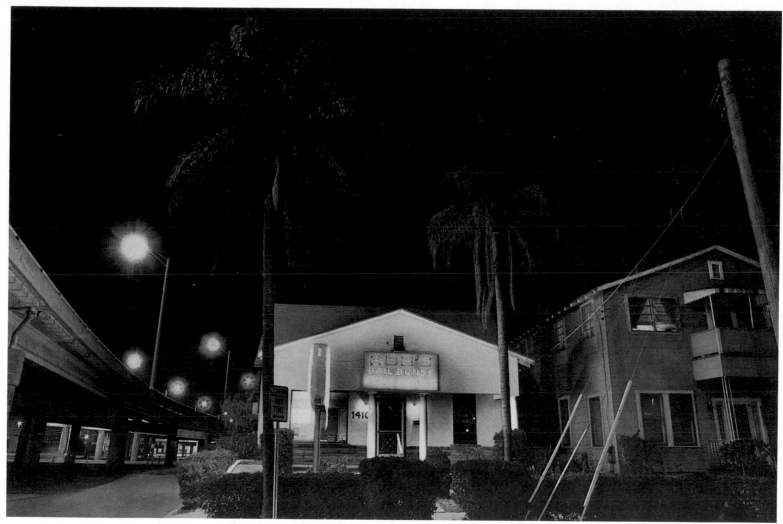

BILL TURNER. *Abe's*, 1981

To obtain the bold colors of this dye-transfer print of houseplants near a window, Kurtz made three acetate overlays from a black-and-white negative—one for each primary color of the dye-transfer process. The overlays, or internegatives, were then used to produce three matrices that in turn transferred the dyes to the final print.

CARL E. KURTZ: *Untitled,* 1980

This arresting vision of giant fish making their way across a palm-lined street was obtained by painting directly on a large black-and-white print made on transparent acetate. Working on both sides of the print, the photographer used opaque watercolors and marking pencils to color the image and add the fish. She completed the picture by airbrushing the back with opaque white.

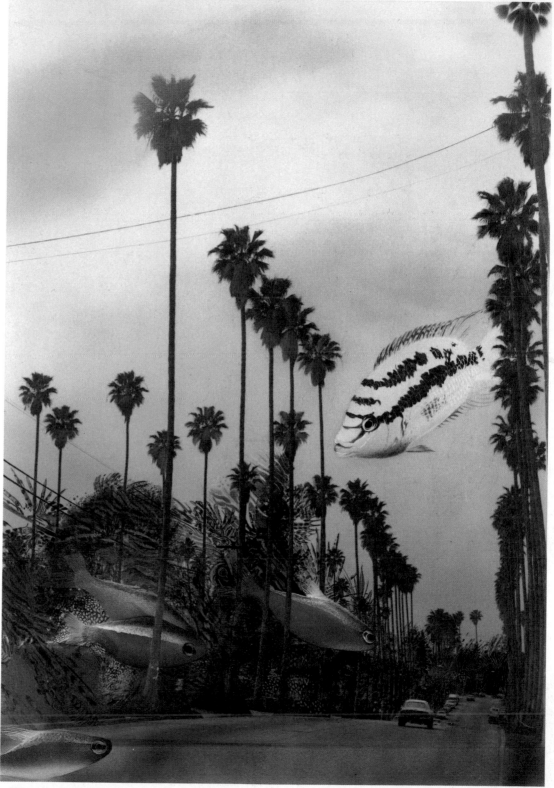

SETA INJEYAN: *Street Scene*, 1980

*The elegant geometry of an adobe storefront
provided the foundation for this exploration of
color relationships. To a carefully composed
black-and-white print, Steinhardt applied oil paints
and colored penciling — "never opaque but
just thick enough to give good color."*

ALICE STEINHARDT: *Secrets*, 1979

This slightly sinister print of a ballerina doll was obtained by the gum-bichromate process. Osinski made four internegatives from a 4 x 5 color transparency — one for each primary color, plus black. She then coated a sheet of drawing paper with four pigmented layers of emulsion that corresponded to the negatives, applying and printing one emulsion layer at a time to accumulate a full range of colors.

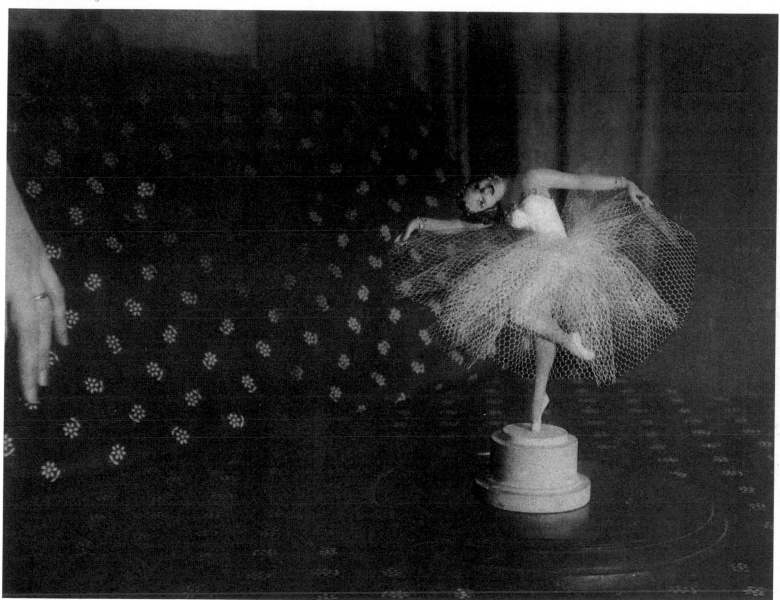

CHRISTINE OSINSKI: *Marisha's Doll*, 1981

In a carefully contrived setup of hands, gloves and plastic glove driers, Fishman invokes a mysterious symbolism that is heightened by her use of strong color. She used artist's oil paints to color her black-and-white print.

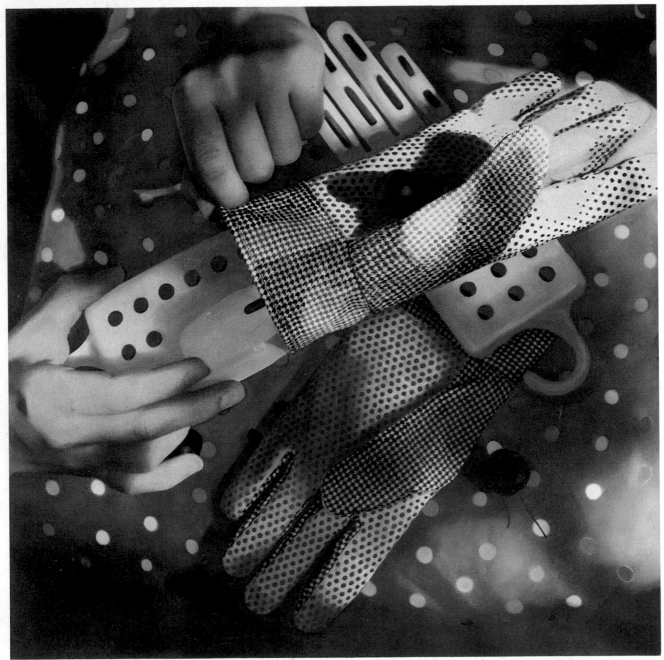

KATHERINE FISHMAN: *Polka Dots*, 1980

The unearthly look of this otherwise ordinary photograph of a trailer in a tree-lined campsite results in part from the photographer's use of infrared film, which registered the leaves as white and blue sky as black. The eerie effect is compounded by photo-oil hand-coloring that turned some leaves yellow, made others acid green, and gave the sky itself a greenish hue.

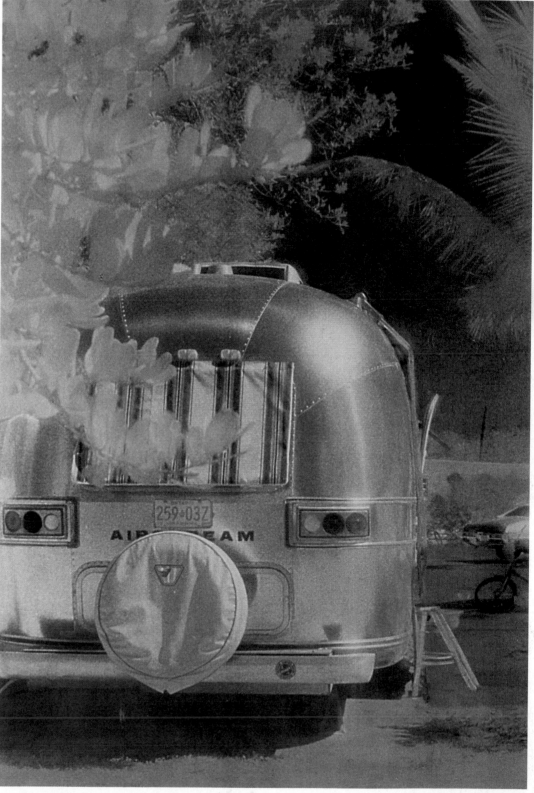

RITA DIBERT: *Nettles Island, Florida,* 1981

KAREN TRUAX: *Painted Woman*, 1979

In this photograph from her series entitled "Painted Women," Truax evokes the knowing seductivity of a so-called woman of the night. The basic blue — a cold value that "lends itself to the impersonal qualities of prostitution" — is the result of iron toning. The other colors are applied by hand, almost as a woman would apply make-up.

CONNIE RITCHIE: *Manhattan Mood #2 (The Whirl),* 1980

The drab rooftops and buildings of Manhattan are transformed into a colorful wonderland to match the exuberant mood of a whirling figure barely visible at lower right. The photographer used photo-oils and cotton swabs to color her semimatte, selenium-toned black-and-white print.

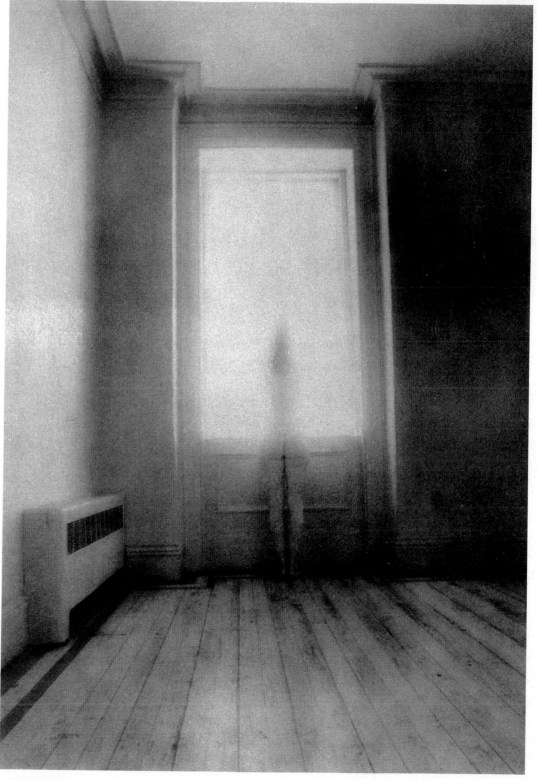

In this haunting photograph, daylight seems to wash away a figure standing at the window of a stark room. The photographer combined hand-coloring with the recently revived carbro-printing process, in which the final image is made from an ink pigment embedded in insoluble gelatin. The gelatin hardens in varying thicknesses, creating a print that seems three-dimensional. Tuckerman added delicate washes of watercolor to enhance its muted tones.

JANE TUCKERMAN: *Untitled*, 1979

Portraits: An Explosion of Fresh Talents

With its higher challenges and powers, portraiture is enjoying a renaissance among photographers interested in "dealing with reality" — specifically the human personality

This has been the year of the portrait in photography. The field is bubbling with productivity and experiment. More than a score of important shows — in Europe and across the United States — have been either entirely or largely concerned with portraiture; the largest was a mammoth exhibit of more than 800 photographs that began a three-month run at Bonn's Rheinisches Landesmuseum in November 1981. Publishers have recently turned out dozens of books devoted to portraiture, and the 1981 spring auction at Christie's in New York saw a record price paid for a portrait by a living photographer: $9,000 for a photograph of actor Ramon Navarro, taken in 1930 by Hollywood portraitist George Hurrell.

The bullish market bodes well for a new and enthusiastic crop of photographic portraitists. Carole Kismaric, the associate editor of *Aperture,* says that for a decade — since the death of Diane Arbus — "virtually no one had been investigating portraiture outside of the snapshot vernacular. Now a great many photographers seem to be in it." In this surge of interest, Marvin Heiferman of New York's Castelli Photographs discerns a return by many photographers "to dealing with reality."

Portraiture has always occupied a special niche in photography, as it does in painting. The relationship between subject, artist and viewer creates a triangle of emotional tension that is unique in the visual arts. When people stare long and carefully at other people who have been arrested in varying degrees of real or psychological nakedness — and who stare back out of their frames — a powerful current of feeling flows. The response of the viewers may be sadness, smugness, joy or even humiliation.

The emotional triangle can be constructed in countless ways. Robert Mapplethorpe *(opposite)* and Toba Tucker *(page 35)* both choose nonconformist subjects — rock musicians or former drug addicts — but their portraits are imbued with a sympathy and a sense of human complexity. If the artist's presence is only implied in the work of these photographers, Lucas Samaras *(page 37)* leaves no doubt as to his whereabouts: Like Alfred Hitchcock making cameo appearances in his own movies, Samaras turns up in odd corners in his recent series of Polaroid studies. "The new portraitists," says Janet Borden of New York's Robert Freidus Gallery, "are using all the techniques and trends of the past few years to make portraits that are very much of the times." The result is a flood of highly personalized, sometimes quixotic imagery, scornful of older norms and unafraid to show its secrets in an effort to engage the viewer. Here and on the following pages are examples of the work of a dozen talented photographers, each of them grappling with that most challenging of subjects, the human personality.

Mapplethorpe's subjects, often coming from the worlds of New Wave music, sadomasochism and male homosexuality, can project defiance, self-assurance or ambivalence, depending on what he asks of them. Here is a rock musician, his hair loaded up with grease, his arm tattooed: a would-be tough. But the arm shielding the eyes suggests vulnerability — and what real-life young tough would choose a tattoo that was inspired by Picasso?

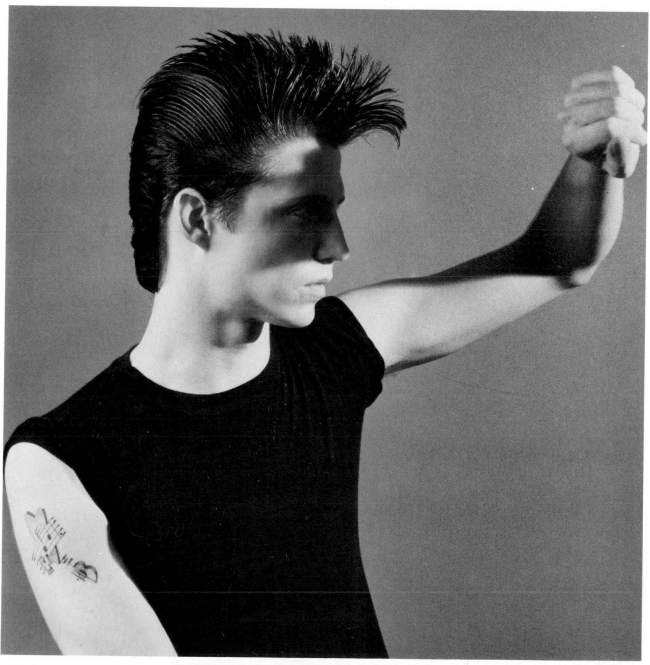

ROBERT MAPPLETHORPE: *Tim, the Rockats,* 1980

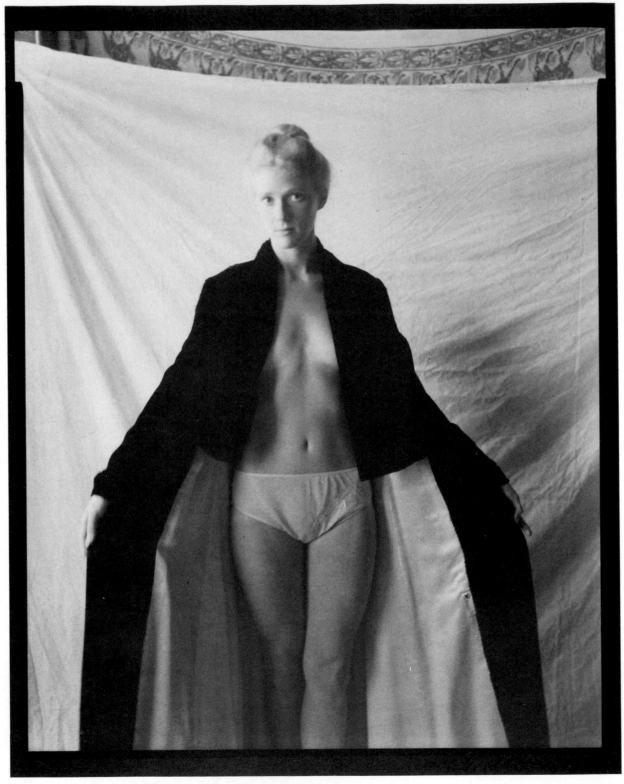

TOM SHILLEA: *Sharon in Open Gesture,* 1979

Shillea says: "I try to express both my own and the subject's personality through gesture, costume and lighting." Here he succeeds stunningly. This woman seems torn between urges to reveal and to conceal. Still partly dressed, she opens her robe, but only enough to suggest her breasts. Her feelings are reflected in her face — timid, watchful, but willing.

Like the preceding portrait, this one is of a draped seminude figure, but the two could not be more different. Where there is quietness and an easy balance in one, there is an awkward angularity in the other. The man steps tentatively, looking at his feet with a kind of quizzical strain in his face. This is less a portrait than a statement of unresolved tensions, both in the contrasting background tones and in the deliberately uncertain pose of the subject.

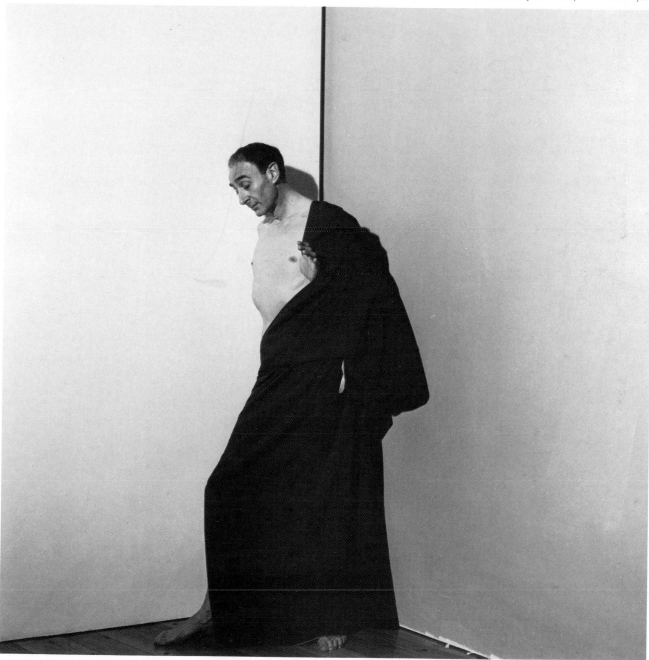

LYNN DAVIS: *Portrait of David Warrilow, 1979*

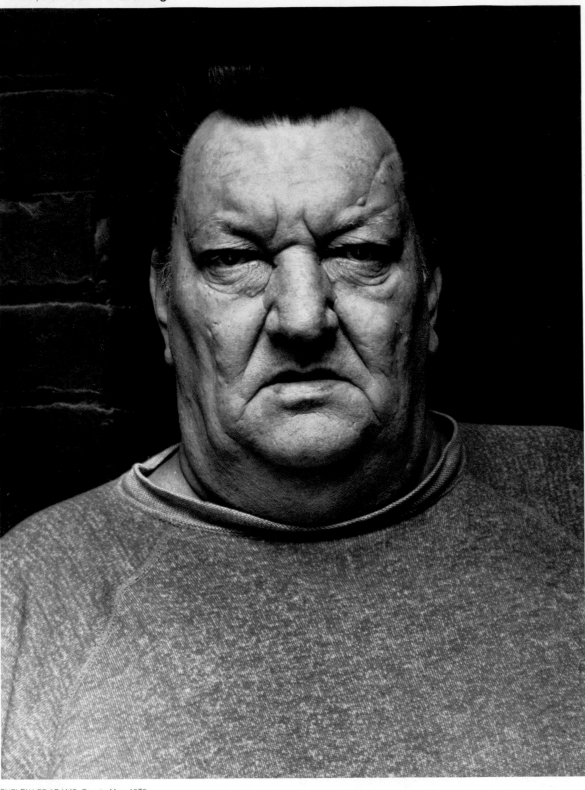

Shelby Adams used a 4 x 5 camera to record this portrait of an unflinching man from Appalachia. Born and raised in Kentucky, Adams has worked long and intimately with the Appalachian people, establishing a rapport with them that few achieve. The lens of his camera is large enough to let his subjects see themselves reflected in it, a trick that relaxes them. "In front of the camera," says Adams, "they will many times drop what they want to be and reveal what I call a true image or portrait."

SHELBY LEE ADAMS: *Granite Man*, 1979

This image of a dark-eyed former drug addict
was one of a series of portraits made by Toba
Tucker, who did not begin her professional
career until she was in her early 40s. In the shaky
progress of the men and women at Daytop
Village, a rehabilitation center in New York, Tucker
strove to find moments when they had shed
their complex defenses. "I wanted the
direct confrontation of their eyes," she says,
"and through them, their feelings."

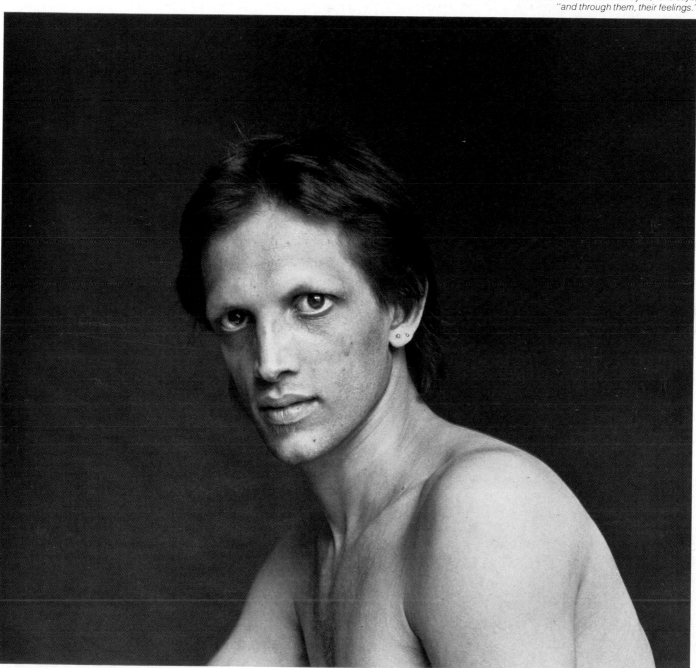

TOBA TUCKER: *Luis, 4/8/80*

This is a portrait drenched with fecundity. A background of rich tropical plants and an equally rich floral robe build up to the great melon of fertility that dominates the picture. Yet the portrait ultimately is of the woman, whose eyes reveal pride mixed with apprehension as she measures the expanse of her belly with anxious hands.

Narcissism exists in much of portraiture but seldom more strangely than in the work of Samaras, who has produced a series of nude portraits — in each of which he is seen sitting to one side. Samaras exposes his methods as well: lights, the colored filters he uses for bizarre effect, the edges of background draperies. Here is one of his tamer works, two jolly women with green faces and red and blue legs.

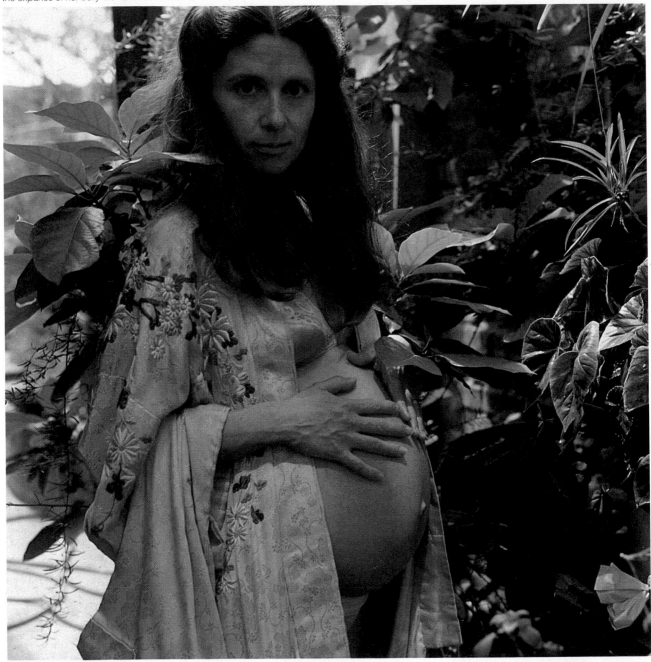

ARNOLD KRAMER: *A.P.*, 1980

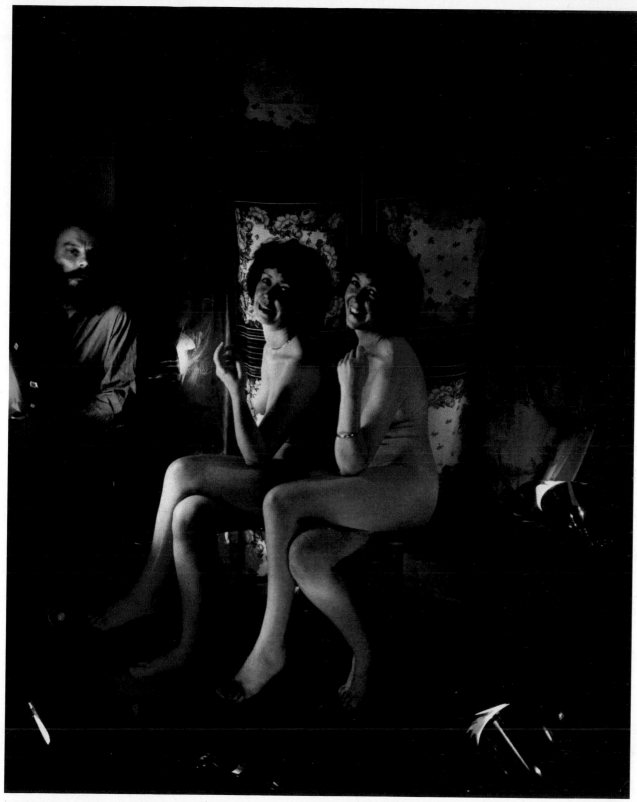

LUCAS SAMARAS: *Sittings 8 x 10, 2/8/79 (35E)*

This seemingly modest picture is part of Misrach's ambitious effort to make an extended portrait of the American people. Convinced that the archetypical average American does not exist, he photographs instead specific men and women in their specific settings — such as this lean, dry desert figure standing amid his plump desert plants. "In my travels," Misrach says, "I have found that Americans don't conform to preconceptions."

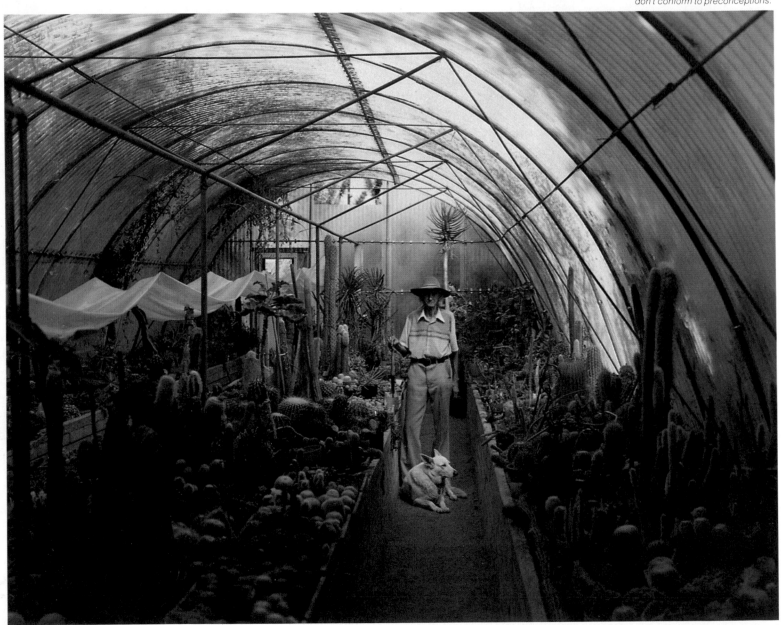

RICHARD MISRACH: *Untitled,* 1980

Joel Meyerowitz made this deceptively casual
portrait of a man called Red with an 8 x 10 view
camera, an instrument whose virtues he
discovered while making landscape photographs
on Cape Cod. "The big camera confronts
people in such a way," he says, "that they give
themselves over to the act of the portrait."

JOEL MEYEROWITZ: "Red" Grey, 1980

MARSHA BURNS: *Anonymous Figure,* 1979

"Often I see someone who attracts my attention by his dress and bearing," says Burns. She saw this man at a wedding and asked if she could photograph him later in the same clothes: a fedora hat, jacket and what appear to be rumpled pajama bottoms. Burns uses long exposures and a muted tonal scale to impart softness and mystery, heightened in this picture by the distorted profile shadow thrown on the wall.

Of all who photograph themselves, few present such uncompromising views as does Black, a relative newcomer to photography who gave up an earlier career in drawing and printmaking to raise four children. In this self-portrait, the photographer records her growth and pain: She has not tried to tidy her hair, remove the bruise of fatigue from under her eye, or glamorize her breast. Here, face to face with the world, is a tired but determined woman.

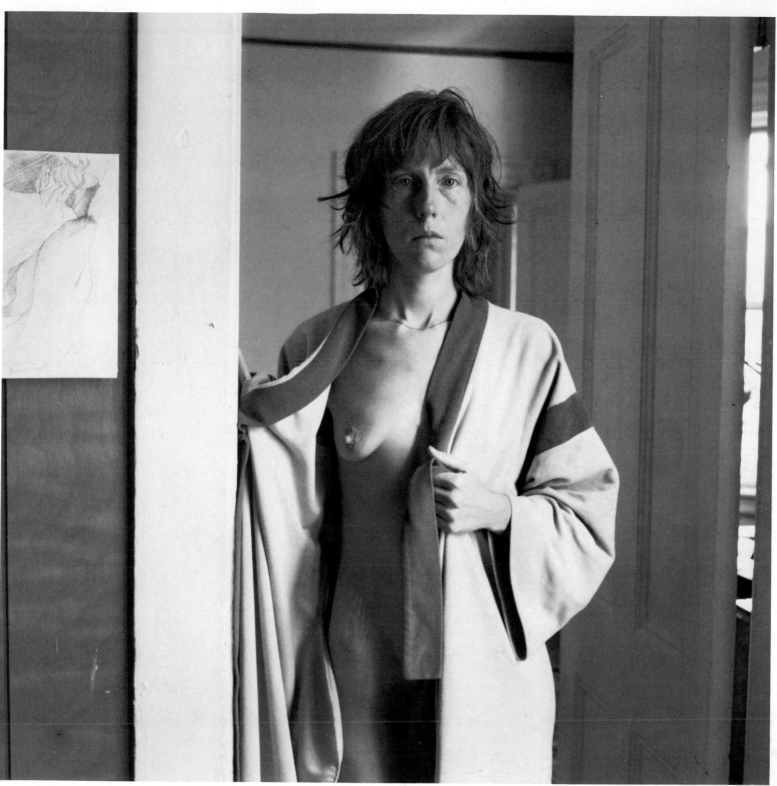

JUDITH BLACK: *Self-Portrait,* 1979

Philippe de Croix seems at first to revert to the stylistic canons of an earlier day. If shot in black and white, this sleek-haired gentleman might have found a home in the pages of the glossy fashion magazines of the 1920s and 1930s. But the use of dramatic lighting, vibrant colors, and extremely precise composition keeps the portrait riveted in the present.

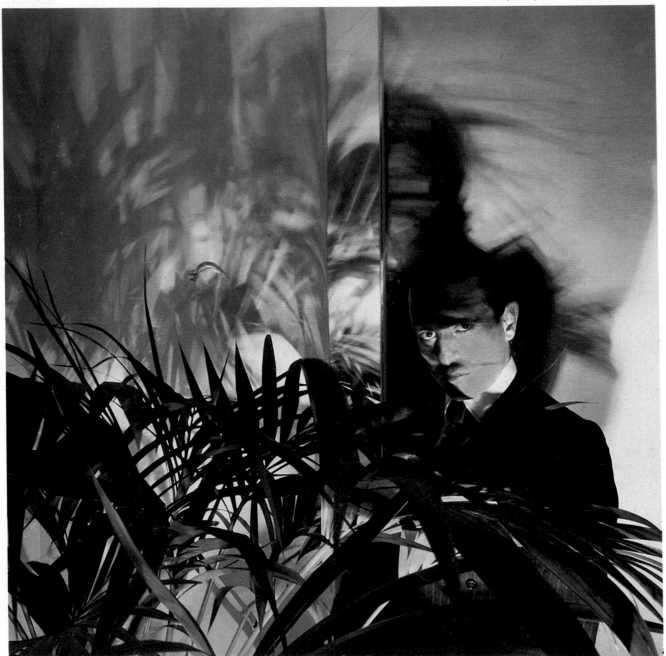

PHILIPPE de CROIX: *Portrait of M. Hervé Goudard,* 1981

The Major Shows/2

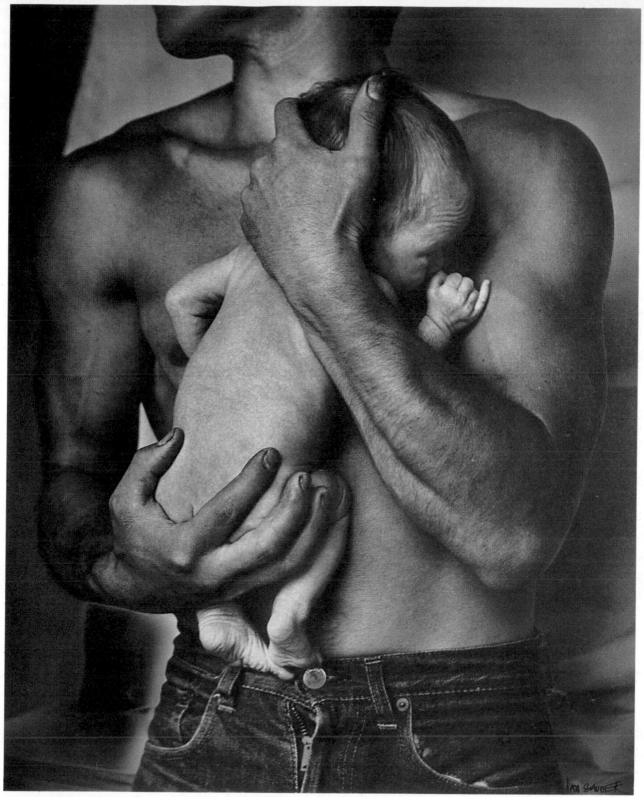

The Major Shows / JAN SAUDEK: *Another child, David is born. I embrace him,* 1966

Panoramas, Close-ups and Personal Views

A traveling exhibit of 205 works traced changing approaches to the photography of America's national parks over the past 100 years

To most Americans and foreign visitors, national parks mean the great natural wonders of the West—Yellowstone, Yosemite Valley and the Grand Canyon. The very mention of national-park photography conjures up panoramic vistas of the sort that did so much to help establish the first national parks in the Western wilderness during the late 19th Century. But today the national parks also include more modest landscapes: quiet seashores as well as military parks where bronze statues and old cannon are framed by flowering trees. As the parks themselves grew more diverse, so did the motives and methods of the men and women who photographed them. This evolution was well documented in *American Photographers and the National Parks,* a traveling exhibition that was organized by the National Park Foundation, Washington, D.C., to display more than a century of national-park photography, from the 1860s to the present.

The show's emphasis was less on the great variety of landscapes and terrains in the national park system—from the icy splendors of Glacier Bay, Alaska, to the green fields of Gettysburg—than on the range of photographic approaches to those landscapes. Nineteenth Century photographers like Eadweard J. Muybridge *(page 47)* and William Henry Jackson *(page 49),* who were among the first to photograph such scenic marvels as Yosemite Valley and the Yellowstone region, carefully considered camera angles and lighting to get the most effective views possible. But their goal was to let the subject speak for itself: They concentrated on making objective records of scenery that was difficult to reach and had to be seen—through the agency of the camera, anyway—to be believed.

As transportation improved and more of the park system became accessible, photographers began to take a personal approach to the parks. Some, like Laura Gilpin and Imogen Cunningham *(pages 56-57),* stuck with the grand views but chose moments when the natural beauties of their subjects were invested with a poetry of light and atmosphere. Others, like Ansel Adams and Brett Weston *(pages 50-51),* closed in on single plants or rock forms, which they often transformed into semiabstract designs. Jerry N. Uelsmann, for his part, combined different elements from the same landscape to achieve surrealistic effects *(page 59),* while Richard Misrach used a blend of natural and artificial lighting to transform desert plants into mysterious presences. Charles V. Janda, whose photographs of remote Alaskan glaciers come closest to 19th Century grandeur and objectivity, chose surprising points of view and lighting.

The result was a show in which photographers and their ways of seeing were as important as the subject matter—even when the subject was a natural wonder. As curator Robert Glenn Ketchum put it: "The greatness of individual photographs is not dependent on the greatness of the site, but on the photographer's vision of it."

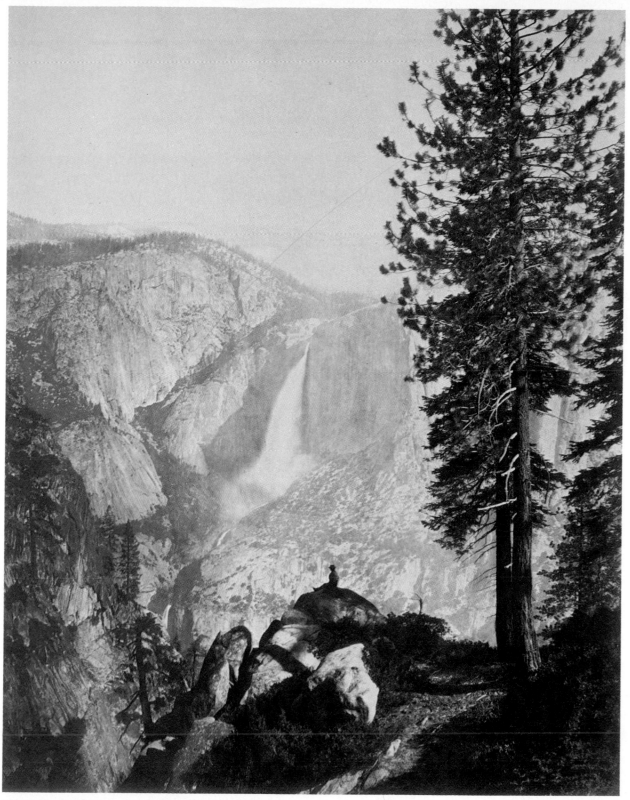

EADWEARD J. MUYBRIDGE: *Yosemite National Park, California*, 1872

RICHARD MISRACH: *Organ Pipe Cactus National Monument, Arizona,* 1975

WILLIAM HENRY JACKSON: *Yellowstone National Park, Wyoming*, 1872

ANSEL ADAMS: *Saguaro National Monument, Arizona,* 1946

BRETT WESTON: *Hawaii Volcanoes National Park,* 1978

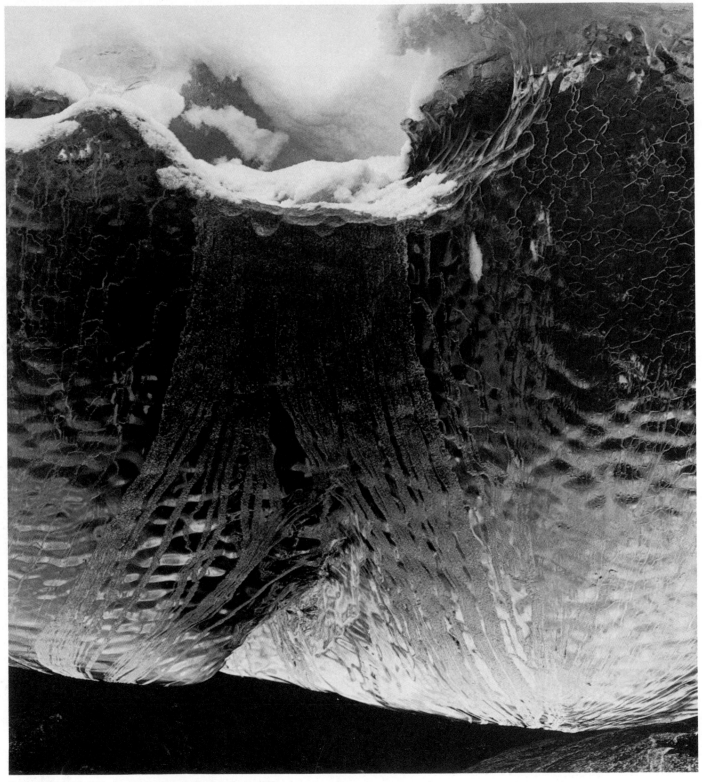

CHARLES V. JANDA: *Glacier Bay National Park and Preserve, Alaska,* 1967

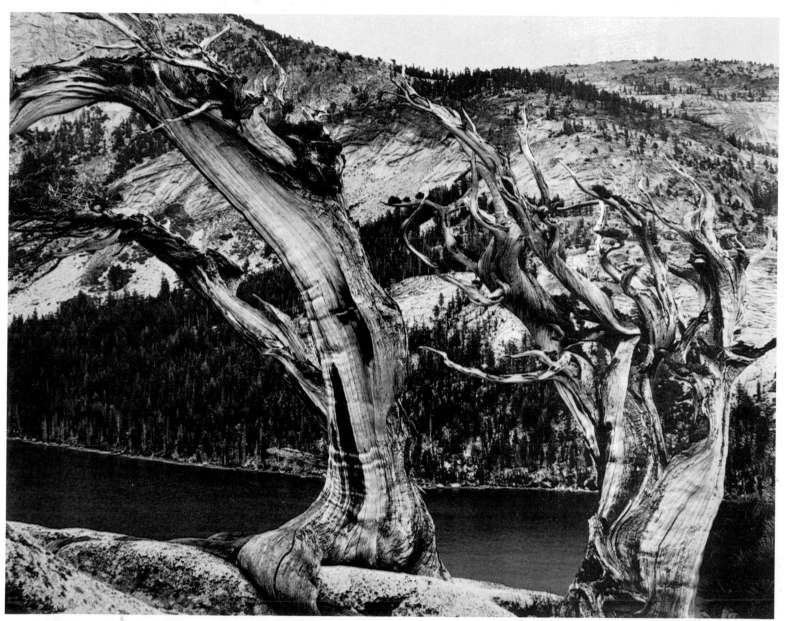

EDWARD WESTON: *Yosemite National Park, California*, 1940

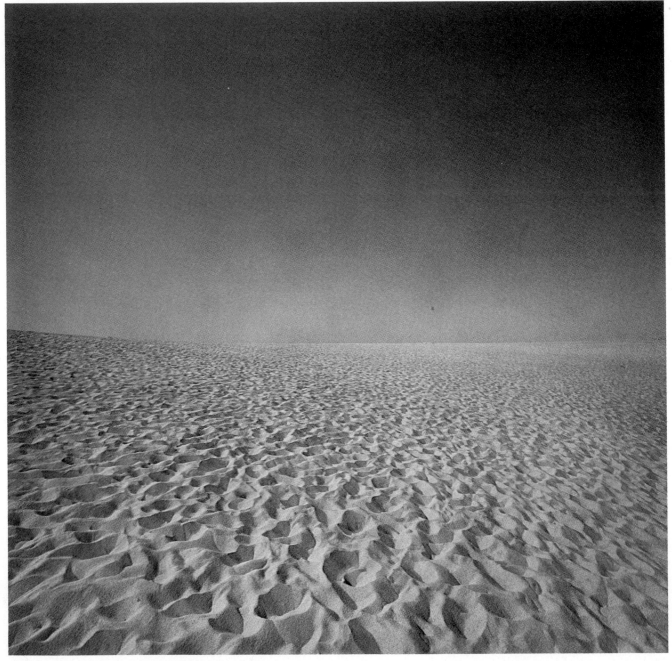

HARRY CALLAHAN: *Cape Cod National Seashore, Massachusetts,* 1972

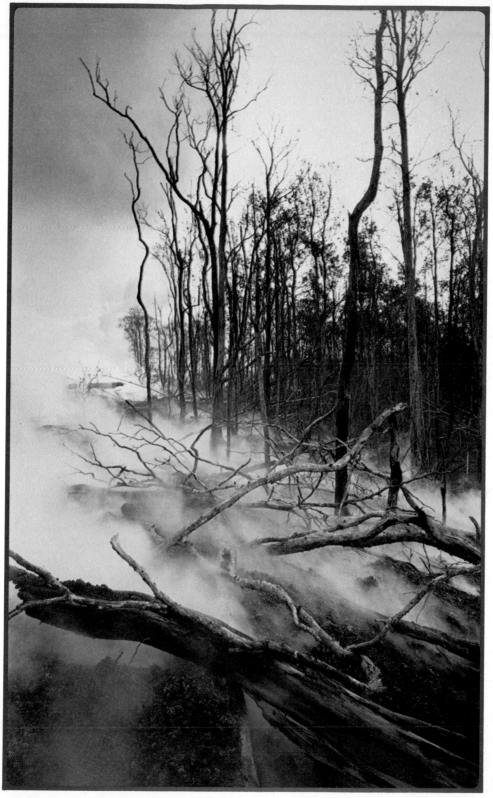

BOONE MORRISON: *Hawaii Volcanoes National Park*, 1977

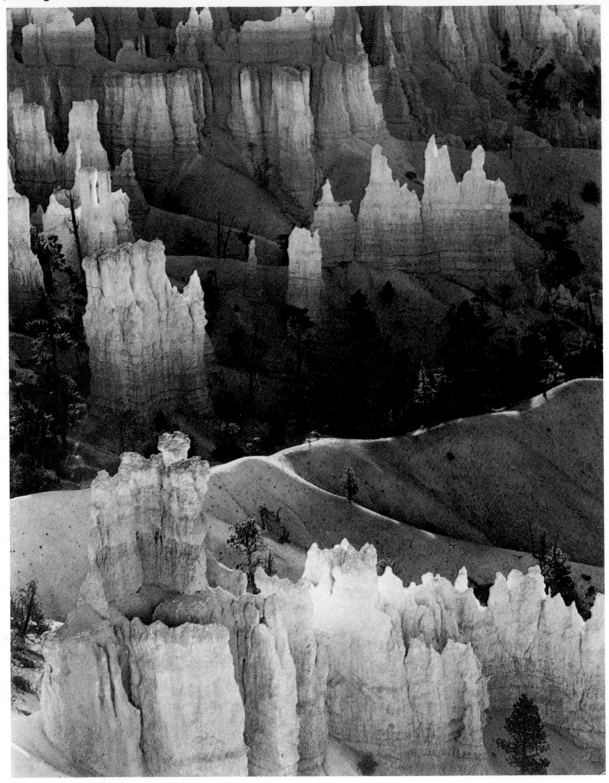

LAURA GILPIN: *Bryce Canyon National Park, Utah,* 1930

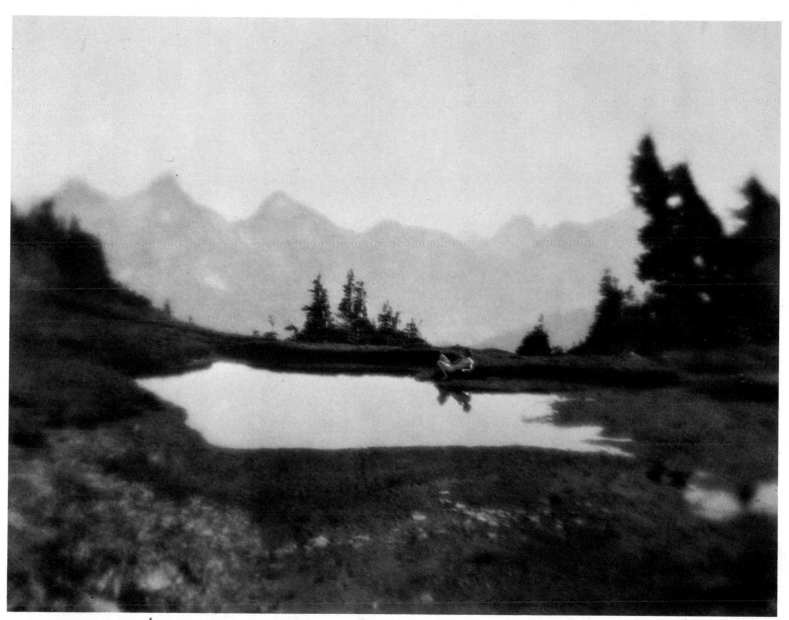

IMOGEN CUNNINGHAM: *Mount Rainier National Park, Washington*, 1915

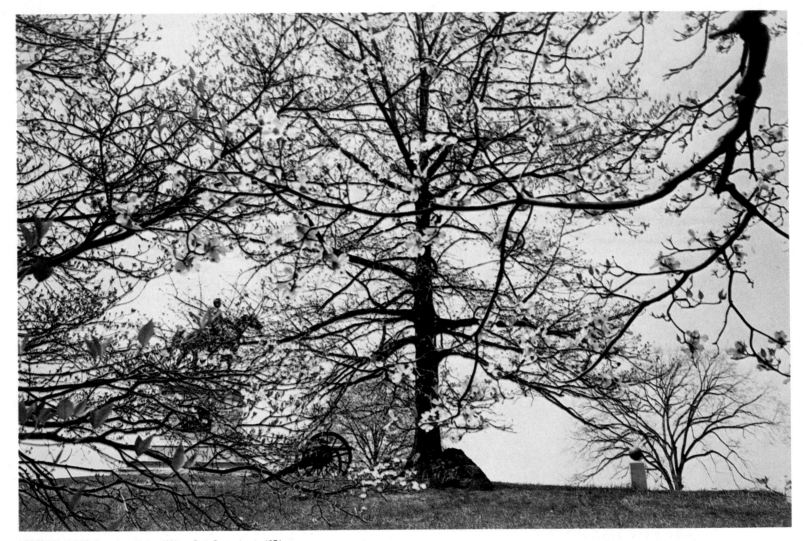

LEE FRIEDLANDER: *Gettysburg National Military Park, Pennsylvania,* 1974

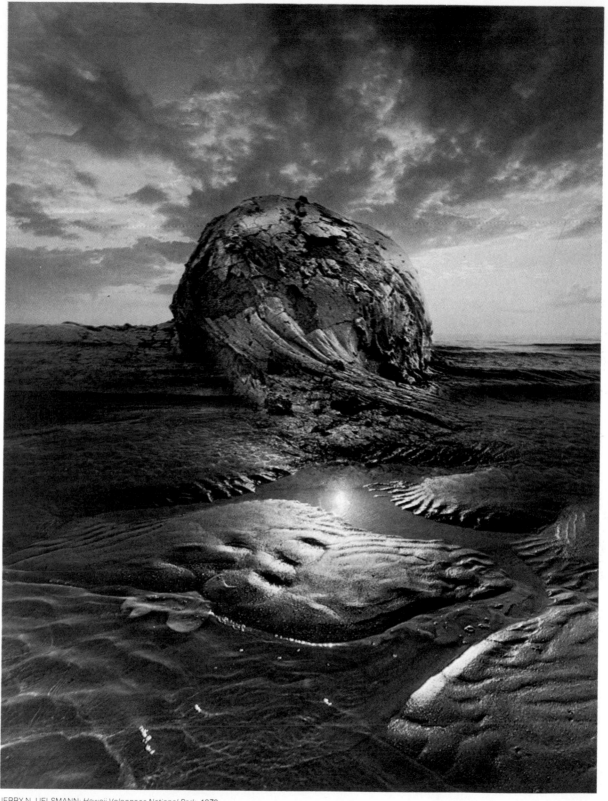

JERRY N. UELSMANN: *Hawaii Volcanoes National Park,* 1979

A "Crazy Idea": To Portray Humankind

From the "forgotten center of Europe" comes the unique art of a Czechoslovakian factory worker who makes pictures in his spare time, hoping they will "praise" his world

During the week, Jan Saudek works in a factory in Prague, as he has since his middle teens. By night and on weekends, he takes photographs, a pursuit that also dates to his teenage years. Since starting with a Kodak Baby Brownie in 1952, Saudek has earned a reputation in Europe for his sometimes perverse, yet often tender, erotic or humorous pictures of his friends and family. His work has been seen in the United States several times since the late 1960s, thanks largely to the efforts of the Jacques Baruch Gallery in Chicago. In the spring of 1981, the gallery staged a major exhibit of Saudek's work: 68 images, many of them delicately hand-colored, and all evidence of an arresting talent.

Saudek's photographs exude an air of allegory. They juxtapose ethereal loveliness with gritty backgrounds, vitality, and intimations of death. But his meaning often remains elusive. Saudek himself insists he is led by instinct. "I don't much trust intellectualism," he has said. "People come and leave again—I want to take pictures of them once and for all, as long as they are here as I know them."

He knows them intimately, as can be seen in his powerful portrait of the newborn child in the arms of his father *(page 45)*. The image is reminiscent of some in Edward Steichen's *Family of Man*. In fact, that historic work so moved Saudek when he first saw it in 1968 that he was inspired to begin what he calls his "crazy idea": to make his own portrait of humanity without venturing out of his native Czechoslovakia—the "forgotten center of Europe," as he deems it. Staying at home, Saudek acknowledges wryly, "hasn't been terribly difficult." Nor has his limited travel shortchanged his work. "I soon learned," he says, "that people are pretty much the same everywhere."

His appreciation of humankind is evident, and his appreciation of the female of the species especially so. "She is the most astonishing creature in the world," he says, and he delights in portraying woman in all her incarnations, from childhood onward. Yet his nudes are very often posed in a dingy room, with flaking paint, decrepit furniture and a single window with no view. Even his portraits of young girls carry a disturbing, surrealist charge—like the child opposite, who sits cross-legged on a stool in that dingy room, wearing a set of headphones that tune her in to another world.

"Not many people understand what I'm doing," Saudek says of his photographic labors. "I work in a factory all day, sometimes overtime. That's enough to live—and to buy photo materials." To one with his singleness of purpose, the hardships seem irrelevant. "While I know that a single photograph cannot be the apotheosis of a human being," he says, "in the best case it can become a small stone in the wall of an immense temple through which a man can praise his world."

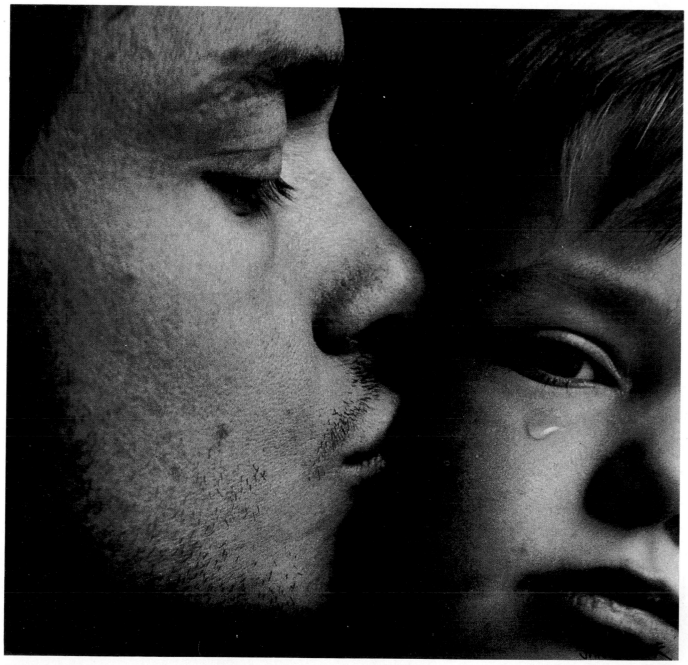

Kissing the tears away, 1966

A Photographic Indictment of Psychiatric Care

Uncompromising photographs of life inside archaic institutions lend emotional force to an Italian campaign for reforms in mental health programs

A new law enacted in Italy at the end of 1980 to reform that country's mental health care system set the stage for a photography exhibit at the Palazzo Braschi in Rome that attracted international attention when it opened in May 1981. The reform law called for abandoning Italy's old psychiatric hospitals in favor of decentralized, deinstitutionalized care for the mentally ill. In order to stimulate public discussion on this and other issues related to the politics of mental health, the city of Rome mounted "Inventario di una psichiatria" (literally Inventory of Psychiatry), an exhibit featuring uncompromising photographs of life—past and present—inside the psychiatric hospitals of Italy and other nations.

One planner of the show was the late Franco Basaglia, director of the psychiatric hospital in Trieste and a prominent crusader for mental health care reform. Basaglia, who died before he could see the success of the project, held that traditional mental hospitals often serve more as institutions of punishment than of healing and that the inmates of such hospitals are frequently the victims of arbitrary definitions of normality and lunacy. It was his hope that the bleak images in this photographic "Inventory" would arouse public awareness of the need for change.

Images of forcible restraint and confinement played a major role in the exhibit: Straight-jacketed inmates collapse passively in sleep or glare into the camera (pages 74-75); barred windows and doors (pages 78-79) trap the vulnerable form of a human body against a field of unyielding institutional straight lines and right angles. Many of the portraits in the exhibit are expressions of shame, fear or despair, as patients bury their faces or hide behind their hands (pages 72-73). Other faces, heavily shadowed by wire mesh or masked by bedclothes, reveal the loss of identity suffered in an institutional setting.

During the two months that "Inventory" was on display, it drew an average of 3,500 people a week to the Palazzo Braschi. The photographs were then invited to tour cities in Italy, Belgium, Germany, Spain and France. They are scheduled to arrive in Paris in the autumn of 1982. Despite the emotional power of the exhibit, one of the photographers involved in the project lamented that some of the most moving things to be seen inside a psychiatric institution are impossible to capture on film. One old woman, he recalled, especially suffered during visiting hours: "The woman waited for her son and watched everyone who came in to see if it was him and always made excuses for her son, saying, 'Poor boy, but who knows how much he has to work.' But in three years no one ever came to visit this old woman, and this I could never photograph."

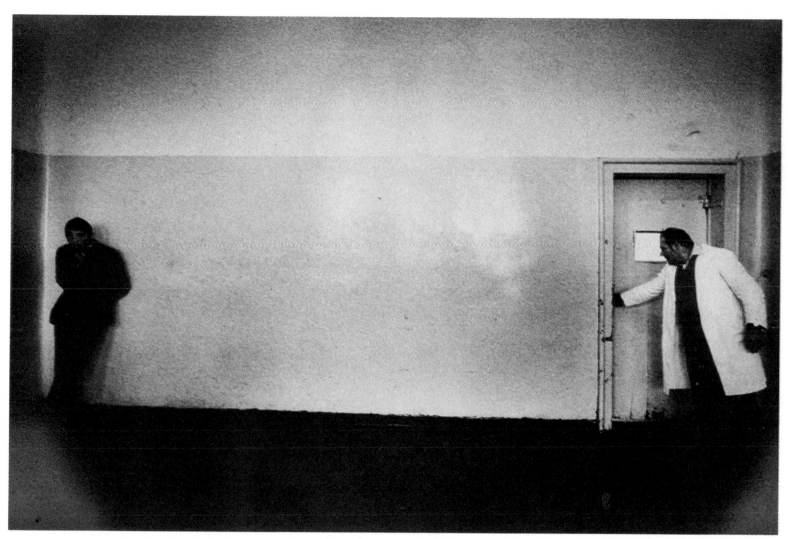

RAYMOND DEPARDON: *Psychiatric Hospital, Naples*, 1978

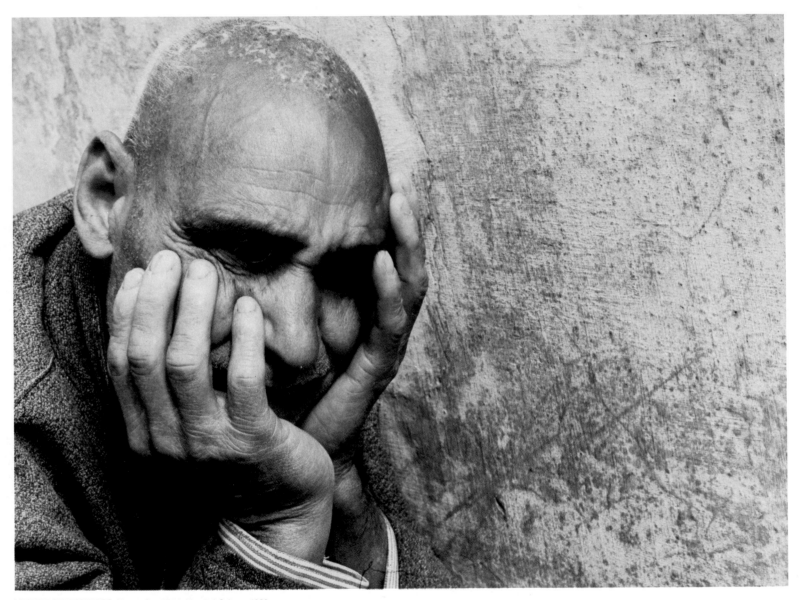

LUCIANO D'ALESSANDRO: *Nocera Psychiatric Hospital, Salerno*, 1966

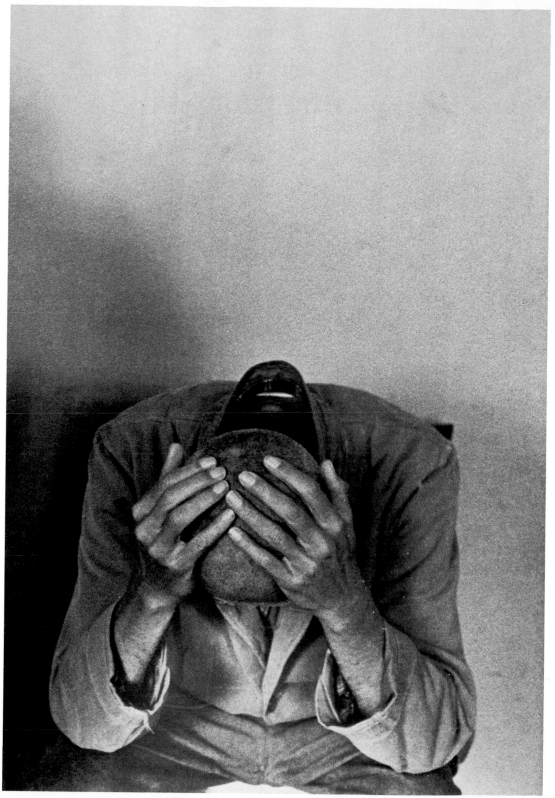

CARLA CERATI: *Psychiatric Hospital, Parma*, 1968

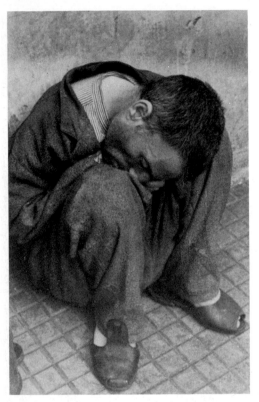 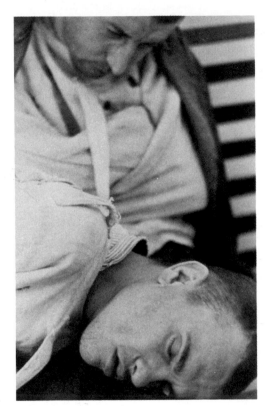 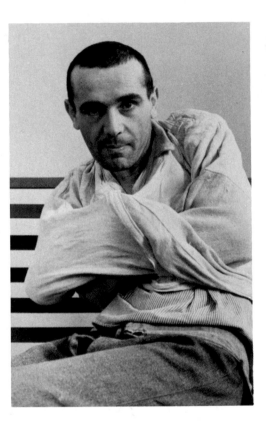

LUCIANO D'ALESSANDRO: *Nocera Psychiatric Hospital, Salerno,* 1966

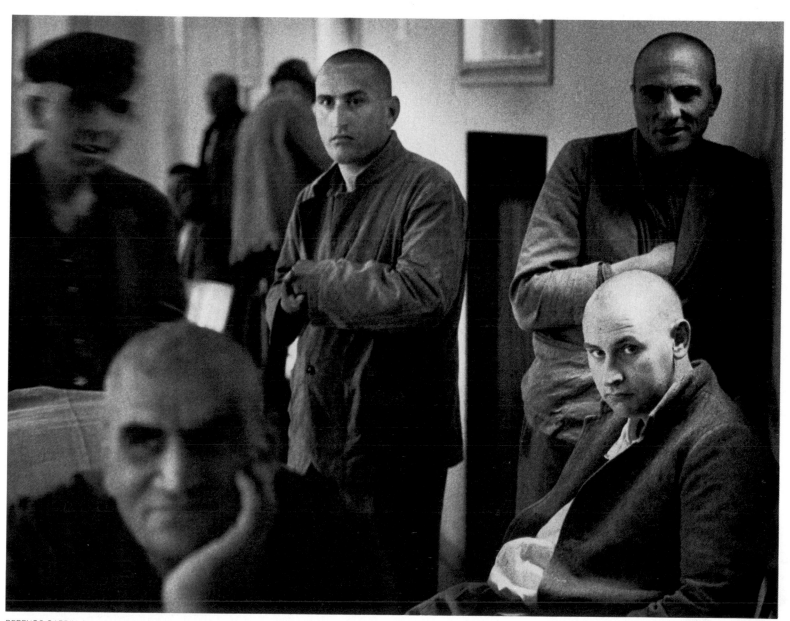

BERENGO GARDIN: *Psychiatric Hospital, Parma, 1968*

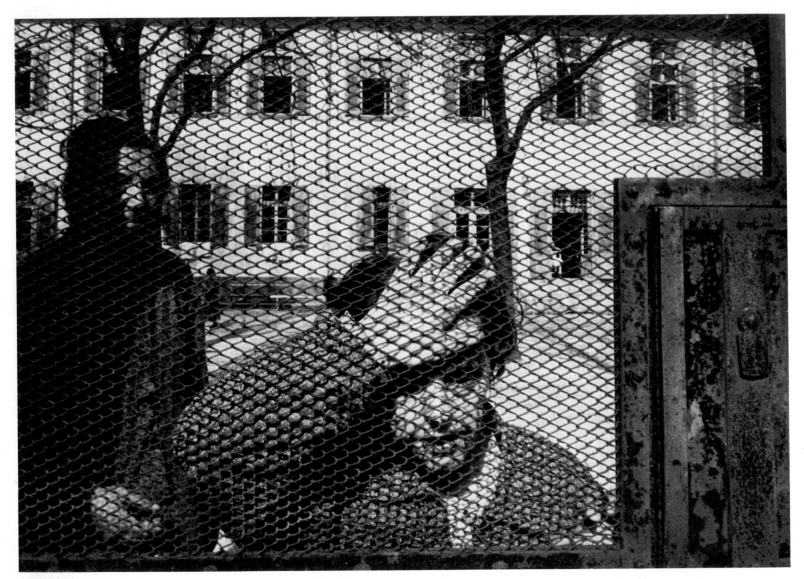

BERENGO GARDIN: *Psychiatric Hospital, Parma, 1968*

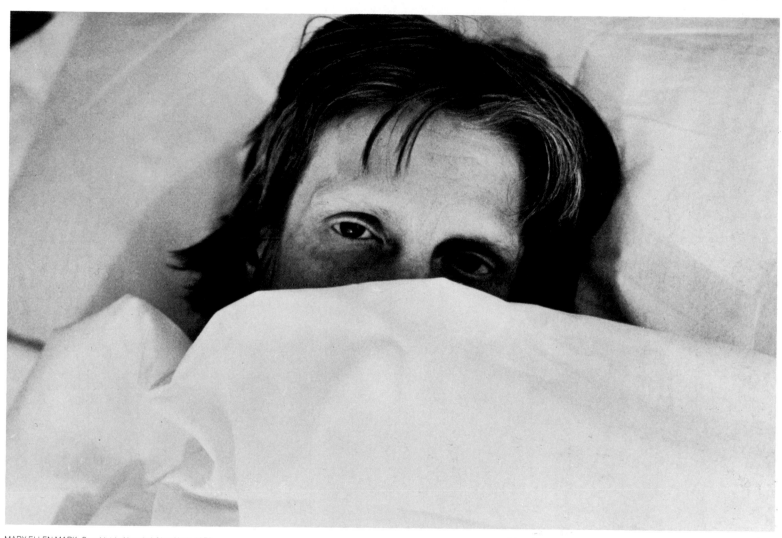

MARY ELLEN MARK: *Psychiatric Hospital, New York, 1978*

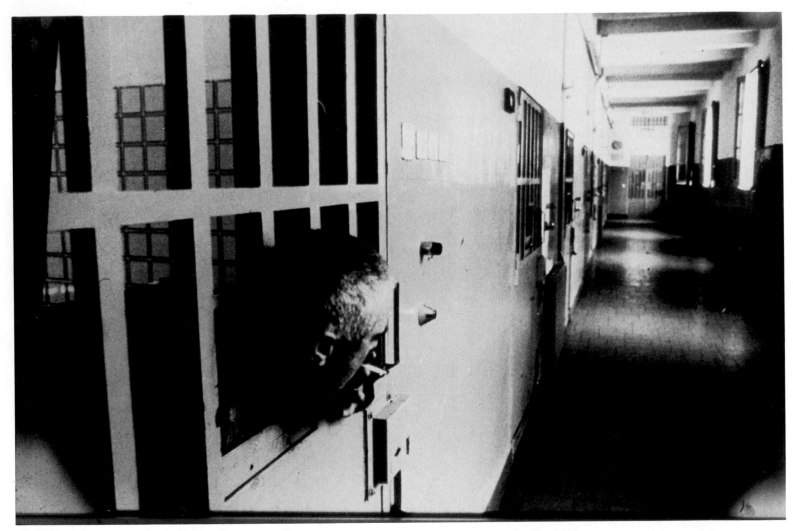

PAOLO LUCIGNANI: *Criminal Psychiatric Hospital, Barcellona,* 1980

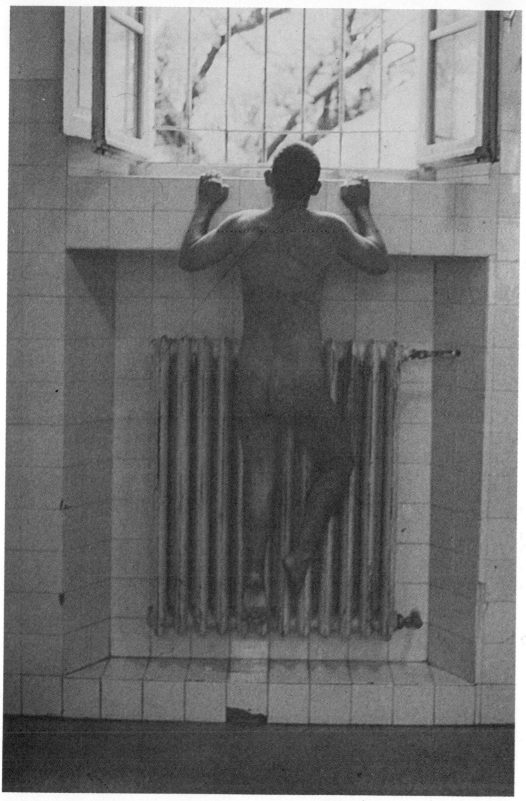

MAZZOLARI: *Private Psychiatric Hospital, Cremona, 1979*

A Potpourri of Ambitious Concepts

Photographic masters of the past and present were highlighted in the major shows of 1981, a year that also saw old barriers broken and photography's roots reassessed

Among the potpourri of photographic exhibits mounted in 1981 by museums and galleries from Japan to Italy, many of the most interesting were marked more by ambitious concepts than—as has often been the case in recent years—by extraordinary size. The shows also tended to focus on seasoned photographers and distinguished careers. In Tokyo, for example, Hiroshi Hamaya assembled what amounted to two concurrent retrospectives of his 50 years' work: "The Face of Man" *(opposite)*, black-and-white photographs documenting both urban and rural life; and "The Face of the Earth," color landscapes usually shot from the air. Lisette Model *(page 94)*, whose influence since the 1950s has been primarily as a teacher (Diane Arbus and Larry Fink were among her students), returned to exhibiting with a New Orleans retrospective that included works dating back to 1937. And Marie Cosindas' mastery of color photography was celebrated in a 20-year restrospective, held to mark the centennial of the Cincinnati Art Museum *(page 84)*.

Several other veteran photographers had major solo exhibitions during the year. In Philadelpia, an exhibit by George Krause *(page 87)* included a series of nudes that combines allusions to classical painting and Krause's longstanding interest in surrealist dream imagery. In London, the insight and emotional power in the work of *Observer* photographer Jane Bown *(page 86)* was displayed at the National Portrait Gallery and elsewhere in Britain. And in Paris, Marc Riboud *(page 92)* presented photographs taken in post-Revolution China and other parts of the world.

A fascination with the roots of photography itself and with traditional notions of art—sometimes accompanied by a challenge to reevaluate them—characterized several displays mounted on both sides of the Atlantic. In Cologne, "Farbe im Photo" *(page 85)* assembled hundreds of images to document the 120-year evolution of color photography. In New York and Paris, the Metropolitan Museum of Art and the Bibliothèque Nationale joined forces to compile "After Daguerre" *(page 90)*, a show of 100 French photographers from the latter half of the 19th Century. And in Bari, Italy, journalistic photographs were mounted for the first time in a state-run gallery—a form of recognition heretofore afforded only to art photography.

Perhaps the most thought-provoking exhibition was mounted at New York's Museum of Modern Art, where Associate Curator of Photography Peter Galassi put together "Before Photography" *(page 91)*, an assemblage of both early photographs and paintings and drawings from the late 18th and early 19th Centuries. The conjunction of images was designed to demonstrate that photography was not merely a technical invention but sprang from a critical shift in artistic norms that preceded its invention.

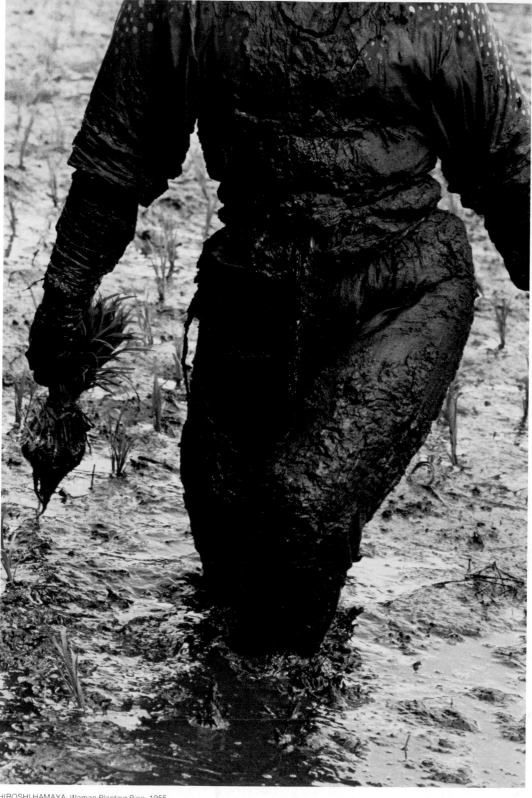

Takashima Gallery—Tokyo

The rounded, mud-caked form of a sturdy woman who seems rooted in a rice paddy echoes the shape and texture of the seedlings in her hand, reflecting Hamaya's abiding concern for the life force present in both humanity and nature. The photograph was part of a dramatic two-part retrospective, in color and in black-and-white, of his half-century-long career.

HIROSHI HAMAYA: *Woman Planting Rice,* 1955

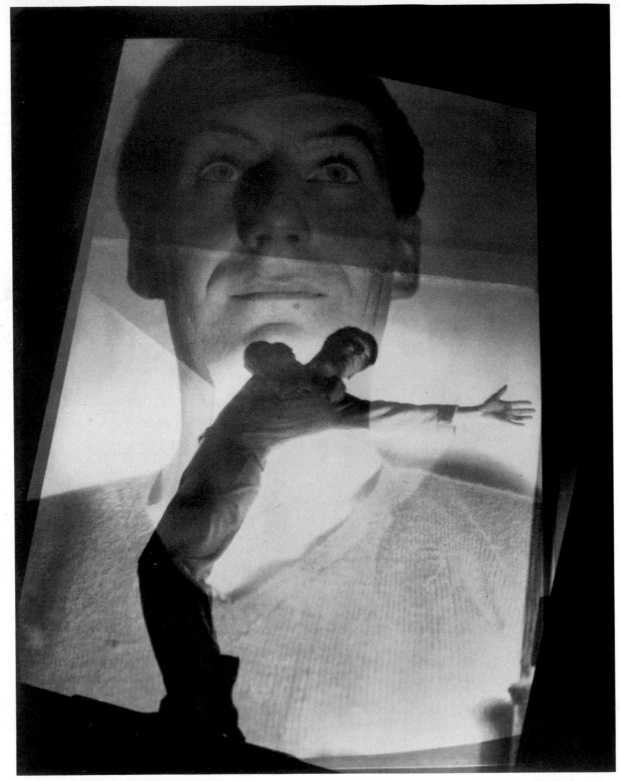

MAURICE TABARD: *Surimpression, Paris 1929*

Sander Gallery— Washington, D.C.

Photo abstraction was well represented at an exhibit of Maurice Tabard's vintage prints, which included this multiple-image montage. An active experimental photographer in the 1930s, Tabard lost most of the work he did before the War during the Nazi occupation of Paris.

Pinacoteca Provinciale— Bari, Italy

A funeral barge in Venice was one of some 1,000 photographs in an exhibit chronicling Italian photojournalism since 1945. The show, mounted in the city of Bari and seen by more than 100,000 people, was the first major exhibit of journalistic photography in Italy's state galleries.

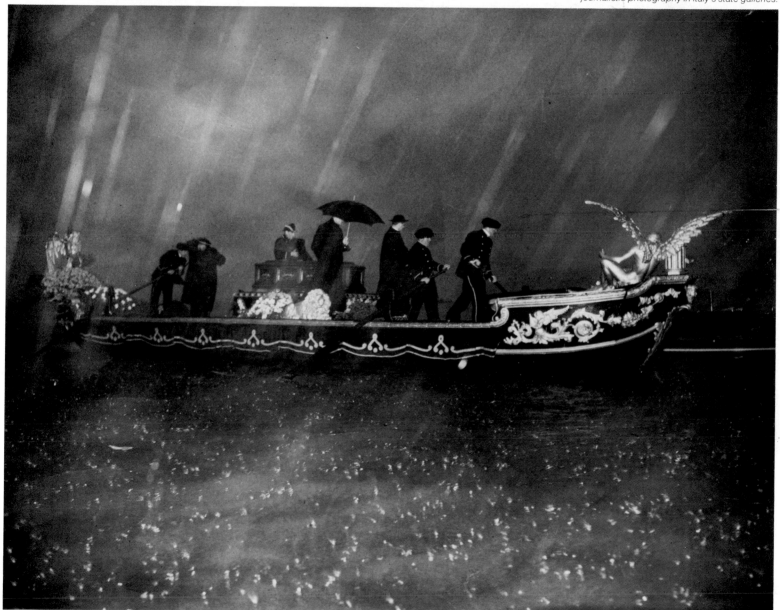

SILVANO LUCCA: *Funeral of Patriarch Monsignor Carlo Agostini,* 1952

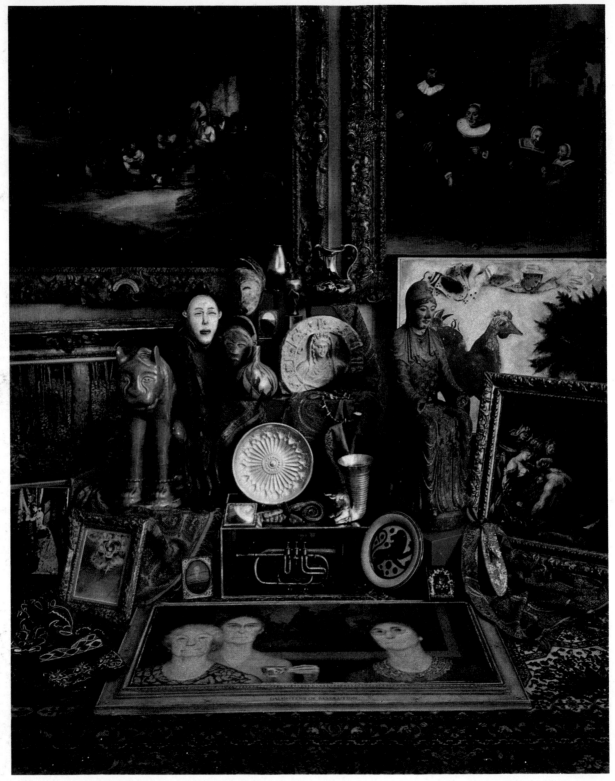

MARIE COSINDAS: *The Cincinnati Art Museum Centennial Still Life*, 1980

Cincinnati Art Museum — Cincinnati, Ohio

Commissioned to create a poster for the museum's centennial, Cosindas assembled this "million-dollar still life" with objects from the museum's permanent collection — including works by Gainsborough and Chagall. The opulent image was included in a retrospective of her career that consisted almost entirely of Polaroid color photographs.

Josef-Haubrich-Kunsthalle — Cologne

The esthetic and scientific history of color photography from 1861 to 1981 was the theme of an exhibit that included this view of a small, orderly cafe in Cologne. In addition to 400-odd images, the show displayed photographic equipment and offered explicatory films.

AUGUST KREYENKAMP: *Interieur*, c. 1928

National Portrait Gallery — London

*This melancholy picture of an ivy-covered
statue was one of 120 in a retrospective of Bown's
three decades as a photographer for the
London Observer. Aptly titled "The Gentle Eye,"
the exhibit traveled throughout Great Britain.*

JANE BOWN: *Female Statue, Crystal Palace,* 1952

**David Mancini Gallery—
Philadelphia**

*Krause, who in 1976 became the first
photographer to be awarded the Prix de Rome,
shot this portrait of himself against a
backdrop of his own work, using black light in
order to heighten the dreamlike effect.*

GEORGE KRAUSE: *The Editing Wall*, 1979

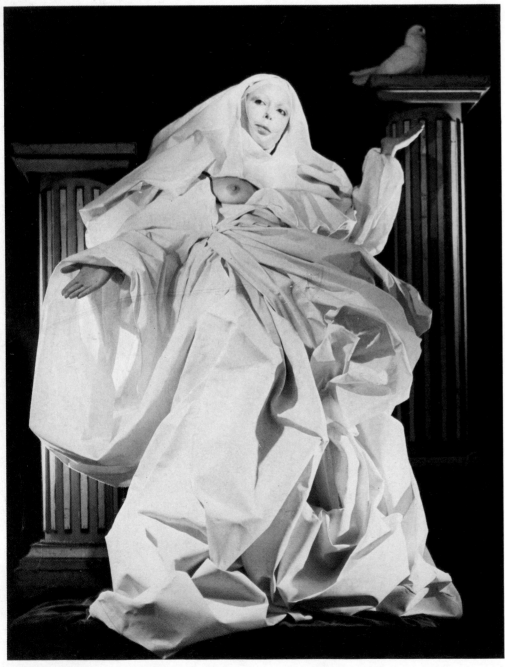

ORLAN: *Mise en scène pour une sainte,* 1980

Centre Georges-Pompidou — Paris

This self-portrayal of Orlan, who uses a single name professionally, appeared in an exhibit of 154 examples of self-portraiture from the turn of the century to the present. "My subject is always the same," she says: "my own identity, seen through the study of the Baroque Madonna."

WALKER EVANS: *Westchester, New York, Farm House,* 1931

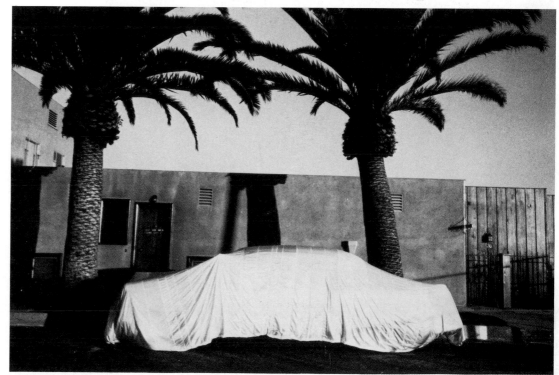

Yale University Art Gallery— New Haven, Connecticut

Separated by a quarter of a century, these two kindred images were paired in an exhibit whose subtitle was "An Essay on Influence." Curator Tod Papageorge's thesis was that Swiss immigrant Robert Frank, in photographing his book The Americans, took an earlier work, Walker Evans' American Photographs, as "not only a guide to what he might photograph in America, but a vision of how he might understand what he saw here."

ROBERT FRANK: *Covered car — Long Beach, California,* 1956

ANDRÉ-ADOLPHE-EUGÈNE DISDÉRI: *The Calabrians*, 1853

The Metropolitan Museum of Art— New York

A master of genre photography in the 1850s, Disdéri made a series of images of anonymous street characters, such as these vagrants, at a time when most photographs of human subjects were formal studio portraits or landscapes and cityscapes in which people were incidental.

Collard, whose first name is not known, was an official photographer for French Service of Bridges and Roads during the 19th Century. He often preferred representative details, like this partial view of a bridge, to images of an entire structure. The series of receding arches made the photograph a natural choice for an exhibit that traced the origins of photography back to the 15th Century invention of vanishing-point perspective.

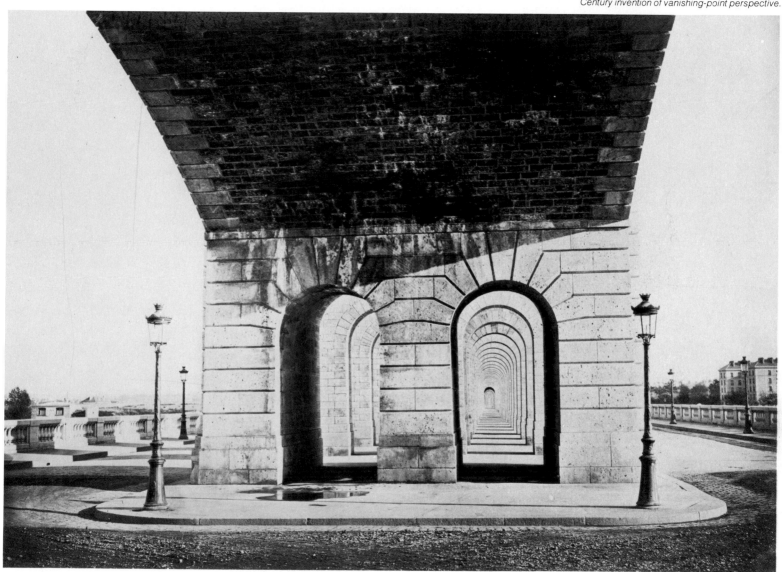

A. COLLARD: *The Auteuil Viaduct at the Pont du Point du Jour*, 1860s(?)

Photograph Gallery— New York

When Marc Riboud photographed her on the first of his five visits to the People's Republic of China, this aristocratically clad woman was already an anachronism on the streets of Peking. The image— indicative of Riboud's gift for getting beyond cliché—was included in a one-man exhibit that also featured the widely traveled Frenchman's views of Vietnam and Morocco.

MARC RIBOUD: *Survivor of the Past, Peking,* 1957

ROLAND FREEMAN: *Arabing, East 21st Street and Greenmount Avenue, 1972*

International Center of Photography — New York

A boy perches on the wagon of a Baltimore street vendor, known locally as an "Araber," while the vendor chats with a customer. Photographer Roland Freeman—who once worked as an Araber's helper—spent 12 years putting together pictures for his exhibit, a study of black life in urban and rural America.

LISETTE MODEL: *Monte Carlo*, 1937

New Orleans Museum of Art
— New Orleans, Louisiana

This portrait of a haughty-looking woman was among 120 displayed at a 1981 retrospective of Lisette Model's work. Model took the photograph during a visit to France in 1937, the same trip that produced the heralded series "Promenade des Anglais." In 1951, Model gave up exhibiting or publishing her work to concentrate on teaching. Hence, more than half of the works that were exhibited in New Orleans had never before been seen by the public.

The Annual Awards/3

*This eerily engaging portrait of a pair of
Celebes apes was taken at the Minnesota
Zoological Garden in Minneapolis. Jim
Brandenburg, who was honored for a portfolio on
a broad range of subjects, underexposed the
film in order to emphasize the animals' eyes.*

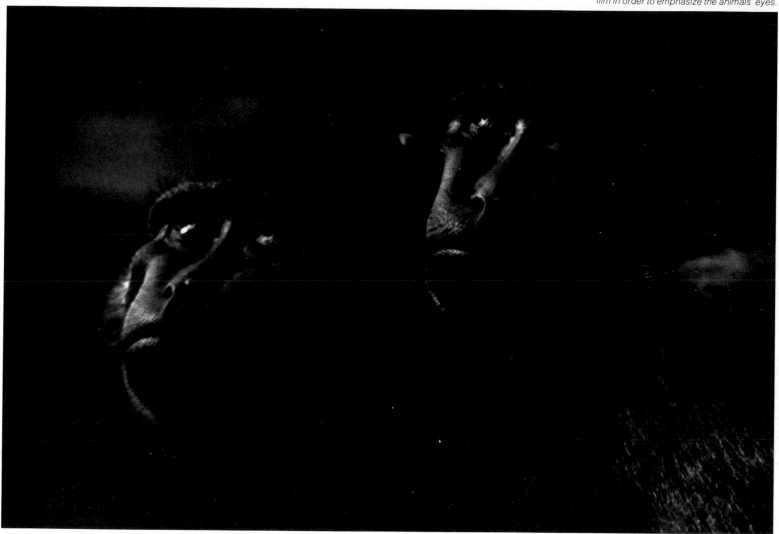

JIM BRANDENBURG: *Celebes Apes,* 1980

Classic Artistry Honored by the World's Juries

A majority of 1981's international awards went to photographers whose pictures were carefully composed, yet evocative of the human condition in the 20th Century

The works of photographers honored by international juries in 1981 covered an expansive range—from the surrealistic view of San Francisco on the opposite page to the portrait on page 100 of a Hasidic Jew who seems to have stepped out of another century. Consistently, however, they were skillfully composed; light and shadow, color and texture were balanced as carefully as though the photographer had wielded a brush instead of a camera.

Even photojournalists, whose work often consists of spontaneous images taken on the run, displayed compositional artistry. In one of the pictures that earned Larry C. Price the Pulitzer Prize for Spot News Photography *(page 104),* a line of receding poles leads the eye from the sprawled bodies of Liberian government officials executed after a coup to the crowd being kept back by soldiers. Later, learning that airport guards were confiscating exposed film from foreigners leaving the country, Price smuggled his pictures out in a seemingly unopened film pack.

Price was not the only photographer to court danger and return with award-winning pictures. Taro Yamasaki, who won a Pulitzer for Feature Photography *(page 105),* spent 10 days in a Michigan prison where many of the inmates were armed. Robert Capa Gold Medalist Steve McCurry, who photographed guerrilla resistance to the Soviet occupation of Afghanistan, was twice picked up and imprisoned by Pakistani officials for crossing the border illegally.

Other kinds of courage received photographic recognition in 1981. Bryce Flynn was named winner of the World Understanding Award for a photo essay dramatizing the challenges faced every day by a woman whose son—now 15—was born with severe physiological defects and is mentally retarded. In France, Jacques Bondon, who made a similarly moving series of photographs of the obstacles encountered and overcome by blind people, shared Le Prix Niepce *(page 101)* with Frédéric Brenner, who was honored for a portfolio on Hasidic Jews in the Me'ah She'arim quarter of Jerusalem.

Brenner, 21, and Bondon, 28, were among the youngest photographers honored in 1981; several veterans also were singled out. In Japan, the Nendo Sho, or Annual Award *(pages 106-107),* was shared by four established photographers for works ranging from a slim exhibition catalogue to multivolume art-photography books. In France, the prestigious Prix Nadar went to Willy Ronis for a retrospective book of pictures that included the nude seen on page 112. And in Germany, a book of photographs by old master August Sander received the Erich Stenger Prize *(page 110),* and Peter Keetman won the David Octavius Hill Award for his wide-ranging life's work, exemplified by the highly contrasted landscape on page 111.

The Netherlands Press Photo of the Year Award went to Mike Wells for a heart-wrenching, stunningly simple portrait of two hands, one small, withered and black, the other large, healthy and white. This single photograph symbolized both the plight of starving children in drought-stricken Uganda and the help offered by Western nations—help that often came too late.

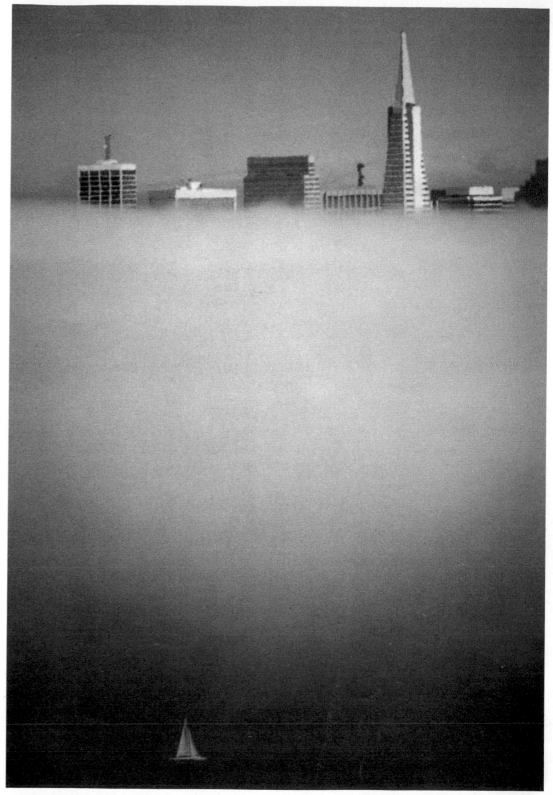

Newspaper Photographer of the Year— U.S.A.

The towers of San Francisco seem to float in the clouds above a ghostly sailboat in a picture taken on a foggy day by prize-winning photographer George Wedding, of the San Jose Mercury News. This is Wedding's second appearance in Photography Year; he was given the World Understanding Award in 1978.

GEORGE WEDDING: *Floating in the Fog,* 1980

*The prize was shared by two photographers,
Frédéric Brenner and Jacques Bondon.
Brenner won for a series of images of Hasidic
Jews, such as the elder below, making his way
along a snow-covered Jerusalem street. Bondon
was honored for two photo essays; one of
them, about the lives of blind people, included the
shot at right of a tandem cycling team:
The lead rider is sighted; his teammate is not.*

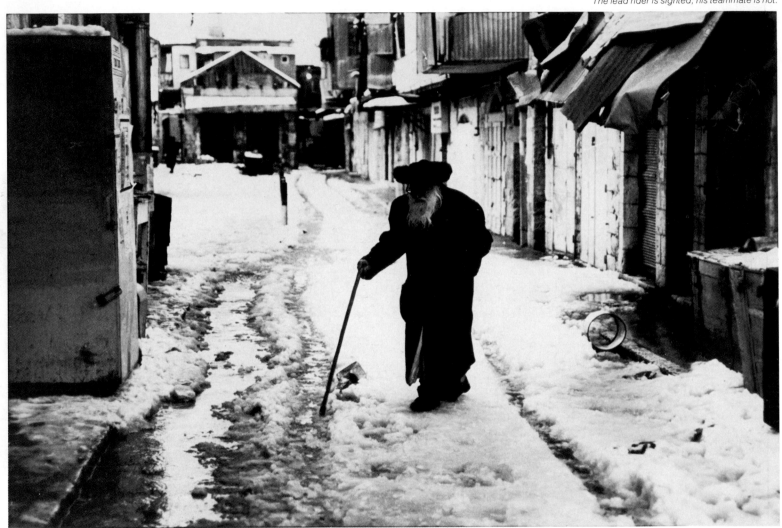

FRÉDÉRIC BRENNER: *Untitled*, 1980

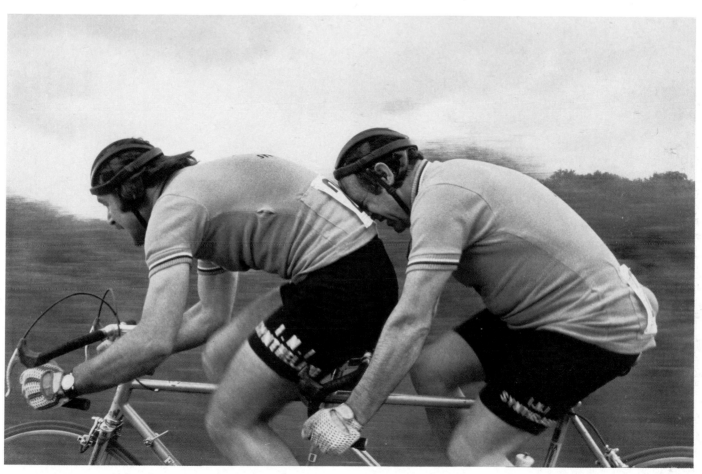

JACQUES BONDON: *Tandem Championship of France for the Blind*, 1980

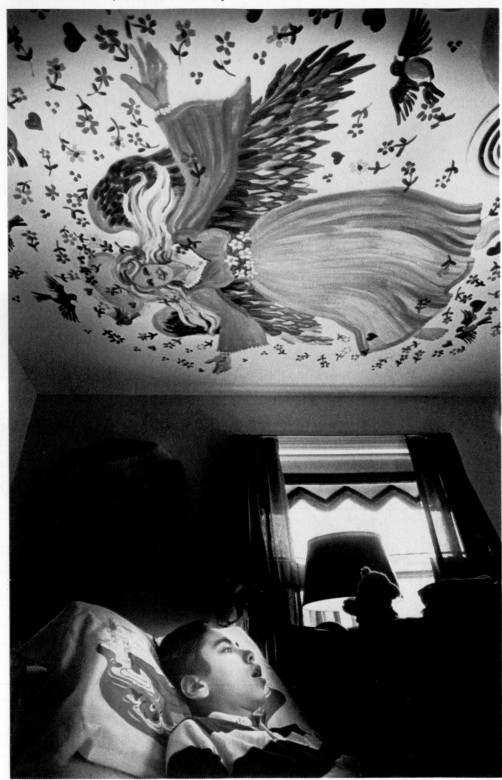

BRYCE FLYNN: *Warren's Guardian Angel,* 1979

World Understanding Award— U.S.A.

Soft light illuminates the face of a handicapped boy and the image of a guardian angel overhead. The ceiling painting was created by two students at the Rhode Island School of Design at the request of the boy's mother; she wanted her son, who must spend much of his life on his back, to have something to look at. Flynn photographed the family over a period of two months. His award-winning essay appeared in the Providence, Rhode Island, Sunday Journal Magazine.

Press Photo of the Year and News Features Awards— The Netherlands

The robust white fingers of a priest form a moving contrast to the nearly fleshless hand of a Ugandan child suffering from kwashiorkor, or chronic malnutrition. This photograph, taken by London freelancer Mike Wells, reflects the ravages of a drought that left more than 20,000 dead in the Karamoja district of Uganda, where the situation was most critical.

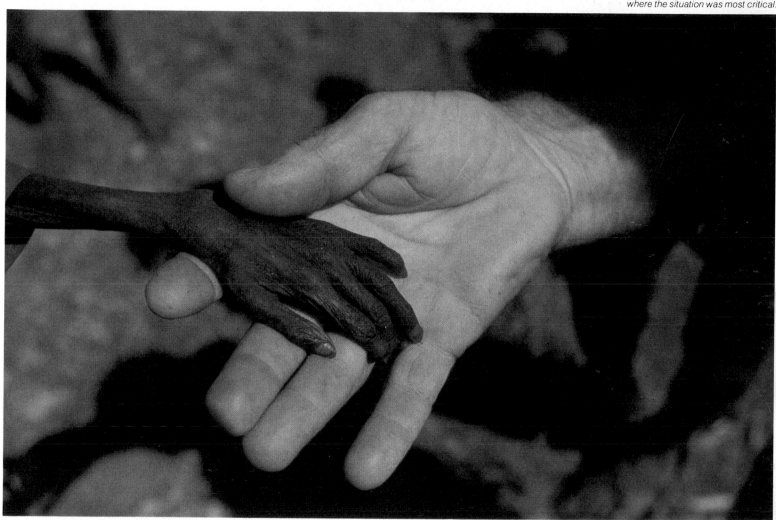

MIKE WELLS: *Drought's Harvest in Uganda,* 1980

*Sunlight filters through smoke from
executioners' rifles as a crowd backs away from
the bodies of Liberian officials shot in the
aftermath of a coup in April 1980. Larry Price, of
the Fort Worth Star-Telegram, was the only
American photographer to witness the execution.
He was so close to the firing squad that
a shell casing struck him above the eye.*

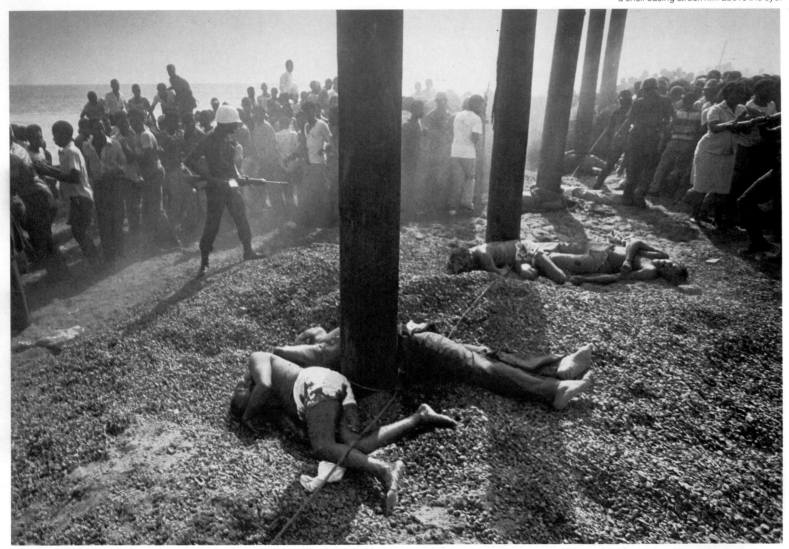

LARRY C. PRICE: *Execution on the Beach*, 1980

*Maximum-security inmates at the State Prison
of Southern Michigan in Jackson are silhouetted
against a glaringly lighted background.
Tight cropping emphasizes the symmetry of
the cellblock and the claustrophobic life of the
prisoners. Taro Yamasaki, of the Detroit Free
Press, won the prize for a series on living
conditions inside the world's largest walled prison.*

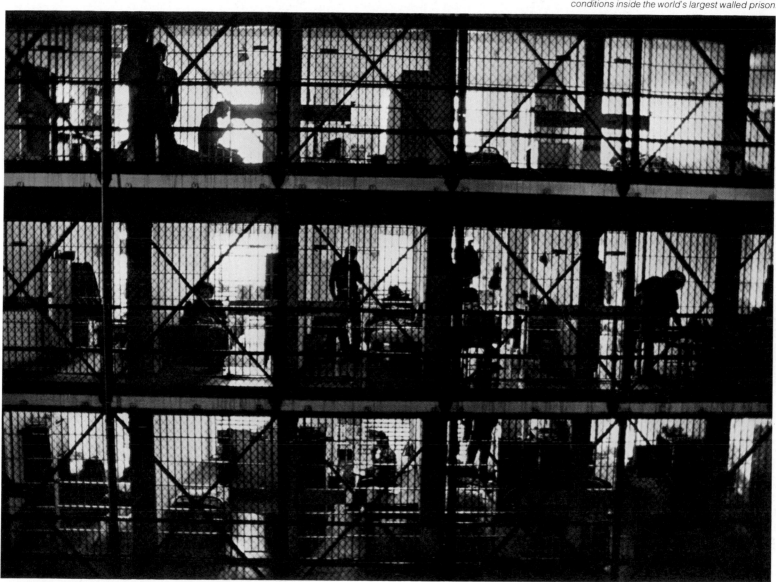

TARO YAMASAKI: *Fifteen Cells*, 1980

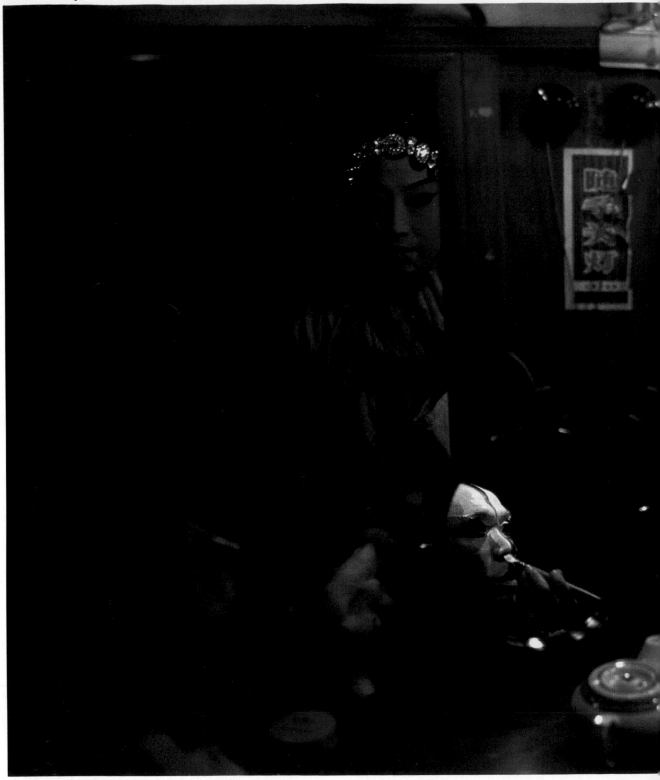

HIROJI KUBOTA: *Untitled,* 1980

Nendo Sho (Annual Award)— Japan

The masklike faces of members of China's Number One Peking Opera Troupe are reflected in multiple mirrors as performers apply makeup in this image from Hiroji Kubota's prize-winning book, The Flow of the River. Kubota shared the Nendo Sho with three other photographers: Yoshikasu Shirakawa, honored for an exhibition and three-volume set of books called Land of the Bible; Takashi Okamura for Vatican Frescoes of Michaelangelo, an exhibition and catalogue; and Banri Namikawa for a book on the Silk Road and a five-volume set, Treasures from the Topkapi Sarayi Museum.

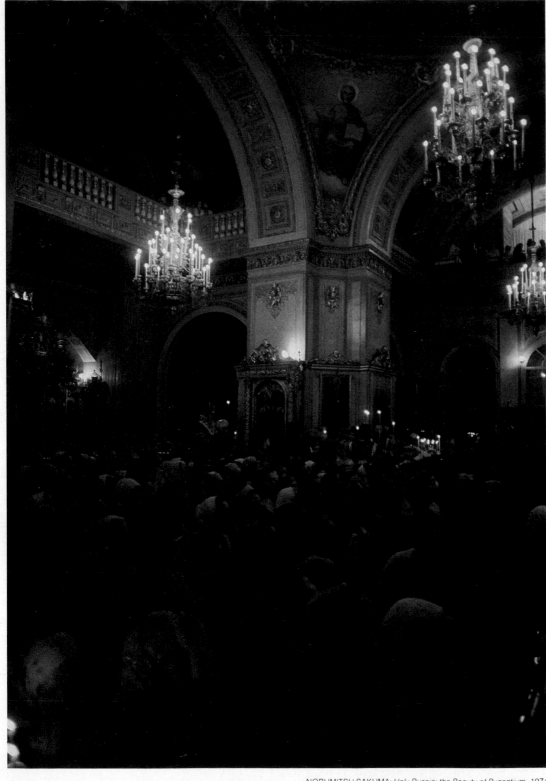

Shinjin Sho
(Newcomers Award)— Japan

A Russian Orthodox congregation stands shoulder to shoulder beneath the gilded pillars and crystal chandeliers of a Byzantine church in Moscow. The photograph is from a series on Russian Byzantine churches begun by Nobumitsu Sakuma in 1974. Sharing the award was Keizo Kitajima, who produced a series depicting the seamier side of life in postwar Japan.

NOBUMITSU SAKUMA: *Holy Russia: the Beauty of Byzantium,* 1974

Robert Capa Gold Medal— U.S.A.

Afghan guerrillas in the mountains of Kunar Province man an obsolete antiaircraft gun, their only weapon against helicopter gunships of the Russian occupation forces. Steve McCurry made several clandestine trips into the country to document the resistance of the Afghans.

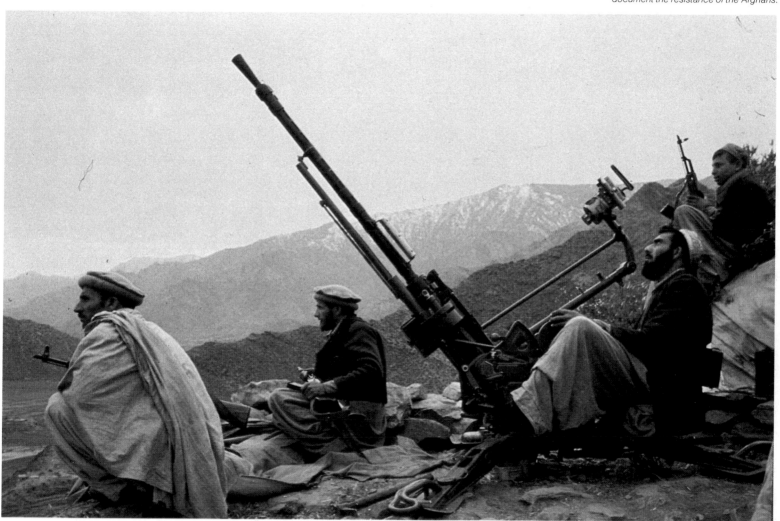

STEVE McCURRY: *Afghan Guerrillas*, 1980

AUGUST SANDER: *Peasant Couple*, c. 1928

Erich Stenger Prize— Germany

The meticulous recording of detail in this portrait — from the fine wrinkles around the old man's eyes to the pattern of the wallpaper — is representative of the unsparing eye of the late August Sander. The award, given by the German Photographic Society for a German publication devoted to the history of photography, honored Man of the Twentieth Century: Portraits from 1892 to 1952, a book of Sander images that was published in 1980 by Schirmer/Mosel of Munich. Sander died in 1964.

David Octvius Hill Award— Germany

Trees, buildings and minute human figures stand in bold relief against the snow high in Germany's Swabian Alps. The contrast transformed what would have been a simple postcard view into a fascinating landscape that resembles a fine woodcut. Peter Keetman was awarded the prize for a lifetime's work photographing a broad spectrum of subjects.

PETER KEETMAN: *Drackenstein*, 1959

With its subtle play of light and shadow, this portrait of a nude washing at a basin in a country house is reminiscent of 19th Century French Impressionism. The photograph appeared in a volume titled Willy Ronis: On the Wire of Chance, a career-retrospective that won the Gens d'Image annual award for the best photographic book published in France.

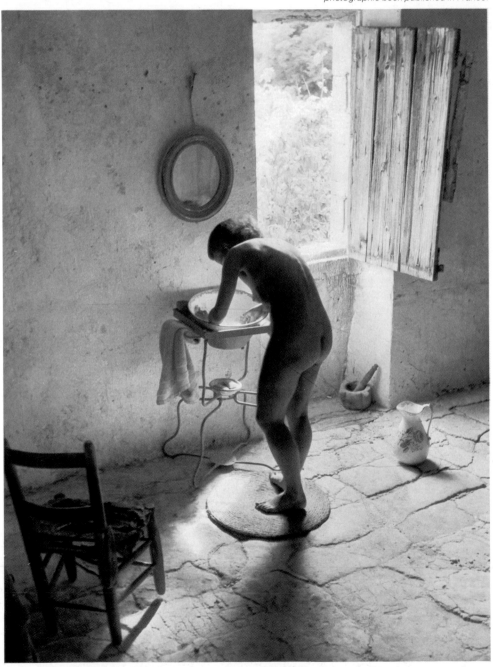

WILLY RONIS: *Nude in Provence,* 1949

The New Technology/4

The New Technology/4

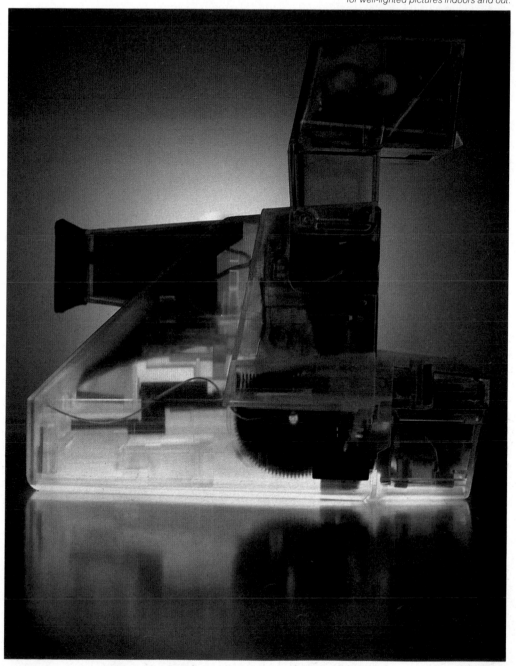

Many Speeds for the Price of One

Modern color-film technology gives rise to two new high-speed black-and-white films that produce fine-grain images through a wide range of exposure settings

Two films for a remarkably different kind of black-and-white photograph came on the world market in 1981. Agfapan Vario-XL and Ilford XP1 400, both nominally rated at ISO 400/27°, use recent advances in color-film technology to produce black-and-white images with the fine-grain characteristics of much slower film. The films, first presented at the 1980 Photokina *(Photography Year/1981 Edition),* also allow the photographer to shoot at a wide range of exposure settings—the equivalent of almost five f-stops—without a significant loss of image quality. Agfa indicates that Vario-XL may be exposed at ratings from ISO 125/22° to 1600/33°, while Ilford sets the range of XP1 from ISO 50/18° to 1600/33°. Although the final prints are black and white, the new films are processed like color film, producing a silverless negative in which the image is composed of dyes rather than silver grains. The films are called chromogenic—color producing—because the dyes are formed in the emulsion during development.

The new chromogenic films have two image-forming layers of emulsion, one more light-sensitive than the other. As in conventional color and black-and-white films, these emulsion layers contain compounds known as silver halides. When exposed to light, the silver halide crystals react by forming a latent, or invisible, image composed of a small proportion of their silver atoms. Chemical developer acts on the latent image to convert more of the silver halides to silver, forming a negative image (dark in the brightest parts of the original subject, light in the dimmest parts). In conventional black-and-white photography, a bath of fixer then washes away unexposed silver halides, leaving the silver image. In the chromogenic films, however, as in conventional color films, the emulsion layers also contain colorless chemicals known as dye couplers. During development, oxidized developer—which has reacted with the silver halide crystals—undergoes a second reaction with the dye couplers, forming clouds of dye around each grain of silver. Both the silver image and the unexposed silver halide crystals are then removed by bleaching and fixing, leaving a negative image formed of dye alone.

With semitransparent clouds of dye forming the image, instead of opaque particles of metallic silver, graininess is much less evident than in conventional black-and-white films. This is because clusters of dye clouds overlap, producing a much smoother grain structure *(pages 120-121).* Agfa and Ilford have applied another recent advance in color-film technology that also reduces graininess: DIR, or development inhibitor releasing, couplers. These chemicals are dispersed in the emulsion and are activated in much the same way as dye couplers, but their function is to restrain the development of silver grains, resulting in smaller dye clouds. The more numerous and smaller the silver grains—and hence the dye clouds that replace them—the sharper the final image and the finer its grain. The DIR couplers make possible the use of large high-sensitivity silver halide crystals in the fast outer layer of emulsion without sacrificing fine grain, because the couplers prevent the dye clouds from becoming too large. The second layer of emulsion has

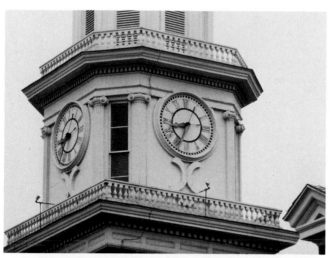

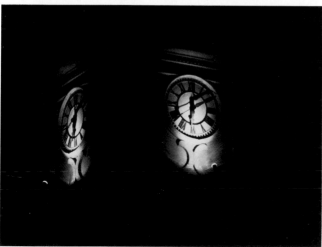

These two pictures of a clock tower, taken in very different lighting conditions, are from the same roll of Agfapan Vario-XL film. The lens setting and shutter speed were the same for both shots. Conventional ISO 400/27° settings would have been 1/500 at f/3.5 for the daytime shot and 1/15 at f/3.5 for the night view. Yet the chromogenic film yielded satisfactory prints both times with a setting of 1/125 at f/3.5.

smaller, slower crystals, and the combined action of the two layers extends the exposure latitude of the chromogenic films.

Despite the use of dyes, the new chromogenic films do not record the colors of the scene. This is because of the way the dyes are dispersed in the emulsion. In color films, the emulsion layers are designed so that the silver halides in each layer react to only one of the three primary colors of light (blue, green or red). The dye cloud formed around each exposed crystal is complementary to the color sensitivity of that layer: Yellow dye forms in the blue-sensitive layer, magenta in the green-sensitive layer and cyan in the red-sensitive layer. Each layer thus registers only certain colors of the image.

In the new films from Agfa and Ilford, on the other hand, the silver halides in both emulsion layers are designed to respond to all colors of the light spectrum. It is solely the brightness of the light during exposure that determines the extent to which the silver halides react *(pages 118-119)*. These reactions in turn determine where the dye clouds will concentrate during development. Theoretically, the dyes used in the emulsions could be any color, since the final image is black and white. In fact, however, the dyes used are yellow, magenta and cyan. These colors are determined by the nature of black-and-white printing papers and by the need of photographers to be able to evaluate the quality of the image at the negative stage.

Black-and-white papers fall into two major categories: fixed-contrast papers, which come in a number of contrast grades and are sensitive only to blue light; and variable-contrast papers, which have two layers, one sensitive to blue and one to green light. One layer is high contrast, the other low. Filters are used to control the proportions of blue and green light and thus the contrast of the final print. If the chromogenic films contained only yellow dye, which absorbs blue light, they could be used only with fixed-contrast paper; magenta dye is added to absorb green light. These dyes alone would suffice for printing on either fixed- or variable-contrast papers, but the combination would produce a negative that is difficult to evaluate. Cyan dye is added to make the negative appear a more neutral color. Couplers for all three dyes are dispersed in each of the two emulsion layers.

Both films can be developed with the commonly available color-negative processing chemicals, at home or commercially—although Ilford has a kit to produce somewhat sharper and crisper images with its film. The advantage of both these films is that they are adaptable to a wide variety of lighting situations: A photographer can use several different speed ratings on one roll of film, process the entire roll in standard fashion, and produce good quality images across the board.

Using Color to Get Black and White

The new chromogenic films from Agfa and Ilford have two salient characteristics: They contain two image-forming emulsion layers that differ in their sensitivity to light, and they resemble color films in that the emulsions also contain dyes. Unlike color films, however, both layers of emulsion are panchromatic — responding to all colors of light — and the dyes convey brightness rather than color to the final image.

As can be seen in the diagrams at right, the outer layer of emulsion contains larger light-sensitive silver halide crystals than the inner layer. During exposure, this fast outer layer is used to record and differentiate the tones in the dimmer areas of the subject; the slow inner layer, for the most part, differentiates the brighter tones and highlights.

Surrounding the silver halide crystals in both layers are molecules of dye couplers for yellow, magenta and cyan dyes. During the color development, the dye couplers form clouds of dye around each grain of silver. The greater the exposure in a given part of the image, the greater the number of dye clouds formed. The size of the clouds is controlled by DIR (development inhibitor releasing) couplers that restrict the development of the silver grains and therefore the amount of dye formed. Bleaching and fixing then dissolve and wash away the silver grains and the unexposed crystals, leaving a pattern of dye clouds to form the negative image. When it is printed on black-and-white paper, the image will be light in the dark portions of the negative because the dye clouds absorb light during printing.

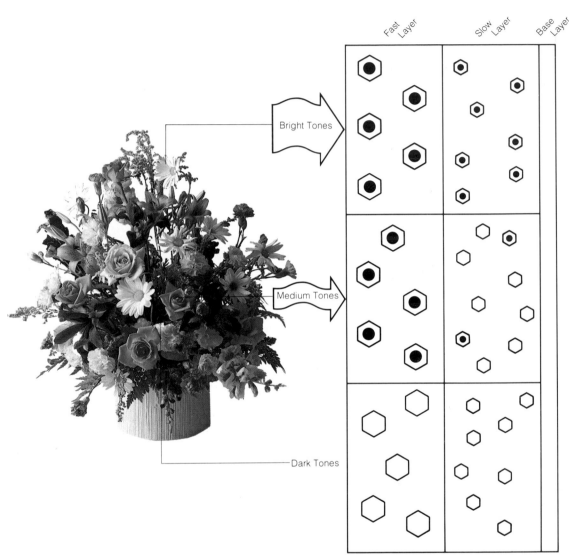

Exposure

Bright Tones

Medium Tones

Dark Tones

During exposure, the film's two light-sensitive layers are affected according to the degree of brightness in the subject. The bright light reflected from the white flowers in this arrangement exposes (black dots) the outer emulsion layer of fast silver halide crystals (large hexagons) as well as the inner layer of slow crystals (small hexagons). Medium-toned flowers primarily affect the fast layer; dark areas of the subject do not expose crystals in either layer.

Development

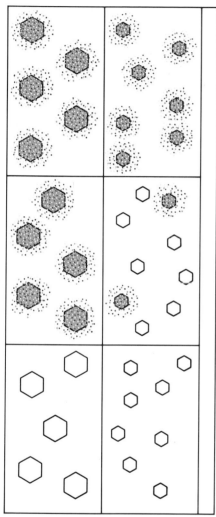

Bleaching and Fixing

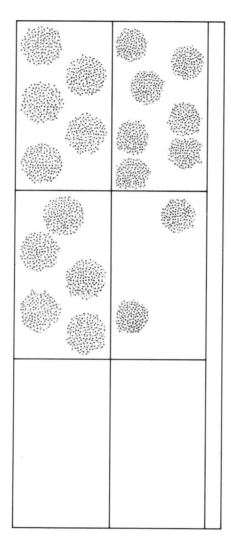

Ilford XP1 400

The plastic base of Ilford XP1 film is magenta-colored. This color combines with the dyes that are used in the emulsion layers and creates a negative image that is reddish-brown.

Agfapan Vario-XL

The base of Vario-XL is almost neutral, with just a slight red tinge. Combined with the emulsion dyes, this makes the negative brown-toned. Both Agfa and Ilford negatives can be printed in the usual way for black-and-white film.

When immersed in color developer, exposed silver halide crystals react to form grains of silver. Some of the reacted developer then combines with dye couplers to produce yellow, magenta or cyan dyes (colored dots) that form a cloud around each silver grain. Other molecules of developer react with DIR couplers, releasing an inhibitor that restrains development of the crystals to keep the dye clouds small.

A chemical bleach converts the silver to a compound that is then dissolved in the fixer, leaving an image formed of dyes only. During printing, the yellow dye absorbs blue light and the magenta absorbs green. This allows printing on both fixed- and variable-contrast papers. The cyan dye absorbs red, making the negative a more neutral color and thus easier for the photographer to evaluate.

Comparing Grain

The granular structure of photographic images arises from individual silver grains or dye clouds formed in the film emulsion by exposure and development. In conventional black-and-white films, the grain pattern is distinct because silver grains are opaque and have an all-or-nothing effect: Where no silver has formed, all light passes through; wherever silver is present, no light passes. As a result, silver groupings stand out.

Chromogenic films can produce images that are less grainy than conventional black-and-white film because the silver grains are replaced by clouds of dye during development. Dye clouds are semitransparent, allowing a proportion of light to pass through. Density is built up gradually, by the overlapping of clouds adjacent to and behind one another, rather than abruptly by opaque grains. The dye clouds are kept small by the action of the DIR couplers *(page 118),* further contributing to the finer grain of the image.

The series of pictures opposite, which are magnified 40 times, demonstrates the variations in graininess between one of the new chromogenic films, Ilford XP1, and two conventional black-and-white films. (The XP1 was developed in standard C-41 chemicals.) With conventional emulsions, severe overexposure or underexposure results in an increased graininess. The XP1, however, tends to keep its fine-grain characteristics across a variety of exposures. Even when exposed at a low speed *(upper right),* which results in heavy exposure and a dense image, it produces a grain comparable to that of Plus X. The grain is only slightly increased when the film is underexposed *(lower right).*

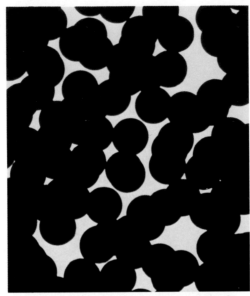

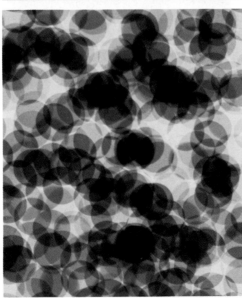

In this simulation created by Ilford, the opaqueness of silver grains (top) results in a sudden shift from dark to bright at the edges of the grains; the dye clouds of chromogenic film (bottom) give more subtle shadings.

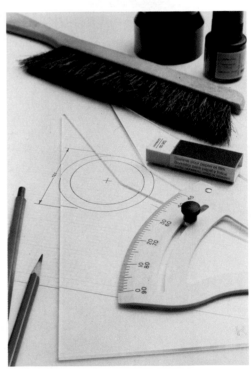

This still life of crisp-edged drafting tools was created to demonstrate the difference in grain between chromogenic and conventional black-and-white films. The chromogenic film used was Ilford XP1, exposed at several speeds. A small portion of each 35mm negative (top) was then enlarged 40 times (opposite).

Conventional Black-and-white Film

Ilford Chromogenic Film

ISO
100/21°

Kodak Plus X film (above), a fine-grain, medium-speed film with a normal rating of ISO 125/22°, was exposed at ISO 100/21°. Ilford XP1 (right)— exposed at the same speed, one quarter its normal rating—has the smoother grain pattern.

ISO
400/27°

Kodak Tri-X (above), a fine-grain, high-speed conventional film, was exposed at its normal rating of ISO 400/27°. It shows a slightly bolder grain than the XP1 (right) shot at the same speed.

ISO
800/30°

The Tri-X (above) was exposed at ISO 800/30° but developed normally. Again, it is grainier than Ilford XP1 (right) exposed at the same speed. But both films show excellent sharpness.

Instant Prints in the Home Darkroom

The technology of instant photography has made its way into the home darkroom with a compact system that creates quick color prints from ordinary negatives and slides

With the introduction of Kodak's new Ektaflex PCT color-printmaking system, amateur photographers can now use the technology of instant photography to make color prints with a minimum of chemical fuss. The system has several components: PCT (for Photo Color Transfer) negative film for making prints from negatives, PCT reversal film for making prints from slides, PCT image-receiving paper, PCT activator solution and the Ektaflex Printmaker machine. The system requires the use of enlargers and filtration, but it eliminates the need for running water and the elaborate mixing of chemicals: The single activator solution comes ready-mixed in a three-quart bottle. Moreover, the Ektaflex process is relatively immune to variations in temperature; the activator may be used at temperatures between 65°F. and 80°F.

The new system is a modified version of the PR-10 instant-camera film that Kodak introduced five years ago *(Photography Year/1977 Edition),* but in the Ektaflex PCT system the various elements are separate rather than preassembled into picture units. Like the PR-10 emulsion—and unlike conventional color films—the PCT reversal film contains an emulsion in which the unexposed parts develop and release dye *(pages 124-125).* In PCT negative film, on the other hand, the exposed parts react conventionally to the developer.

Although the Ektaflex system takes practice to master, it is relatively easy to use *(opposite),* even for darkroom novices. With the room light still turned on, the Printmaker is loaded with activator and a sheet of PCT receiving paper (which is insensitive to light). Then, with the room light turned off, the original negative or slide is placed in the enlarger and the image transferred to PCT negative or PCT reversal film. The usual rules for color printing apply here, with one exception: The original negative or slide should be placed emulsion side up in the enlarger—that is, facing away from the lens rather than toward it—since the left-to-right orientation will later be reversed when the image is transferred to the PCT receiving paper.

After exposure, the PCT film is positioned on the Printmaker ramp and slid into the solution tray to soak for 20 seconds. In this alkaline environment, the emulsion develops and the dyes in the film are freed. At the end of the soak, the film and the image-receiving paper are aligned by a plastic guide and cranked through a pair of rollers that laminates them into a sandwich. Both the film and the paper have opaque bases that make them light-proof, so the room light can be turned on as soon as the sandwich comes out of the Printmaker. After a few minutes' wait, during which the dyes in the film transfer to the paper, the sheets are pulled apart. The waiting time depends on the room temperature: from eight to 15 minutes at 65°F., from six to 10 minutes at 80°F. The negative portion is discarded; the print, which dries in minutes, can be cut and mounted like any conventional color print. Ektaflex materials are available in 5 x 7 and 8 x 10-inch sizes, and larger sizes are planned.

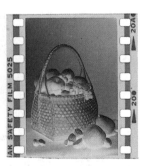 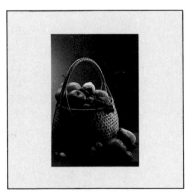

Kodak's Ektaflex PCT system can make a color print from a color negative (above, left) by using a special PCT negative film, a single activator solution and PCT image-receiving paper. The system is also designed to produce prints from color slides (above, right) with the use of PCT reversal film (pages 124-125).

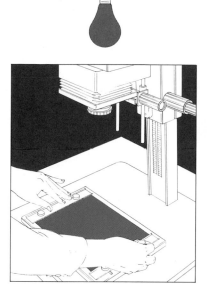

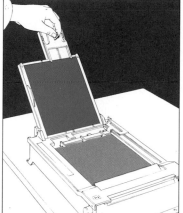

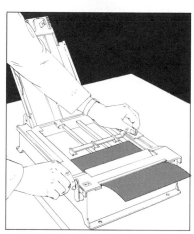

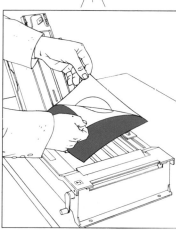

The original is placed emulsion side up in the enlarger and exposed with suitable filters, on PCT film (orange).

The PCT film is placed face up on the loading ramp and slid into the solution tray beneath the PCT paper (blue).

Crank rotation begins after 15 seconds. At 20 seconds, the film and paper advance into the laminating rollers.

Room lights can be on while the image transfers (typically eight minutes). Then the film-paper sandwich is peeled apart.

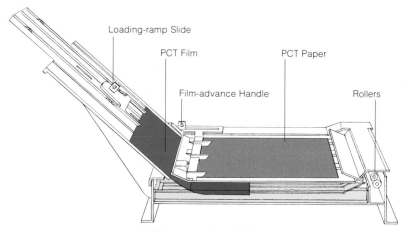

Loading-ramp Slide

PCT Film PCT Paper

Film-advance Handle Rollers

In this cutaway view of the Printmaker, the loading-ramp slide moves the PCT film (orange) into the activator solution (light blue) in the tray below the paper shelf. Pushing the film-advance handle moves both the film and paper (blue) into the hand-cranked rollers for lamination.

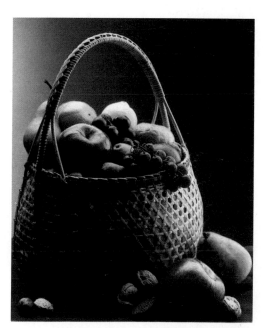

This Ektaflex print of a basket of fruit was made from the negative shown opposite. The borders of the oversized print paper have been trimmed.

Reverse Development for Instant Color

In the new Ektaflex PCT process, both the film used to make prints from negatives and the reversal film used to print slides have three layers of light-sensitive emulsion, each of which responds to only one color of light and contains complementary-colored dyes that are part of dye-releaser molecules. However, in PCT reversal film — as in Kodak's PR-10 instant color film — the silver halide crystals do not react conventionally to exposure and development, as can be seen in the sequence of diagrams at right.

The crystals in the reversal film have been altered so that exposure to light from an enlarger affects very active sensitivity centers deep within the crystals, rather than less active centers on the surface. When the film is put into the alkaline environment of the activator for development, a so-called fogging agent in the film is freed; it has an effect similar to that of light. In exposed crystals, the effects are again channeled to the interior centers in preference to the surface centers. But in unexposed crystals, fogging takes place at the surface.

Developing agent in the reversal film cannot react with the interiors of the exposed crystals, so these do not develop; but it does react with the fogged surfaces of the unexposed crystals, causing them to form silver grains. Reacted developer then sets off other chemical actions that free nearby dye molecules. The freed dye migrates to the PCT receiving paper during lamination, forming a positive image.

Projecting a slide of a colorful toy (left) through an enlarger exposes the three light-sensitive layers of PCT reversal film. Each layer contains silver halide crystals (shown as hexagons) that are sensitive to only one color of light (blue, green or red) and molecules of dye releaser (anchored dots) for dyes of the complementary color (yellow, magenta or cyan). Dotted hexagons represent the exposed crystals.

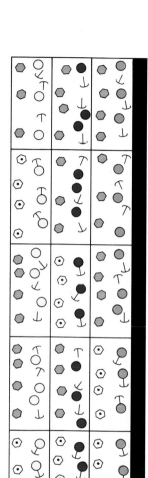

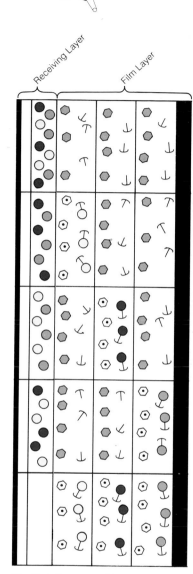

Receiving Layer

Film Layer

Finished Print

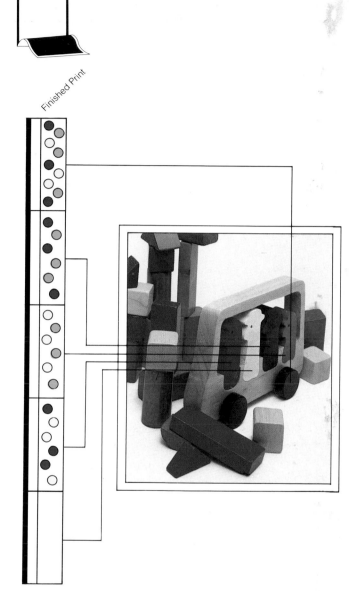

When the film is soaked in the PCT activator solution in the Printmaker, the exposed crystals are not developed. The unexposed crystals, however—because their surfaces have been chemically fogged—do react with the developer, becoming grains of silver (gray hexagons). The developer, which has been oxidized, then reacts with nearby dye releasers to free molecules of dye from their anchors in the emulsion.

The film is then passed between narrowly spaced rollers and laminated to the image-receiving PCT paper. The released dye molecules migrate from the film to the receiving layer of the paper, where they are held fast by a chemical called a mordent. Both the film and the paper have an opaque backing that makes the film-paper sandwich impervious to light during the time the image is forming.

After the lamination period, a full-color image (above, right) has been transferred and the sandwich is peeled apart. Where blue light has struck the reversal film, only magenta and cyan dye (which absorb green and red light, respectively) transfer. Blue is thus the only color reflected from this area. Other colors are similarly recreated. Black is produced where all the dyes are present, white where no dye is present.

125

Ultrafast Film and "A Piece of the Sun"

With two new point-and-shoot cameras and a high-speed film, Polaroid's 600 System not only makes instant snapshots easier than ever but brightens shade with a fill flash

In mid-1981, Polaroid Corporation announced an imaginative extension of established technology— its new 600 System, which aims at making amateur instant-snapshot photography virtually foolproof. The system consists of an ultrafast SX-70-type instant film and two modestly priced but technically innovative cameras that take advantage of the film. At ISO 600/29°, the film is four times (two f-stops) more sensitive than previous instant color films. Its high speed lets the cameras use smaller lens apertures for greater depth of field, as well as faster shutter speeds to reduce blurring caused by movement of the subject or the camera.

The most notable new feature of the cameras, however, is a built-in flash that not only lights up the dark but adds a precise amount of extra illumination to a bright scene. This supplementary light— the "piece of the sun" promised by Polaroid's ads— is commonly known as fill light. As can be seen in the comparison shots *(opposite)*, the flash lightens, or fills in, harsh shadows that form in strong sunlight. It also can prevent a brightly backlighted subject from becoming a silhouette devoid of detail. In bright conditions— and within the flash's range— the cameras are programed to allow three quarters of the exposure to come from existing light and one quarter from flash. In dimmer conditions, the cameras will add as much flash as necessary for the optimum exposure.

The new cameras— the 660 and 640— are look-alikes. Both have the flash mounted in a flip-up cover, and both have a squared-off base that ejects photographs. But each goes about the process of automatic picture taking in its own manner. The more sophisticated 660 has Polaroid's Sonar autofocusing system; it emits an ultrasonic chirp and gauges the subject's distance by measuring the time it takes the echo to bounce back. The 660 then automatically focuses by rotating a disc with four lens elements, selecting the one that will combine with a fixed element to produce a sharp image at the established subject distance. Simultaneously, the camera's advanced circuitry couples its knowledge of subject distance with data from a light-reading to determine the optimum aperture opening at which to fire the flash. By contrast, the less expensive 640 model has only a single-element fixed-focus lens— everything from four feet on is sharp— and relies entirely on its light-sensing system to control the duration of the flash. The lenses of both cameras have complex, nonspherical surfaces *(Photography Year/1979 Edition)* that improve the quality of the image.

The new Polaroid 600 film, which is compatible only with these two cameras, achieves its superior speed by having more— and slightly larger— light-sensitive silver halide crystals as well as improved sensitizers that control the crystals' response to color. The 600 film also has two "spacer layers" that, according to Polaroid, increase "the efficiency of light utilization." The film pack contains a new high-powered battery that runs the cameras' flash and circuitry.

These two pictures show the effect of using the Polaroid 660's automatic fill flash with a subject in bright, direct sunlight. When the flash was disengaged (left), the camera exposed for the predominant bright tones in the scene. Shaded areas beneath the subject's chin and hat brim fall outside the film's contrast range; they become very dark and almost devoid of detail. When the fill flash is added (right), it contributes very little to the bright areas but lightens the dark areas significantly.

Two Automatic Flash Systems

Both the 660 and the 640 Polaroid cameras
fire a built-in flash for every shot, but the ef-
fect depends on subject distance and the
brightness of existing light. In brightly lighted
scenes, the flash supplies a fill light that is 25
per cent of the total exposure when the sub-
ject is within the camera's flash range. In dim
light, the flash provides nearly all the illumi-
nation. How each camera obtains these re-
sults is shown at right. The charts trace the
build-up of exposure in three typical situa-
tions: direct sunlight, open shade, and dim
indoor light. The inset pictures illustrate the
different stages of exposure.

The 660 camera *(top row)* can measure
subject distance with its Sonar autofocusing
system. The camera calculates the amount
of light that will reach a subject at a given
distance and how much is necessary for
proper exposure. The flash is fired at the in-
stant the shutter blades *(diagrams below
charts)* open wide enough to admit the cor-
rect amount of light.

The 640 camera must rely solely on its
light-sensing system to control the timing
and duration of the flash. In bright conditions,
the light sensor monitors the existing light un-
til three quarters of the necessary exposure
has been received. Then it triggers the flash
for fill light, monitors the output and shuts it
off when the remaining quarter has been
supplied. In dim conditions, the light sensor
triggers the flash when the shutter opens to
its largest aperture, and shuts it off when it
has added enough light for proper exposure.

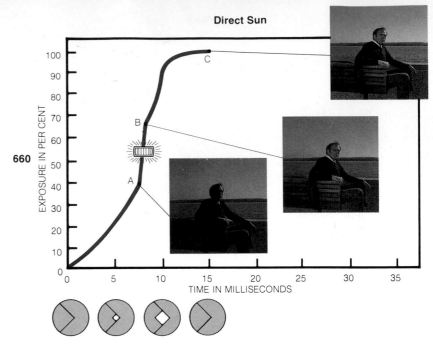

Direct Sun

With a brightly lighted subject eight feet away, the
660 gauges the proper aperture for fill flash. When
this aperture is reached (A), about 40 per cent
of the exposure has built up. Flash adds another
25 per cent (B). The shutter keeps opening to
complete the exposure (C), then closes.

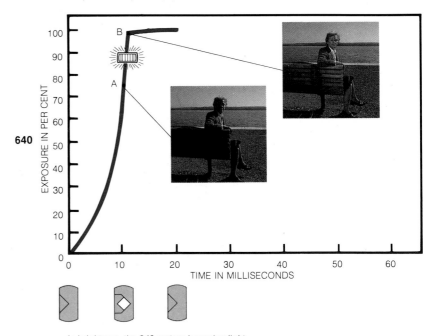

In bright sun, the 640 meters incoming light
until 75 per cent of the required exposure builds
up (A). Then it fires the flash, monitors the
reflected light and cuts off the flash when the
remaining 25 per cent fill light has been
received (B). The shutter then closes.

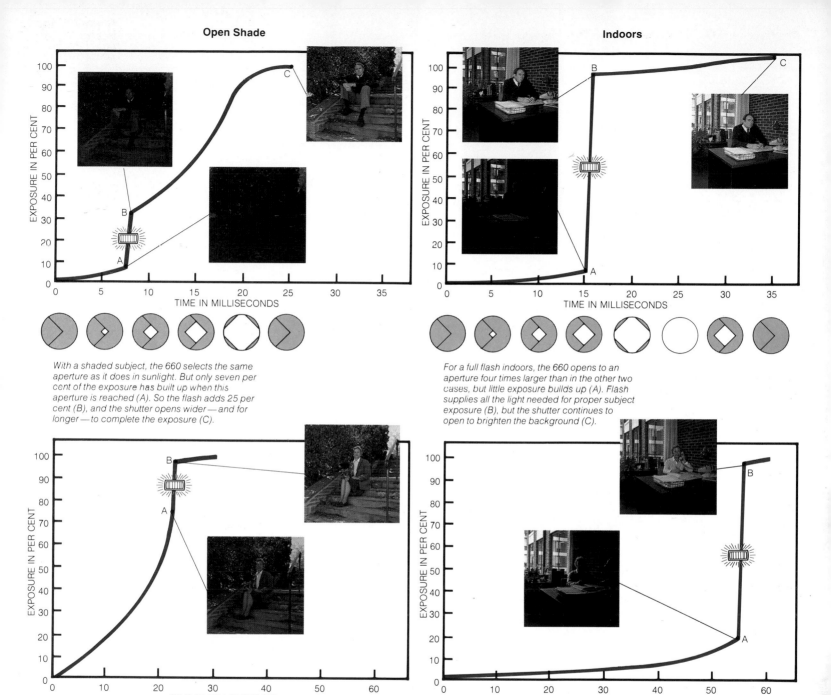

Open Shade

Indoors

With a shaded subject, the 660 selects the same aperture as it does in sunlight. But only seven per cent of the exposure has built up when this aperture is reached (A). So the flash adds 25 per cent (B), and the shutter opens wider — and for longer — to complete the exposure (C).

For a full flash indoors, the 660 opens to an aperture four times larger than in the other two cases, but little exposure builds up (A). Flash supplies all the light needed for proper subject exposure (B), but the shutter continues to open to brighten the background (C).

In shade, the 640 senses that it is still bright enough for fill flash. But the existing light takes more than twice as long to build up 75 per cent of the needed exposure (A). The flash is then fired, monitored, and turned off when the remaining 25 per cent has been added (B).

For full flash indoors, the 640 fires the flash after its shutter has opened to full aperture. During this time only 20 per cent of the required exposure has built up (A); the flash then adds the other 80 per cent (B). The initial exposure to existing light brightens the background where the flash is dim.

Cameras and Equipment

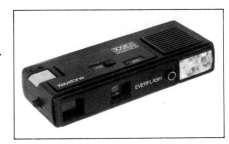
Keystone 309ES with Built-in Automatic Flash

Two New Miniatures

Minox has produced its smallest "spy" camera yet in the model EC. The camera weighs only two ounces; it is just under 3¼ inches long, 1¼ inches wide and ¾ inch thick when closed—not much larger than the special film cassette within. The EC has a 15mm fixed-focus f/5.6 lens with a depth of field from 3.3 feet to infinity. Exposure control is automatic through electronic control of the shutter. Shutter speeds vary from 8 seconds to 1/500 second. A red light-emitting diode in the viewfinder flashes if the shutter speed designated by the camera is 1/30 second or slower; this warns the photographer to use a flash or brace the camera. An accessory flash-cube adapter fastens to one end of the camera. Film is advanced in the EC by pulling the case open and pushing it closed.

The Keystone 309ES Tele-Everflash is a 110 camera that has a single shutter speed

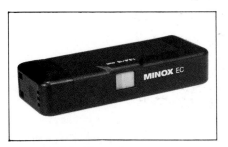
Minox EC "Spy" Camera

of 1/125 second and a built-in flash that switches on automatically when the shutter is pressed in dim light. If flash is needed for proper exposure, the camera will beep a warning and the flash will be charged. A few seconds later, a blinking green light will come on, indicating that the flash is ready and the picture may be taken.

Easy-to-Use 35s

Several compact 35mm cameras with varying degrees of automation were introduced in 1981. From Canon and Chinon came two with complete automation: Focusing, exposure control, film advance and rewind, and built-in flash are all automatic. However, the two cameras use differing approaches to autofocus: one passive, one active.

Canon's new Super Sure Shot is a passive system, unlike the preceding Sure Shot model which focused by emitting an infrared beam and gauging the angle of the reflected rays *(Photography Year/1981 Edition)*. In the new camera, light from the center of the scene is admitted through two windows near the viewfinder, forming two separate images on an array of tiny sensors. Each segment of the array is a charge-coupled device that accumulates an electrical charge according to the amount of light falling on it. The relative

positions of the two images on the array are determined by the distance of the subject. The camera's circuitry calculates the focusing position from the charge patterns and then activates the spring-driven lens to move to the proper focusing position.

The Canon system is accurate enough to allow use of an f/1.9 lens; at wide apertures, this lens produces images with little depth of field and requires precision focusing. The system adjusts to dim light by leaving the sensors on longer to accumulate charge.

The Chinon Infra-Focus camera is an active system that sends out an infrared beam when the shutter button is partially pressed to start the process. The beam bounces back from the subject and is detected by a pair of movable sensors. If the subject is not in focus, one of the sensors will receive a stronger reflection than the other. This imbalance signals a small motor to move the lens and sensors until the reflection is balanced and the subject is in focus. The system allows for one of three steps to happen next: The button can be fully pressed for the shot; the camera can be re-aimed to change the

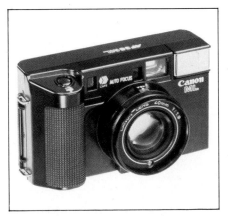
Fully Automated Canon Super Sure Shot

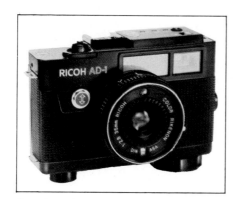

Ricoh AD-1 with Spring-wound Motor Drive

composition of the shot and then the button pushed and the shot made; or the button can be let up and the shot canceled.

Both the new Canon and the new Chinon have loading systems that eliminate the need to thread the film leader into the take-up spool; just laying the leader in place and closing the back is sufficient.

Many new 35s have partial automation. Minolta's Hi-matic AF2 has automatic exposure and focus and a simplified loading system; it does not have motorized film advance. The Minolta's autofocus system, like the Chinon's, emits an infrared beam but has no moving parts. Partial pressing of the shutter button starts the focus calculation.

The reflected infrared rays are recorded on an array of sensors. The position of the image on the array depends on the distance of the subject and is used to compute the focus setting of the lens. The computed value is stored until the button is fully pressed and the lens springs into position, or the button is released. Audible and visible signals are used to indicate when flash is needed and whether the subject is within flash range.

The Fujica Auto-5 is also motorized, pro-viding automatic advance and rewind of the film. Loading is easy, requiring only laying the leader in place. Exposure and flash are automatic. Focusing is manual, by distance scale or zones marked around the lens.

Ricoh has introduced two cameras that have uncommon features. The AD-1 is an automatic-exposure camera equipped with motor drive—but the motor is spring-wound rather than battery operated. One full winding (20 turns) is sufficient for about 10 shots at two frames per second when the camera is set to continuous frame. The camera also has a built-in date imprinter that records the date, month and year in a corner of the frame.

In the Ricoh 500ME, the auto-exposure control can be overridden and both aperture and shutter speed set. A multiple-exposure switch keeps the film from advancing when the shutter is cocked, allowing many exposures to be made on the same frame. Focusing is manual with a rangefinder aid: Alignment of two images in the center of the viewfinder indicates proper focus. A spring motor-drive accessory also is available.

Among 1981's pocket-sized 35s with built-in lens shields are the Mamiya U and Cosina

CX-2. The bug-eyed Mamiya U has a sliding port located on its dome-shaped lens cover. It offers programed exposure automation, built-in flash, zone focusing and a self-timer.

The lens of the Cosina CX-2 is revealed when the lens cap is twisted. Among its features are programed exposure automation, zone focus and self-timer. An accessory motor winder is also available.

New SLRs

Several new SLRs entered the market in 1981. One is equipped to avoid battery failure problems, one can switch automatically from aperture priority to shutter priority if the situation calls for it, and two have new liquid crystal displays (LCDs) like those used in digital watches and calculators.

Canon has produced an automated version of its F-1 professional SLR. The new camera, still called the F-1, features a combination of electronic and mechanical shutter controls that protects the most often used shutter speeds against power failure. Over the range from eight seconds to 1/60 second, the shutter is controlled electronically; from 1/125 to 1/2,000 second, control is mechanical. With a working battery installed, control of the flash synch speed, 1/90 second, is electronic; otherwise it is mechanical.

The new F-1 also features interchangeable viewfinders and focusing screens that increase the flexibility of the camera. Exposure automation depends on the accessories the photographer uses.

With its standard viewfinder, the F-1 has a match-needle exposure meter that is used as a guide to manual setting of the camera controls. Mounting the AE Finder FN—a pentaprism finder that is one of four accessory finders available—converts the camera to

Pocketable Cosina CX-2

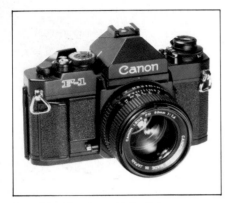

Canon F-1 with Interchangeable Viewfinders

aperture-priority automation: The f-stop is set manually and the camera automatically sets the shutter speed. Mounting the power winder or the high-speed motor drive converts the F-1 to shutter-priority automation: The camera sets the aperture according to the shutter speed chosen by the photographer. When both the AE Finder FN and the power winder or motor drive are in place, either form of automation or manual operation can be used.

In addition to the standard and automated pentaprism finders, the F-1 system includes a speed finder with a large viewing port that can be rotated for viewing at eye level or at waist level. It also has two waist-level finders with different magnifications.

Focusing screens that may be used with any of the finders determine the angle of view of the exposure meter. With 32 screens available, 13 are weighted for the central 50 per cent of the image, and another 13 screens read the central 12 per cent. The remaining six screens read only the central three per cent of the scene.

Other features of the new F-1 include a self-timer and special backs used for 100-frame film rolls and for imprinting data on the

film. The camera also is designed to make multiple exposures on a single frame.

Canon also has come up with a new multimode version of its model AE-1. The AE-1 program not only has manual and shutter-priority exposure control but it can be set to a fully automatic program as well. Its standard focusing screen — a split-image rangefinder that has a microprism collar — has been improved in order to reduce the finder black-out that commonly occurs when a small-aperture lens is mounted. The prisms in the rangefinder are cut at two angles — shallow for smaller-aperture lenses and steep for larger-aperture lenses. The standard screen can be interchanged with any one of seven other focusing screens, depending upon the requirements of the photographer. There is a wide range of other accessories available, including fast motor drive.

The Mamiya ZE-X is another multimode camera: Exposure control can be manual, aperture priority, shutter priority or fully programed. The ZE-X has additional features, however, that extend the role of electronics in the control of the camera. If a control called Crossover AE is switched in, the settings called for by aperture or shutter priority are overridden in cases where the selected shut-

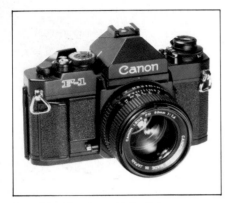

Mamiya ZE-X with Crossover Control

ter speed would be slow enough to risk camera shake. The camera instead will alter the settings so as not to go below shake speed.

The minimum recommended speed on the ZE-X depends on the focal length of the lens being used. The 50mm lenses allow shutter speeds as slow as 1/30 second before the Crossover AE overrides; the 135mm lens, with its greater magnification, allows up to 1/80 second. Focal-length information as well as aperture and focusing-distance information enter the camera through a set of electronic contacts on the lens mounts.

The Crossover AE setting can also be used with the Mamiyalite MZ18R and MZ36R electronic flash units. When the camera is set to aperture priority, the flash output is regulated to match the focusing distance and the aperture selected. If the light required for the focal distance is more than the flash can produce, the preset aperture will be overridden and the aperture widened to compensate. When the camera is set to auto or to shutter priority, the flash output remains constant and the camera regulates the flash exposure by automatically adjusting the aperture to match the focal distance of the subject. The Crossover AE system can be switched off for manual or standard automatic operation.

In Minolta's new XG-M, the most recent in their XG series, exposure control is either aperture-priority automation or full-metered manual. An LED in the viewfinder shows the shutter speed needed for a given aperture setting. On automatic, the camera prevents overexposure by locking the shutter if the required speed exceeds the camera's top speed of 1/1,000 second; a smaller aperture must be chosen before the shutter will fire. The XG-M has a wide range of accessories, including a new high-speed motor drive.

Solar-powered Ricoh XR-S

Ricoh has introduced two aperture-priority SLRs with a unique viewfinder display in common. The XR-7 and XR-S have a column of shutter speeds displayed at the right of the finder. The shutter speed selected by the camera's automatic exposure system is indicated by what appears to be a conventional needle, but which is, in fact, an LCD.

Apparent movement of the needle occurs when one LCD bar switches off and another switches on. LCDs have an advantage over the LEDs used in most cameras in that they require less battery power.

The two cameras also operate in manual mode; LCD symbols flash to indicate when the manually set speed does not match that which would be set automatically. Manual speeds are timed by a quartz oscillator.

The XR-S differs from the XR-7—and all other SLRs—in having a set of solar cells mounted on its prism housing to charge the camera's storage batteries. If the light level is high enough, the solar battery powers the camera directly. The solar cells will last almost indefinitely, and the nickel-cadmium storage batteries should last up to five years.

Two Roll-film Cameras

Plaubel has brought onto the market two new roll-film cameras: the Makina W67 and the Proshift 69W. The Makina W67 comes with rangefinder focusing and a fixed, wide-angle 55mm f/4.5 Nikkor lens. The angle of view on the 2¼ x 2¾-inch images is 77°, which is comparable to that of a 27mm lens on a 35mm camera. The lens can be retracted for compactness when it is not being used, and a built-in exposure meter activates an LED readout in the viewfinder.

The Proshift 69W, which produces 2¼ x 3¼-inch images, has a Schneider Super Angulon 47mm f/5.6 lens that projects a 93° angle of view on the film—equivalent to that of a 21mm lens on a 35mm camera. The lens can be shifted 13mm horizontally or 15mm vertically. The option of shifting the lens from its center position enables the photographer to capture the top of a building, for example, without tilting the camera, thereby avoiding the extreme convergence of parallel lines that is produced by tilting. Unlike the Makina W67, the Proshift 69W has neither exposure meter nor rangefinder; the depth of field of the wide-angle lens makes zone focusing sufficiently accurate.

Plaubel Proshift 69W with Wide-angle Schneider Lens

Ricoh AF Rikenon Lens with Built-in Autofocus

Autofocusing Lenses

In 1981, for the first time, two manufacturers of equipment introduced automatic-focusing lenses for use with SLR cameras; the autofocus systems are built into the lenses instead of into the cameras.

In the Ricoh AF Rikenon 50mm f/2 lens, a shutter blocks the light from one of two windows located above the lens, as an array of light sensors detects and a memory records the pattern of brightness that is entering the other window. The shutter then opens and a rotating mirror scans the scene through the first window, reflecting a portion of the scene onto the array. When the pattern of brightness entering through this window matches the pattern that already has been recorded through the other window, the position of the mirror is memorized and the focusing distance is calculated. Automatic focusing operates from 39 inches to infinity; manual focus is possible down to 20 inches.

The new Canon 35-70mm f/4 zoom lens uses an autofocus system similar to that in the new compact Super Sure Shot *(page 130),* but in the lens, a motor, instead of a spring, is used to move the lens for focusing. The zoom control is set manually.

133

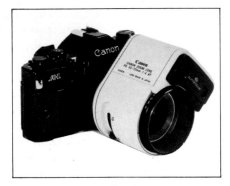

Canon 35-70mm Autofocus Zoom Lens

As is the case with other automatic focusing systems, low light, low-contrast subjects and repetitive patterns can occasionally turn out to be too subtle and can cause the lens to focus incorrectly. With SLR through-the-lens viewing, however, this kind of problem most often can be recognized and corrected by the photographer.

Stretching Zoom Lenses

New designs are stretching the range of zoom lenses. Tokina has marketed a 50-250mm ATX lens, a span of focal lengths that ranges from the normal to what many consider to be the limits of hand-held photography. The maximum aperture varies from f/4 to f/5.6 over this range. Tokina's new lens weighs about 23 ounces and is 5.5 inches long and 2.6 inches in diameter. It can focus down to 2.05 inches, producing images that are approximately 7/10 life size.

There were a number of extra-wide-angle zoom lenses marketed in 1981. This class of zoom is useful for photographing both landscapes and interiors, because the photographer can frame the image exactly. All of the new wide-angle zoom lenses use separate rings for focusing and zooming.

The Tamron SP24-48mm f/3.5-3.8 lens has interchangeable mounts that adapt to almost any SLR, and an angle of view ranging from 84° to 48°. The lens is compact, weighing about 12 ounces and measuring only 2.6 inches in length and 2.5 inches in diameter. Its closest focus position is 24 inches.

The Soligor C/D 24-45mm f/3.5-4.5 lens is also adaptable to most SLRs. It has a macro setting that reduces its minimum focusing distance from 31 inches to 3.1 inches, producing magnifications that are one-third life size. The angle of view ranges from 84° to 51° (from extra-wide to normal). The lens is 2.6 inches both in length and in diameter, and it weighs 14 ounces.

The Osawa 24-43mm f/3.5-4.5 lens has an angle of view ranging from 84° to 53°. Shifting into macro mode provides one-third life-sized magnifications. The lens weighs about 16 ounces, measures 3¼ inches long by 2¾ inches in diameter. With proper mounts, the lens can fit most SLRs.

Minolta has a new 24-35mm f/3.5 lens in its MD series. The lens is small — just under two inches long — and weighs about 10 ounces. The angle of view ranges from 84° to 63°, and the lens can focus down to 12 inches without a macro setting.

In the zoom ranges, one that is appearing with increasing frequency is the 70-150mm range. Although a zoom ratio of 2 to 1 is rath-

er short for a tele-zoom, the relative compactness of these lenses makes them a good compromise. The short focal lengths are excellent for portraits, while the longer focal lengths provide up to three times the magnification of a normal lens.

From the manufacturers of cameras have come the Minolta 75-150mm f/4 MD, the EBC X Fujinon 70-140mm f/4-4.5 DM, the Konica 70-150mm f/4 Hexanon, and the Ricoh 70-150mm f/4 XR Rikenon.

Independent makers of lenses introduced the Osawa 70-150mm f/3.8 ITM, the Makinon 75-150mm f/4.5, and the Sigma 70-150mm f/3.5-4. All the lenses will fit most SLRs.

A New Category: Dual Focus

Soligor has brought out a new category of lenses offering a choice of two focal lengths in one compact design for less than the cost of a zoom. Two Dualfocal lenses are now available: The C/D 28+35mm f/3.5-3.8 offers two popular wide-angle focal lengths, and the C/D 85+135mm f/4 offers two popular telephoto focal lengths. Switching from one focusing position to the other on the C/D 28+35 requires a simple push-pull motion; on the C/D 85+135 the change is accomplished by pressing a button and rotating a ring on the lens.

Telelenses for Low Light

Nikon introduced three new telephoto lenses that combine large apertures with high performance, thereby enhancing the photographer's ability to shoot in low-light situations. The Nikkor 85mm f/1.4 lens is well-suited to available-light portraits; the Nikkor 105mm f/1.8 is among the fastest lenses available in this range. The Nikkor 180mm f/2.8 ED combines a fast aperture with the use of low-

Stretching the Zoom: Tokina's 50-250mm Lens

dispersion glass. This glass reduces chromatic aberration, which can be a serious problem with telelenses. The three lenses are said to produce sharp images even at their maximum apertures.

Soft-focus Lens

A lens designed to produce soft-focus images is the Sima SF. A single-element lens at the end of one of two telescoping tubes provides very-soft-focus pictures. The adjustable length of the tube gives magnification about three-fourths life size. The insertion of waterhouse stops—disks with holes of different sizes in the center—changes the aperture and the softness of the images, because aberrations are reduced when only the center of the lens is used. The lens is 100mm f/2, but using the waterhouse stops yields f/4 and f/5.6. Additional control is provided by a neutral-density filter that reduces brightness without changing the softness.

Dedicated Flashes

In 1981 independent manufacturers introduced dedicated flash units to the market in force. Camera makers have long taken advantage of the electronic sophistication of cameras to create dedicated flash systems that set the flash synch speed and aperture, signal full charge in the viewfinder and even use the camera's meter to control the light from the flash. Independent manufacturers have had to come up with circuits that match the variety of camera systems, while trying to pass through legal thickets to market their compatible units.

Sunpak has introduced two models that— using dedicated modules, or adapters— mate with eight brands of SLRs; there also is one module with a standard shoe connec-

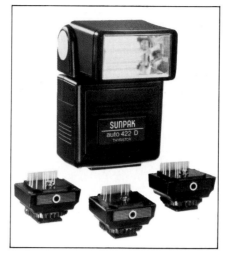

Sunpak Dedicated Flash with Adapter Modules

tion. The Auto 422 D is a powerful unit, with a guide number of 100 with ASA 100 film. It tilts and swivels for bounce flash, and its energy-saving automatic circuitry operates at any one of three apertures for any film speed. On manual control there are five flash-output settings, from full power to 1/16 power. This variable power provides the photographer with greater flexibility in choosing apertures and simplifies the balancing of multiple-flash setups. Even without accessory diffusers, the flash covers the angle seen by a 28mm lens on a 35mm camera.

The Sunpak Auto 322 D is a smaller unit, with a guide number of 80 with ASA 100 film. It operates automatically at two apertures and has two manual power settings, full and one-eighth power. It covers the angle of a 35mm lens but does not tilt or swivel.

Both units have an exposure-test lamp that lights if the exposure is sufficient when a shot or test flash is made. Both units also have easy-to-read scales on the back and accept

a wide variety of accessories, including a remote cord that permits dedicated operation with the flash detached from the camera.

Vivitar has brought out an array of new dedicated-flash models—the 3000 series— and an adapter to make an earlier model part of the dedicated family. The most powerful in the new series is model 3900, a handle-mounted unit that couples to the camera with a dedicated remote cord. Its guide number is 120 with ASA 100 film. Three apertures may be used for automatic operation. A variable manual setting ranges from full power to 1/64 power. The angular coverage is that of a 28mm lens, and the flash head both tilts and swivels for bounce.

The model 3500 has a zoom light-spread control that focuses the flash for use with lenses from 35mm to 85mm. The guide number with ASA 100 film is 66 in the wide position, 94 in the telephoto. The head tilts for bounce. Exposure is controlled automatically at three apertures; manual operation is possible at full or one-eighth power.

The model 3200 is an inexpensive nontilting unit with a guide number of 60 and the coverage of a 35mm lens. There is automatic exposure control at three apertures as well as a manual setting.

The ready indicator and exposure-test indicator on all the Vivitar 3000-series flashes are both audible and visible; the beeping that eliminates the need for a visual check of the lights can be switched off.

Dedicated modules for the 3000 series currently include adapters for a standard shoe and for six camera brands. A new adapter module can be used with the model 2500 nondedicated flash: The adapter converts the unit to dedicated operation and actually enhances the flash unit's capabilities

by expanding from two to five the number of apertures for auto operation. The 2500 does not beep, but the adapter provides a blinking light in the camera's viewfinder to indicate sufficient exposure.

Alfon has an MD series of strobes that adapt without interchangeable modules to dedicated use with four brands of cameras; when mounted, the units automatically adapt themselves. The most powerful flash of the series, the 680-MDZ, has a guide number of 100 without its zoom, covering the field of a 50mm lens. The zoom provides 85mm to 200mm coverage and a guide number of 150 in the telephoto position. Use of a diffuser with or without the zoom covers the wider angles. Exposure control is automatic at two apertures. Full-power manual also may be selected. The head tilts for bounce flash.

Other dedicated flashes that are offered this year include the Luminex T/805 series, which includes five models, and the Toshiba QCC-300D and the Lenmar FFD40, each having interchangeable adapters and two auto apertures.

A Remote Flash System

A new remote flash-triggering system called Slavex has been developed by Wein Products. A small battery-powered transmitter is attached to the camera hot shoe, and a batteryless receiver is linked to the flash. When the camera is fired, an encoded chain of high-frequency pulses is transmitted. The receiver, powered by a trickle of current from the flash, decodes the signal. If it matches a preset code, the flash is triggered. The signal processing takes place in less than 1/1,000 second. Adjustments are provided to recode the units if another photographer happens to be operating on the same channel.

3M ASA 640-T Color Slide Film

Films and Papers

In the past year several new sensitized materials were introduced besides those featured on pages 116-121. A new, very fast color film, balanced for use with tungsten light, has been brought out by 3M. The film— ASA 640-T 35mm color slide film— is designed for available-light photography. Though balanced for photographic lamps burning at a temperature of 3,200° K., the film produces pleasing, slightly warm colors when used with ordinary household lamps, and can be used with fluorescent light as well. The film is processed in readily available E6 or compatible chemicals.

Polaroid added a new peel-apart color film to its catalogue— Polacolor ER film. The ER stands for extended range. The emulsion is less contrasty than in earlier Polacolor films, has greater latitude and reproduces greater brightness range on the print. It is available in sheets that are 4 x 5 and 8 x 10, and in eight-exposure packs of 4 x 5 and 3¼ x 4¼ formats. The low contrast of the film makes it well suited for use in copying slides.

Cibachrome-A II paper, another product that appeared in 1981, uses a refined version of the Cibachrome dye-bleach process for making prints from slides. The new paper and its P-30 processing system use a color-masking technique that improves the color rendition of the material. Contrast also has been improved in the new system.

In the dye-bleach process *(Photography Year/1976 Edition),* the unexposed emulsion contains both silver halide crystals and dyes. Wherever the emulsion is exposed, silver is developed by the developer solution; wherever the silver is developed, the bleach bath bleaches away dye.

The new color-masking technique is used to correct for unwanted color absorption by the image-forming dyes. Such absorption occurs in all color films; in Cibachrome's case, the red-absorbing cyan dye and the green-absorbing magenta dye also absorb some blue light, but the new masking process compensates for this by proportionally reducing the amount of blue-absorbing yellow dye that remains in the print.

Incorporated into the developer is a solvent that dissolves unexposed light-sensitive crystals in the blue-sensitive layer as it develops the exposed crystals. Unless inhibited by other reactions, the dissolved silver combines with tiny particles, called colloidal silver, in the masking layer that lies just below the blue-sensitive layer and just above the green- and red-sensitive layers. If there is no exposure in the green- and red-sensitive layers, the magenta and cyan dyes are not bleached and no inhibiting reactions take place in the mask. The silver then formed in the masking layer causes extra bleaching of the yellow dye to compensate for the extra blue absorption by the cyan and magenta.

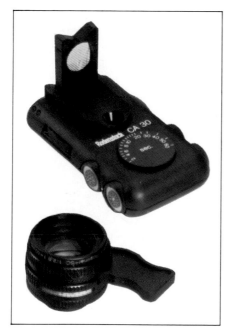

Rodenstock Color Analyzer and Enlarging Lens

Where there is exposure in the green- and red-sensitive layers, silver is formed that bleaches out some of the cyan and magenta. Thus, less compensatory bleaching of the yellow dye layer is needed. Chemical by-products of the development in the lower layers migrate into the masking layer and inhibit the formation of silver grains. This reduces the silver in the mask and thus the extra bleaching of the yellow layer.

The new Cibachrome is available with two surface textures — glossy and pearl — and in sizes from 4 x 5 to 16 x 20 inches.

New Lens and Printer in the Darkroom

For printmaking, manufacturers came up with a novel lens design and two tabletop printers for making instant prints from slides. Rodenstock's Rogonar SC enlarging lenses

have an access slot located in the lens barrel that permits insertion into the lens itself of special-effects filters or a color analyzer. A cover seals the access slot when the lenses are used for straight printing. Currently, two Rogonar SC lenses are available: a 50mm f/2.8, for enlarging 35mm images, and a 75mm f/4, for 2¼ x 2¼-inch images.

The filter sets include groups for such manipulations as soft focus, contrast reduction, color effects and star patterns; an empty filter holder also is included for the photographer who wants to devise his own special effects.

The CA 30 color-analyzer probe, which also fits into the lens, reads the average light brightness and color. Although the photographer may program the analyzer for the color balance of any paper, the CA 30 is preprogramed for an average filtration of Kodak 74 paper. A set of LEDs indicates when filtration is correct. An adapter is available so that the analyzer can be used with other lenses.

Two companies are offering devices for making instant prints from slides. Both the Polaroid Polaprinter and the Samigon Rapid Image 205 Slide Printer make images on Polaroid's 3¼ x 4¼ pack films. For color copies, one of Polaroid's new extended-range films *(see above)* — 669 ER — works best; and for black-and-white, the 665 film can be used to produce a positive and a negative simultaneously. The proportions of the films do not match those of 35mm slides, however. With the Polaprinter, cropping is done from the long dimension of the slide in imaging. The Rapid Image, on the other hand, reproduces the whole slide, but the image has black edges along the length because the image is narrower than the image area of the print.

The Polaprinter has a small slide viewer that allows the photographer to decide which

portion to crop. Alignment of the viewer makes the adjustment internally. Exposure is determined by an automatic-exposure flash system that has a manual lighten-darken control. Because contrast buildup is always a problem when making copies on materials that are designed for camera use, Polaroid has built in a variable-contrast control. Filters can be inserted to shift color.

The Rapid Image also uses flash for its exposures. Density is controlled by manual setting of the aperture in the imaging system. Color filters can be used for correction, and a fixed-contrast reduction is built into the system. The Polaroid 405 film-pack holders are removable, making it easy to switch from black-and-white to color printing at any time.

Agfa Family System

A unique new way to make 8mm movies and still images — and prints from both — is the

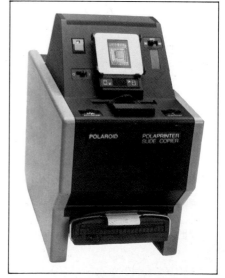

Polaroid Polaprinter for Making Prints from Slides

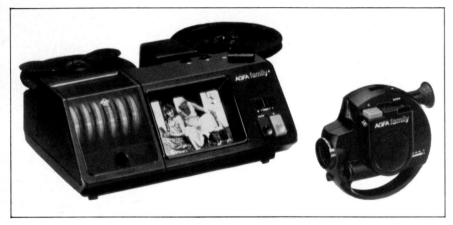

Movies and Still Shots with Agfa Family System

Agfa Family System. The camera, which shoots Super 8 movie film, has a fixed f/1.5 lens and automatic exposure and only two controls. Pressing one control shoots the usual 18-frames-per-second movies; pressing the other shoots a single frame and exposes an area at the edge of the film that serves as a code, indicating a still image. The viewer, or monitor, replays processed reels of film up to 400 feet long. When a coded still frame is reached, the film advance halts and, if the timer is on, the still is projected for three seconds.

It is also possible to view any frame as a still and to advance one frame at a time, a feature that is especially useful when the system's Family Instant Print unit is used. By replacing the film reel storage unit with the instant printer, any frame can be printed on Kodak instant color film.

Kodak Projectors

The basic gravity-fed system of Kodak's Carousel line of slide projectors is unchanged, but the company has made some refinements. Models 5200, 5400 and 5600 now have a small built-in viewing screen that can be used with a special lens in the projector; the main projection lens is used with conventional separate screens.

All three of these models have improved access to the lamp in order to change bulbs, and they all use an improved GE lamp that has a longer life. The lamp is located in a removable unit that can be replaced quickly. The projector controls are positioned on a sloping side panel and are illuminated for easy identification.

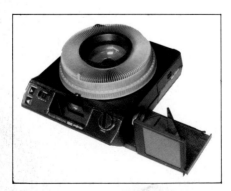

Kodak Carousel Projector with Small Built-in Screen

Electronic Stills

Sony became the first company to announce its intention to market an all-electronic system of still photography. The Mavica system's SLR-sized camera has an array of charge-coupled devices with nearly 280,000 photodetector elements. Pressing the shutter button turns on the array to record color images. Information in the array is read out and stored as electronic signals on the Mavipak, a rotating magnetic disk in the camera that can be placed in a Mavipak viewer for instant television replay with no processing.

The Mavica system will be very flexible. The camera can be used with video tape recorders. Mavipak images can be copied on another disk in a special Mavipak copier or reproduced as paper prints. Images also can be transmitted over telephone lines to a receiver, where they can be duplicated on a copier, projected on a television screen or printed out as color prints.

Sony aims to market Mavica in 1983, with the camera and viewer priced at about $800. Mavipak disks storing 50 frames are to cost only a few dollars.

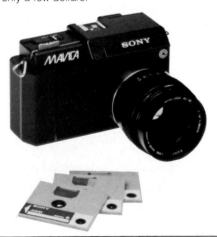

Revolutionary Mavica Camera and Mavipak Disks

Discoveries/5

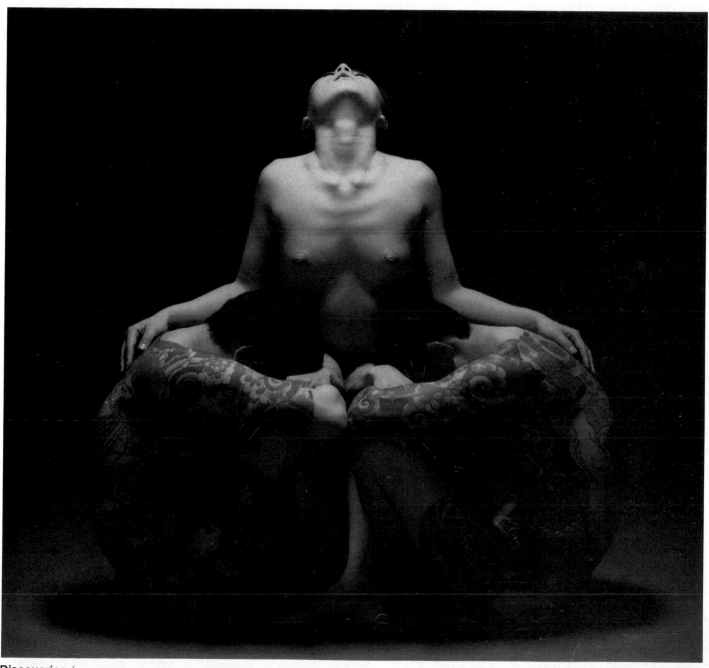

Discoveries / MASATO SUDO: *Ransho (Indigo Image)*, 1980

Discoveries

The View through Four Cameras

From an intensive international search that drew 94 portfolios from four continents, four photographers emerged, each uncommonly adept at communicating a strong personal vision

The photographers whose works are shown on the following pages are all gifted but relatively unknown artists who were discovered during *Photography Year's* annual search for new talent. Time-Life Books staff members in various parts of the world and Time Inc.'s international network of correspondents sought out professionals whose day-to-day work keeps them in touch with large numbers of local photographers. Gallery directors, museum curators, newspaper and magazine editors and picture-agency staff members were among the experts consulted. They were asked to recommend local photographers of outstanding merit who were not yet well known — who had not, for instance, had a solo exhibition at a major museum or a book devoted exclusively to their work. When all the recommendations were in, each photographer was asked to submit a portfolio of up to 25 pieces to *Photography Year's* editors, who made the final selections.

This year the editors saw a total of 94 portfolios from all parts of the world. Three fourths of the submissions came from the United States, with the Northeast and the West especially well represented. Of the remainder, five came from Japan, four from France, four from Italy, three from Czechoslovakia, two from Spain and one each from Germany, Australia, and the British crown colony of Hong Kong. Surprisingly, given the proliferation of color photography, the portfolios were almost evenly divided between work in color and work in black and white (eight portfolios included both), and portfolios submitted by men outnumbered those submitted by women by about 3 to 1 — a ratio only coincidentally reflected in the final selection. The increased interest by photographers in hand-coloring and portraiture was evident in the submissions, and the work of five of this year's candidates for the Discoveries section can be seen in the Trends section *(pages 12-42)*.

In addition to uncommon talent and a lack of widespread recognition, the four photographers whose work was selected for Discoveries share another trait: They all submitted portfolios that were coherent and original. Each had a clear personal vision to convey and each knew what was needed to communicate it.

Tom Zetterstrom used motion to create what at first appear to be photographic "accidents" — blurred and streaked black-and-white images — that show his concern for the destruction of the natural environment in his native Connecticut *(pages 144-151)*. Masato Sudo of Japan, on the other hand, employed the classic techniques of nude photography in color to reveal the little-known beauties of Japanese tattooing artistry *(pages 152-163),* especially as practiced by the master tatooist, Horijin (wearing traditional dress in the photograph with Sudo on the opposite page). Robert Giard, working in black and white, adapted the traditions of 19th Century landscape and portrait photography to reveal a mysterious modern world in Eastern Long Island *(pages 164-171),* while Sally Mann — to express her sense of the fragility of life — set up and photographed subtly colored still lifes in her Lexington, Virginia, home *(pages 172-178)*. Four singular visions, four definite styles: four Discoveries.

MASATO SUDO AND HORIJIN

ROBERT GIARD

SALLY MANN

TOM ZETTERSTROM

A World of Fleeting Images

A Connecticut photographer expresses his concern for the environment by transforming fields, woods and waters into strangely flickering visions

In Tom Zetterstrom's bare, black-and-white landscapes, nature is a presence at once familiar and unfamiliar. The subjects are simple, almost banal: four maples seen across a snowy field, a white picket fence, an old wooden dock sticking out into the Gulf of Mexico. But the treatment is surprising. Outlines are blurred, details obscured. In many pictures, there is a streakiness that runs from one side of the frame to the other, in others a kind of vortex at the center that causes other parts of the image to dissolve into a haze. The result is a landscape in which nature is oddly distanced. Nothing in it is unknown, but the viewer is unable to apprehend it clearly.

Zetterstrom himself lives close to nature. Born in 1945 in Canaan, Connecticut, he studied botany before turning to sculpture and then to photography. In 1970, after putting in a two-year stint teaching photography to inner-city teenagers in Washington, D.C., he returned to Canaan, where he lives in a 14-by-18-foot, one-room cabin in the woods, with a view of the Berkshire mountains but no running water or modern plumbing.

Soon after his homecoming, he became concerned that a proposed New England highway-building program might "put a cloverleaf right in my backyard." He joined a movement to limit such expansion and, as part of his contribution, made a color-slide presentation showing what would happen to the rural environment if more highways were built. To illustrate how little motorists actually saw of the countryside through which they drove, Zetterstrom took pictures from a moving car. As it turned out, the highway proposal died for lack of funds; but Zetterstrom carried on his moving-point-of-view photography in black and white — usually shooting from cars or trains, occasionally from bicycles or boats — "to point out our blindness to the things around us." He uses a 35mm single-lens reflex with a wide-angle lens that exaggerates and distorts perspective, and he increasingly prefers slow film and long exposures. Often while shooting he pans his camera in order to keep one element of the picture sharper than the rest — for instance, the right center portion of the picket fence on page 150 — while the rest dissolves into a blur of motion.

Only one in several hundred of Zetterstrom's moving-point-of-view pictures is successful. More than most photographers, he says, "I must accept luck and accident in my work." There are also limits to his method. "I can't shoot any slower and retain a photographic reality; the next step is just an optical blur." But the technique succeeds in capturing what Zetterstrom wants: For him, the pictures "reflect an anxiety about what we are doing with the world and what we are losing by not observing what is around us."

151

An Ancient Art Brought Up to Date

Masato Sudo reveals the beauty of tattooed bodies in photographs that combine traditional Japanese art with modern abstraction

The subject matter of Masato Sudo's color photographs is the ancient art of tattooing—he titles all of them *Ransho,* meaning "indigo image." But what he does with this subject is unhesitatingly modern. He starts with tattooed men, often contrasting their dark, elaborately ornamented bodies with the pale, untattooed body of a woman. But he uses these human models as fluid elements in new designs of his own. In some, he intertwines the tattooed male body and the unornamented female body in erotic poses, but he never individualizes them by showing their faces. In others, he reduces the living human forms to semiabstract shapes, lining up a row of tattooed backs like painted china eggs on a shelf, or coming in so close to tattooed hips and thighs that they resemble folds of tapestry.

Sudo, now an assistant to one of Japan's foremost photographers, Yasuhiro Ishimoto, was born in 1955 in a small fishing village in northeastern Japan, where he was encouraged in his passion for photography by high-school teachers who recognized his talent. He later went on to study at the Tokyo College of Photography, and during his second year he came across the subject matter he now photographs. While traveling around the country shooting pictures of trucks decorated in a fantastic, uniquely Japanese style—some with neon lights and erotic paintings, since banned in Japan as hazardous distractions to other drivers—Sudo met a tattooed truck driver who introduced him to master tattooist Horijin. An oil painter by training, Horijin takes his tattoo motifs from classic Japanese works by such famed 19th Century artists as Hokusai and Hiroshige, sometimes enlarging details from their works to cover the body from neck to feet—a bizarre style that has underworld associations. Sudo began to photograph Horijin at work, and eventually began to use extensively ornamented clients of the tatooist in his own photographic compositions.

His pictures require special care in lighting the models to avoid shadows and reflections that might obscure the outlines of the tattoos—generally broad illumination. For some images with the female nude, he employs a spotlight with a diffuser. The results are more than pictures of tattoos: They are pictures in which tattoos are part of an artistic whole.

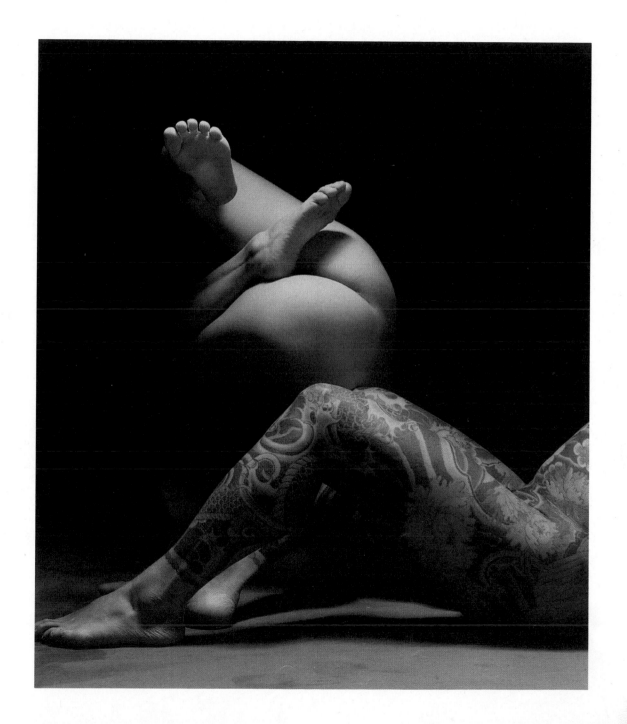

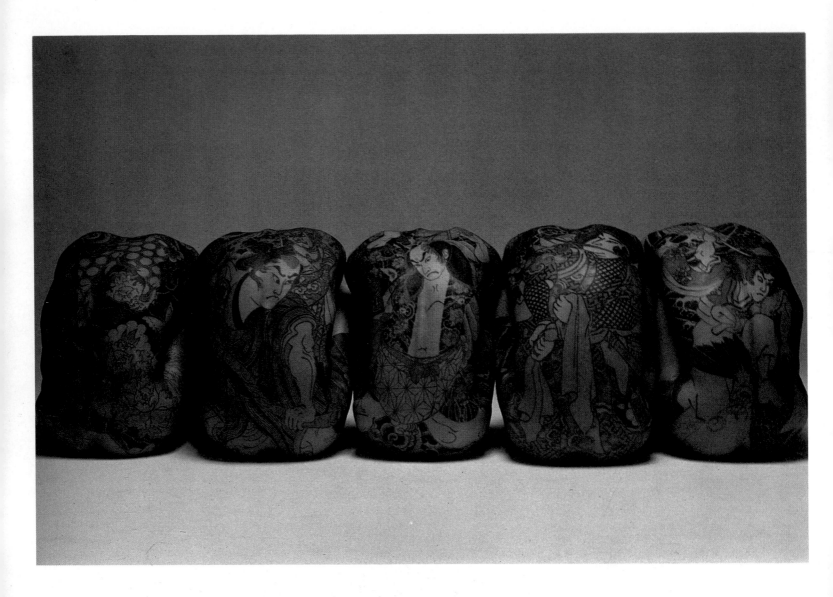

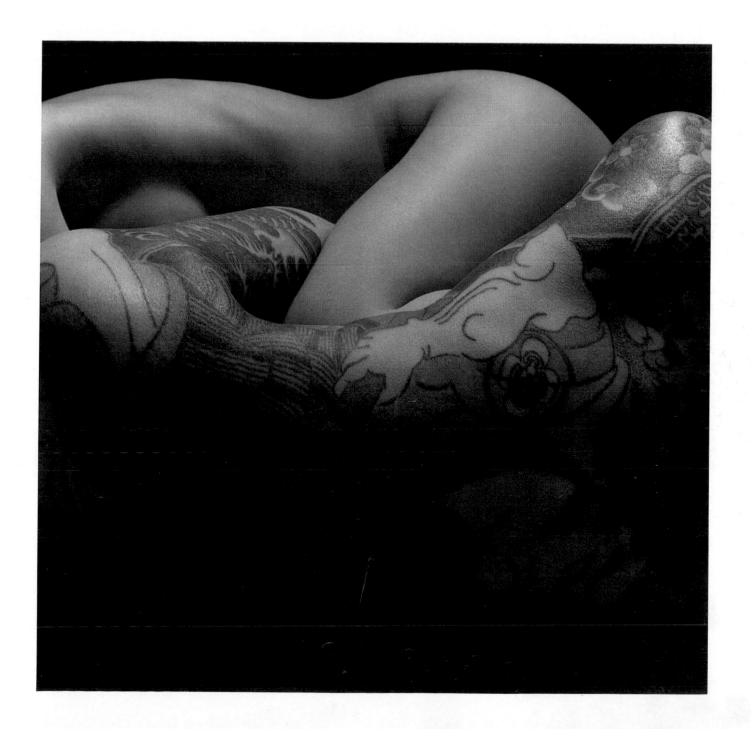

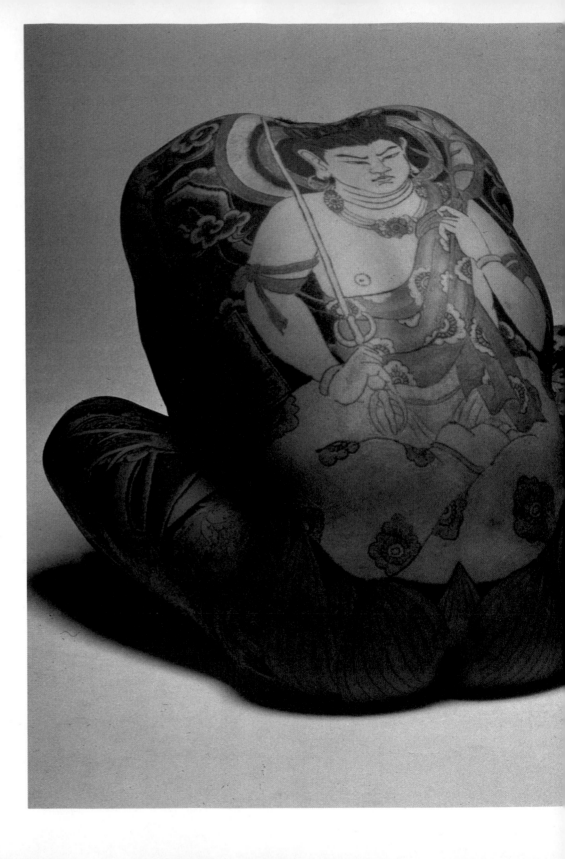

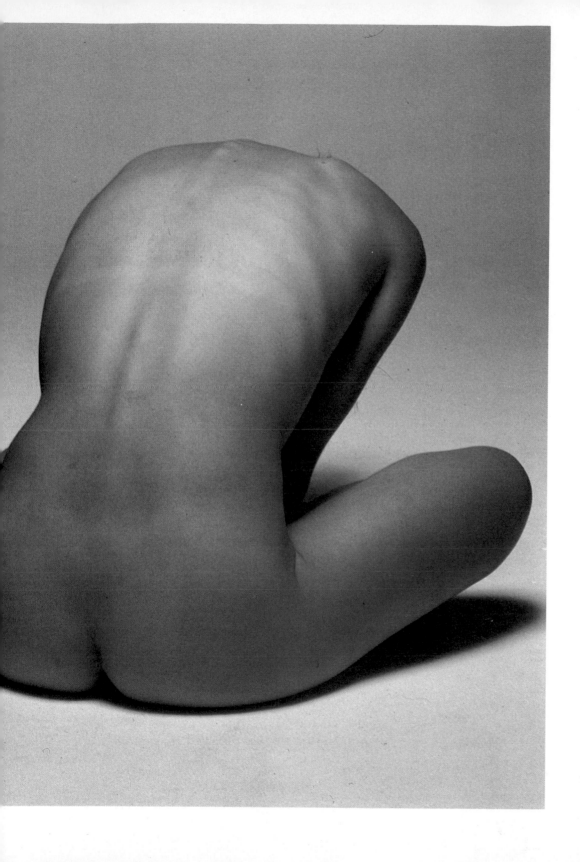

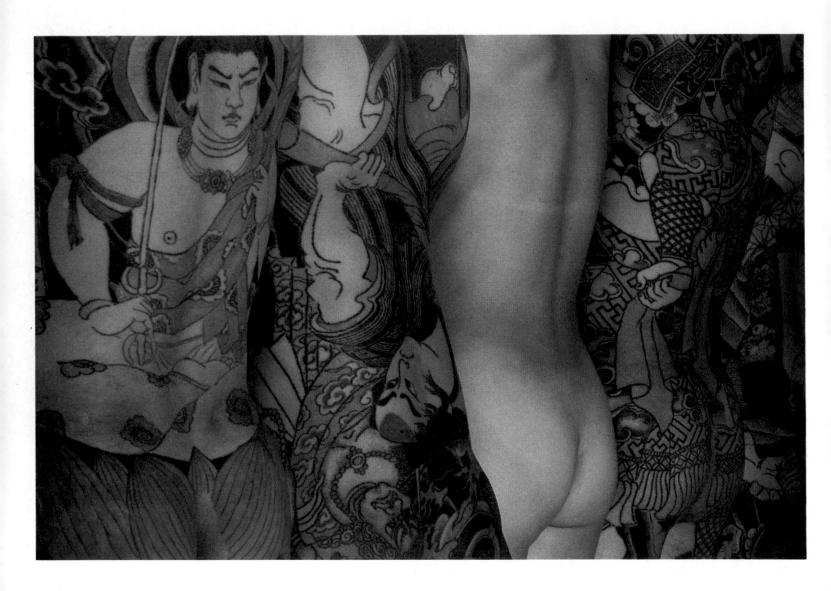

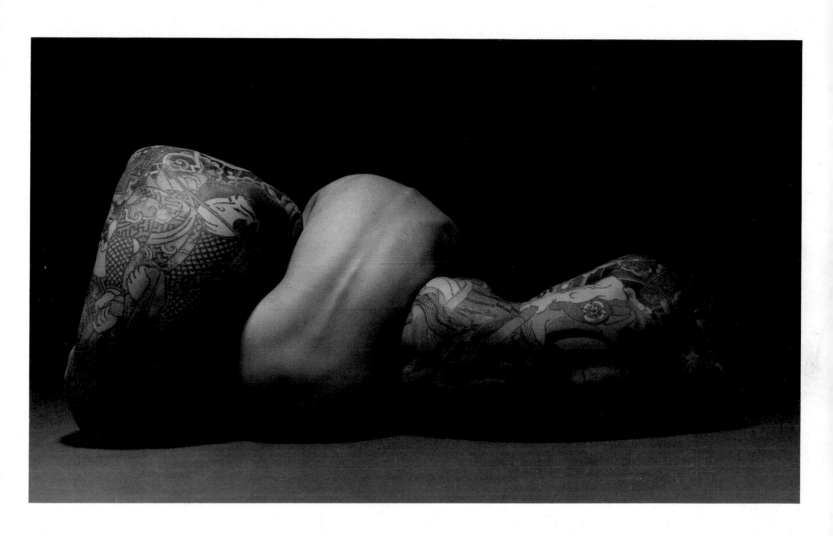

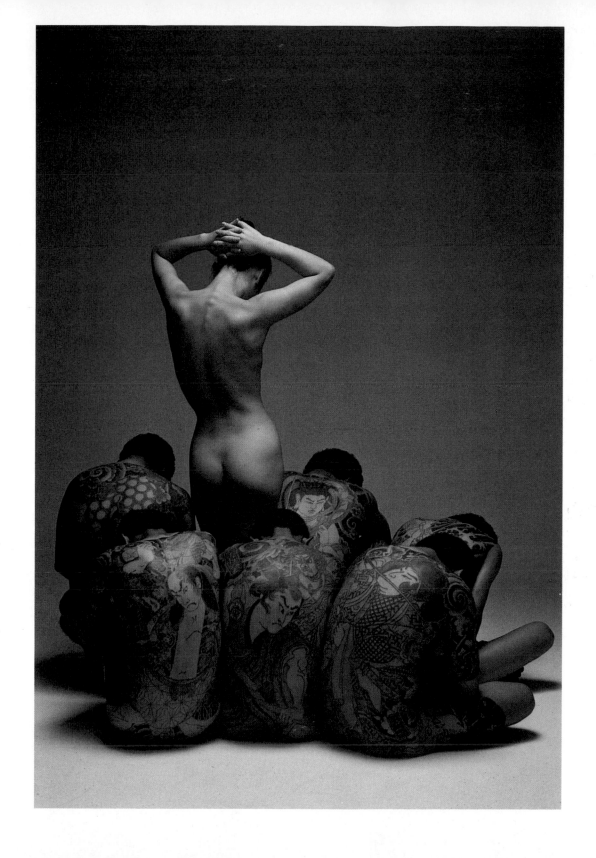

Meditations and Mysteries

In a small town on eastern Long Island, Robert Giard roams his neighborhood to make studies of friends and local scenes that evoke life's inscrutability

Although Robert Giard takes three kinds of pictures—portraits, landscapes and nudes—all of his photographs are quietly meditative and touched with mystery. The mystery is most striking in the landscapes—dark, simple shots of small-town lawns and hedges against which unexpected objects glow brightly in the sky's dying light: star-shaped balloons, convex mirrors or a strange, ghostly shape that turns out to be a fishing net left out to dry. The mystery is also present in the portraits, where a simple costume or prop takes the sitter out of the realm of everyday life and into a world of the imagination. Even the nudes possess a mysterious resonance, because they are more individual and portrait-like than nudes usually are: The viewer is invited to contemplate not just a human body more or less beautiful, but a full human being, with all the inconsistencies that human beings have.

There is in Giard's photographs a suggestion of unexplained contradictions, and an invitation to contemplate conundrums. In many of his prints, the subtle differences in darkness between a hedge, a tree and a lawn demand that the viewer examine each picture carefully in search of clues to meaning.

Giard draws heavily on great photographers of the past for inspiration. The self-portrait at right, for example, deliberately copies the pose employed by Nadar, the fashionable Paris photographer of the mid-19th Century, for a picture of novelist George Sand. And he is guided by the work of landscapists ranging from Atget to Walker Evans: "In their creations the landscape is made to live, even when no human society is included; in fact, especially then," Giard says. Despite his gift for tapping tradition, he had no academic training in photography. Born in Hartford, Connecticut, in 1939, he studied literature at Yale and at Boston University, then taught for nine years in a private school in New York City before devoting himself full time to the camera.

Giard's working methods are simple. Most of his portraits and nudes are of friends; most of his landscapes were photographed within a few blocks of his home in the seaside town of Amagansett in eastern Long Island. His only camera is an old Rolleicord twin-lens reflex, which he bought secondhand for $60. He tones his prints in selenium but pulls the print before the toning is completed to achieve a three-dimensional effect: The selenium affects the denser areas most, creating a warm brown shade there that contrasts with cold grays in lighter areas. Whether he is photographing people or places, he studies his subject in advance, perhaps sketching his idea for a picture before shooting, and waiting (in the case of landscapes) until the lighting, weather and season conform to his idea. Though he uses simple props in some portraits, he does not add props to his landscapes, artificial as they may look. The stars, fishing net and mirrors were all on the scene when he came along and saw them.

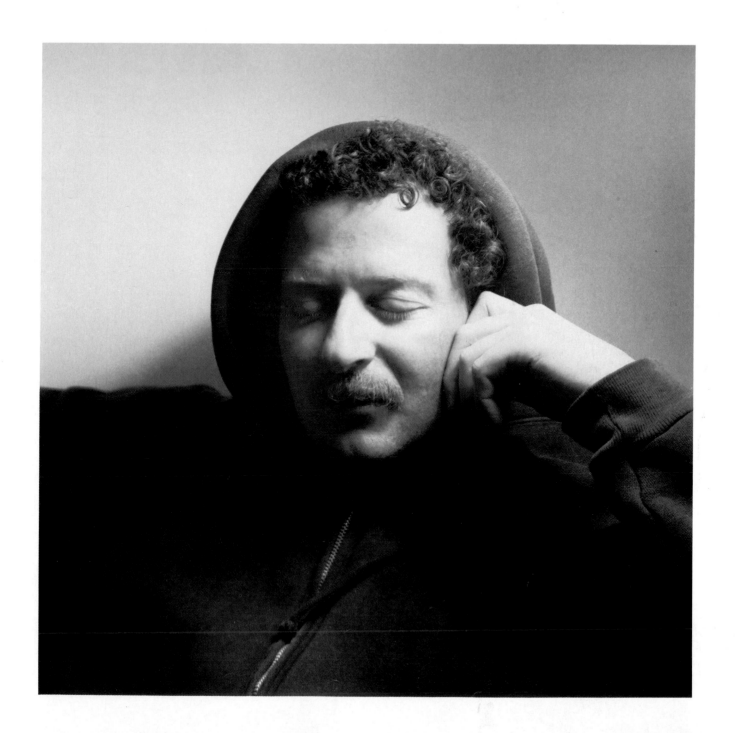

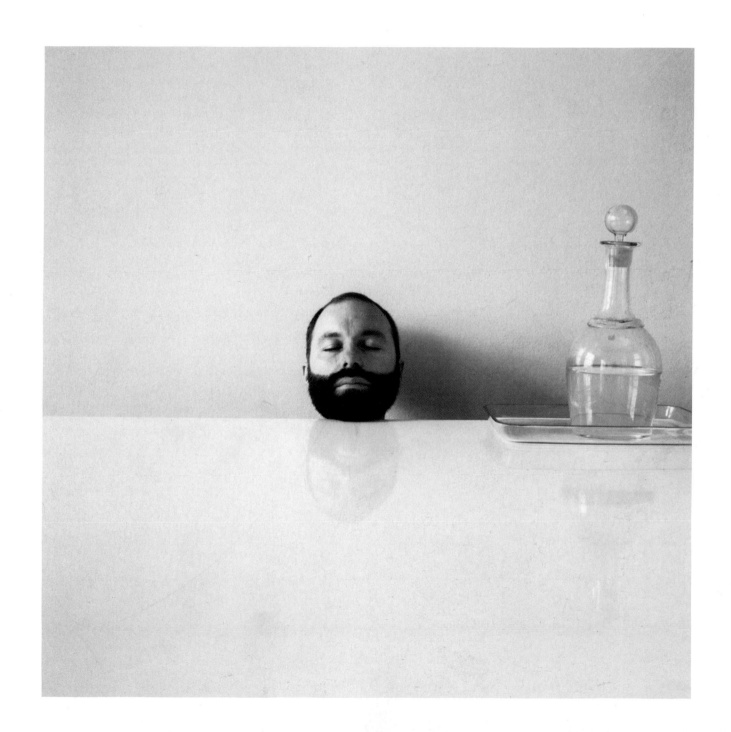

Soft-focus Subtlety and Fragile Grace

A Virginia photographer captures a delicate sensuality in the subtle still lifes she puts together with flowers and thriftshop odds and ends

There is a flower-like delicacy of color and form in Sally Mann's soft-focus semi-abstractions that reflects her own feeling about life. Her principal subjects—soft, sheer fabrics and flowers—are things that are ephemeral or easily destroyed. And gentleness characterizes many of the colors she favors—pale pink, off white, soft blues and yellows and dusty black. The result is what she describes as a mood of "fragile grace"—a hint that life is fleeting and subject to unexpected reverses, and a kind of nostalgia for a past that seems safer and more secure.

"I don't know why I perceive life as so fragile," she says. "I have a very stable, routine life myself." She has been making photographs since she was in high school, when her father, a doctor and art collector, gave her an old Leica. While majoring in literature in college, she began working as a freelance photojournalist and commercial photographer. She has taught photography, published a book on the architecture of Lexington, Virginia (her home town), edited a photographic journal, and begun the restoration and printing of a collection of nearly 10,000 19th Century glass-plate negatives—the lifework of Michael Miley, who is best known for his portraits of Robert E. Lee.

Although she has exhibited in a number of group shows, and once in a one-woman show at the Corcoran Gallery in Washington, D.C., most of her time has been spent as staff photographer for Washington and Lee University. Her personal work is done late at night and on weekends. At one time she concentrated on delicate black-and-white landscapes that she printed by the difficult platinum process, but more recently many of her pictures have been color still lifes set up in her living room and taken "in the odd hours that I have between jobs and diapers." The pictures that follow were made with a single-lens reflex camera. The soft-focus effects are due partly to the gauzy fabrics in the still lifes and partly to the photographer's use of weak, low-contrast developer and a long developing time in the printing.

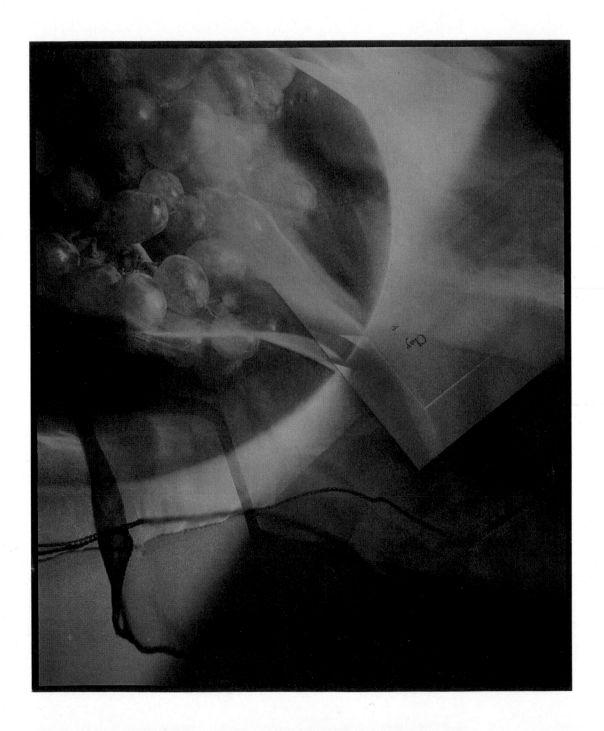

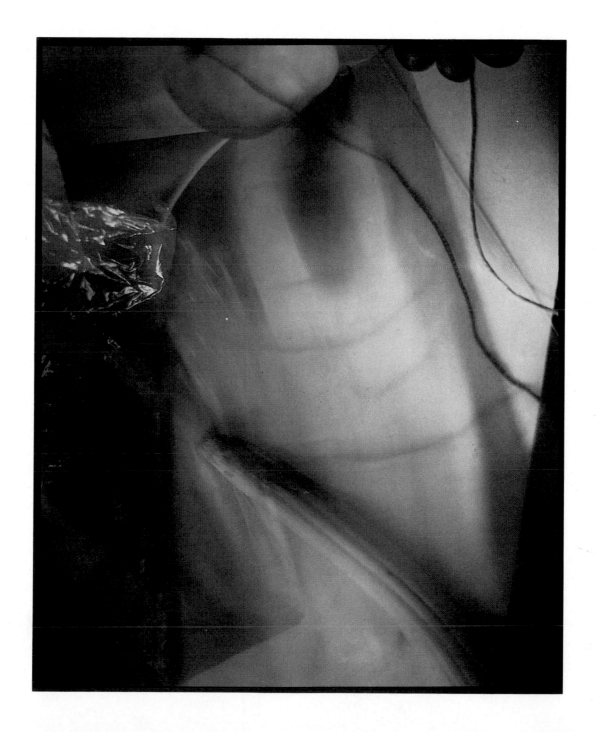

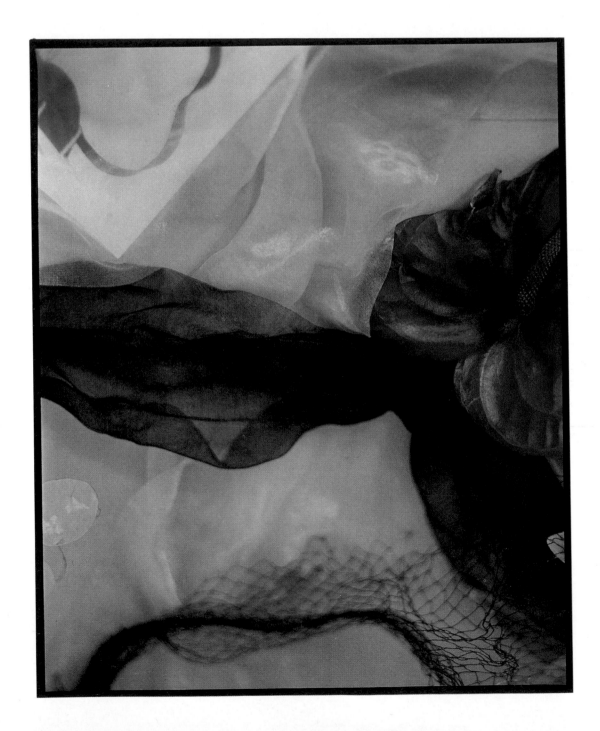

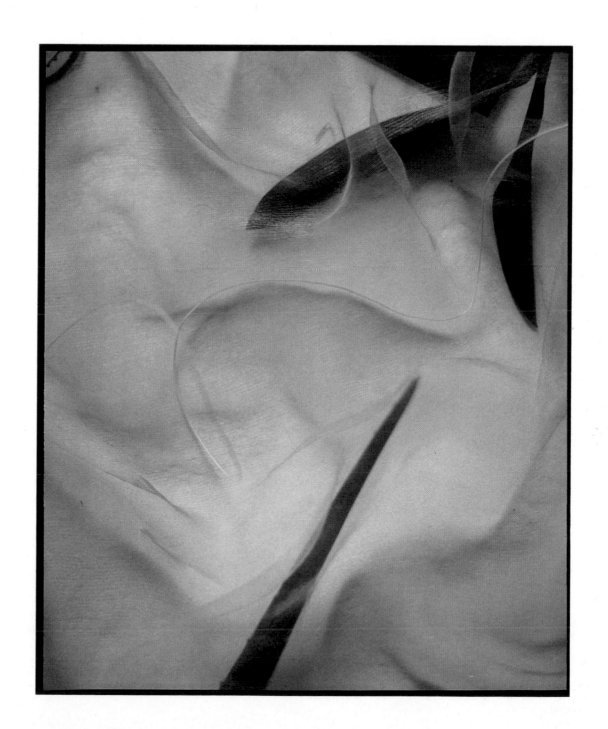

The Year's Books /6

In a book that pays homage to his homeland (pages 206-217), an Indian photographer captures the diversity of the inhabitants of the state of Rajasthan, including a Bhil tribesman shown here with a mask used in religious festivals.

Land of Legend /RAGHUBIR SINGH

A Frontline Report on Insurrection

With a compassionate eye, photojournalist Susan Meiselas covers Nicaragua's revolution at close range

NICARAGUA: JUNE 1978-JULY 1979
By Susan Meiselas. Pantheon
Books, New York. 120 pages. 71 plates.
Hard-cover, $22.95. Soft-cover,
$11.95.

In January 1978, freelance photographer Susan Meiselas read an article in *The New York Times* reporting the assassination of Pedro Joaquin Chamorro, the publisher of Nicaragua's opposition newspaper, *La Prensa*. "It was more attention than was usually paid to Latin America," she later recalled, "and it started me thinking." Within a few months, Meiselas had initiated a project that would eventually win her the 1979 Robert Capa Gold Medal *(Photography Year 1980, page 70)* for the "exceptional courage and enterprise" of her photographic work. Now 71 of her color photographs have been gathered into a book recording the violence that wracked Nicaragua between June 1978 and July 1979, when rebel Sandinista forces overthrew the regime of dictator Anastasio Somoza.

Meiselas had no previous experience in war photography. A graduate of Sarah Lawrence with a master's degree in education from Harvard, she had taught photography to rural and inner-city children, and had compiled visual histories of a mill town in South Carolina and of women exploited in New England country-fair "girl shows." *(Carnival Strippers,* the product of Meiselas' New England odyssey, was published by Farrar, Strauss & Giroux in 1976.)

Nicaragua was her first attempt at news coverage. She went there alone, without an assignment, speaking no Spanish. But the images she sent back to New York were so obviously taken right in the thick of battle that her adviser at Magnum—the New York photo agency she had joined in 1977—promptly sent her a 300mm lens, an implicit suggestion that Meiselas keep a bit more distance between herself and the violence. She continued to shoot primarily with a 35mm lens, and when Nicaragua's revolution finally hit the headlines, her coverage of the hostilities was published worldwide—in *The New York Times Magazine, Paris Match, Geo* and *Time*.

For a year, Meiselas was never out of Central America more than four weeks at a time, and then only to sort through the piles of her contact sheets and slides at Magnum. "No matter how much I'd already shot," she recalled, "I had a sense that every moment was vital, and different from everything that had gone before." To her own astonishment, she found herself gladly racing to meet newsmagazine deadlines. "I had a story that was important, that I cared about, something the world had to be shown," she says.

The images in *Nicaragua* convey this intense commitment to the people she was photographing. The book opens with deceptively quiet views—a rain-soaked village, all mud streets and tin roofs; a woman washing clothes in a sewer in downtown Managua; Anastasio Somoza and a coterie of men, prosperously dressed in immaculate white suits, stepping out of a shiny black limousine. Thereafter, the story evolves wordlessly into pictures of uniformed soldiers, ragged children around street bonfires, and soon the scenes of battle and its traumatic aftermath. All the captions are withheld until the end, allowing the images of Nicaragua—and its people—to speak for themselves.

Anticipating a National Guard attack, a masked rebel soldier in Matagalpa dashes across the street to a new position. At this early stage of the insurrection, photographer Meiselas recalls, townspeople—such as the man and woman seen standing in their doorways here—were more fascinated than frightened by the fighting that was going on around them.

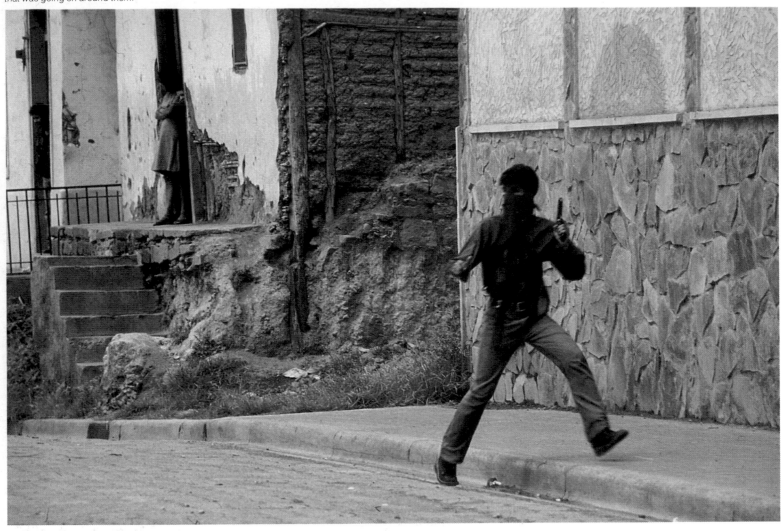

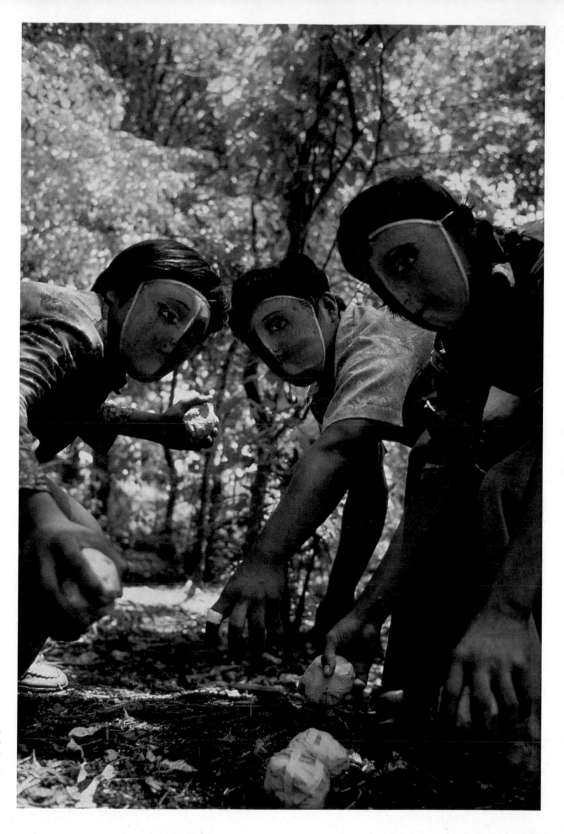

In a village southeast of Managua, the capital, young Monimbo Indians learn to handle live contact bombs — primitive handmade grenades that explode on impact. The masks, used in traditional Monimbo dance celebrations and unique to the area, quickly became identified with the revolution when the Monimbos adopted them as disguises.

A woman in the town of Masaya searches the bombed-out shell of her home for scrap metal to melt down and sell. When insurrections erupted in five Nicaraguan towns during September 1978, President Somoza responded with several days of aerial bombardment.

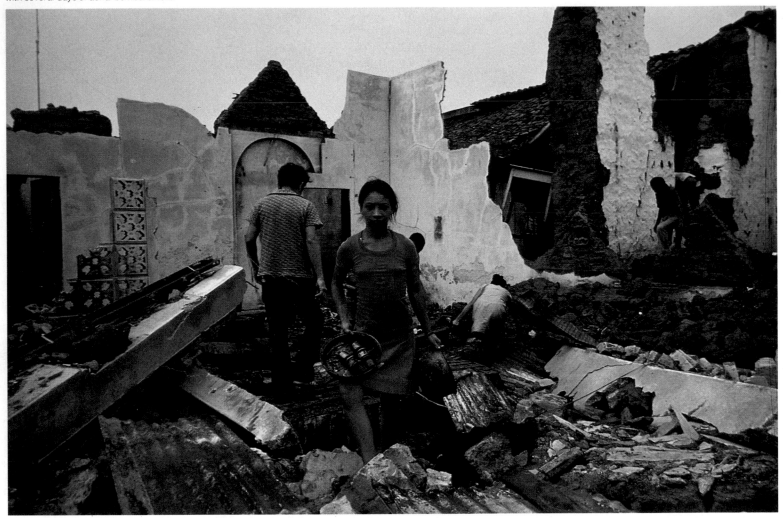

As their father reaches down to comfort one of them, two young brothers whose home in Managua was hit by a 1,000-pound bomb lie mortally wounded in a church a few blocks from their house. Three other members of the same family died as a result of the attack, in June 1979.

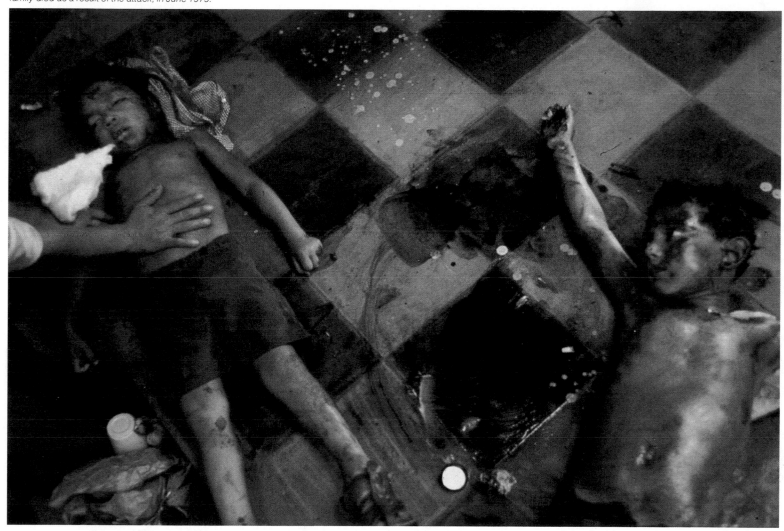

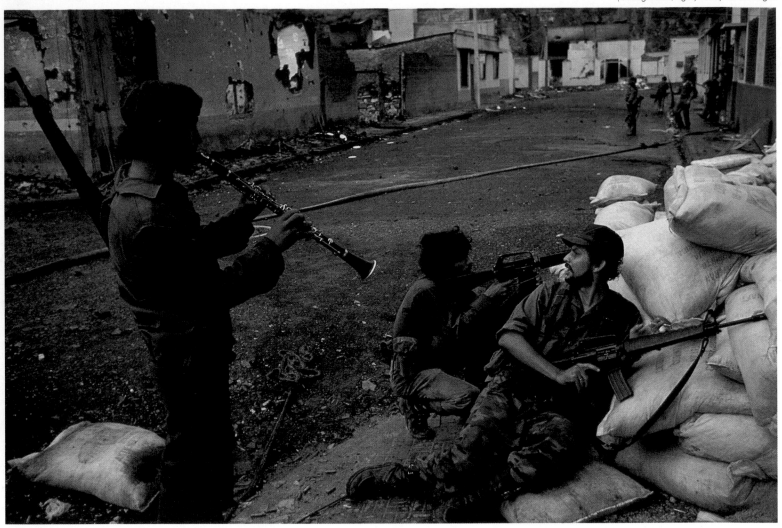

Outfitted with uniforms and arms captured from the National Guard, Sandinista rebels man a barricade outside the just-taken garrison of the National Guard in Matagalpa — while one incongruously tries out a clarinet that the Guards left behind. Although Matagalpa had been heavily bombed, the garrison itself (background, right) escaped damage.

Jubilation reigns and crowds line even the roof and ledges of the National Cathedral as Sandinistas enter Managua on July 20, 1979, to celebrate their triumph. A fire truck flying the blue-and-white Nicaraguan flag (right, middleground) carried members of the victorious junta.

A Craftsman's Tour of the Urban Scene

After a 20-year hiatus, Californian Max Yavno again focuses his "passion for the well-made object" on urban streets and figures

THE PHOTOGRAPHY OF MAX YAVNO
Photographs by Max Yavno. Text by
Ben Maddow. University of California
Press, Berkeley. 122 pages. 85
plates. Hard-cover, $39.95. Soft-cover,
$19.95.

Someone once said to Max Yavno, "You come into a room without disturbing the air." The 85 images in *The Photography of Max Yavno* reveal the truth of that assessment. Shot in New York, Los Angeles, San Francisco, Jerusalem and Cairo, the photographs reflect what Yavno's friend and textwriter Ben Maddow calls a concern with "the pleasures of the real": the buildings, faces, street scenes and incongruities of urban life. Whether recording a crowded California beach in 1949 *(page 198)* or the odd juxtaposition of Hassidic Jews and sailors before Jerusalem's Wailing Wall in 1979 *(page 202),* Yavno exhibits an uncanny ability to capture diverse elements of a society while maintaining the serene distance of the quintessential observer.

But creative mastery only begins with the clicking of the camera's shutter. As Maddow points out, Yavno's darkroom "is not a passive place." Yavno spends an entire day— sometimes two— on each print, meticulously adjusting shadow and light to achieve the precise tones he wants.

Ironically, Yavno has had no formal photographic training, except for a brief course for Army photographers given by *Life* in 1943. His introduction to the camera came in 1927, when he was a 16-year-old, $15-a-week runner on the floor of the New York Stock Exchange. For $20, he bought a 10 x 15cm Zeiss camera from a member of the Exchange, then spent 50 cents for a Kodak book entitled *How to Develop and Print Pictures.* These were serendipitous investments. Yavno had inherited a yen for perfection from his carpenter father, and photography soon became an obsession for him.

By the time he moved to California in 1945, his great gifts were so evident that he was chosen over such luminaries as Edward Weston and Ansel Adams for a $1,500 Houghton Mifflin Fellowship to do *The San Francisco Book,* published in 1948. That volume, followed by *The Los Angeles Book* in 1950 and Edward Steichen's purchase of 19 of his prints for the Museum of Modern Art in 1952, established Yavno as a master chronicler of urban life, having both a sculptor's eye for form and composition and a sorcerer's gift for darkroom technique.

In 1954— spurred by the sobering example of Edward Weston's struggle for economic survival— Yavno turned what fellow-photographer Aaron Siskind has called "his passion for the well-made object" to more lucrative commercial work. He was highly successful, twice receiving the New York Art Directors Gold Medal, but he had trouble reconciling his advertising and artistic careers. As a result, he focused strictly on commercial work for two decades.

Then, in 1975, a particular view of Utah's Canyon de Chelly so excited him that he realized, "I just couldn't stand to do commercial work anymore," and he returned to his real love. There is thus a gap of more than 20 years between the photographs in the early and the later sections of this book— but Max Yavno's genius is manifest from first to last.

Self Portrait, 1977

Keyboard, 1947

Cable Car, 1947

Power Station, El Segundo, 1949

The Leg, 1949

Muscle Beach, 1949

Première at Carthay Circle, 1949

Self Service, 1978

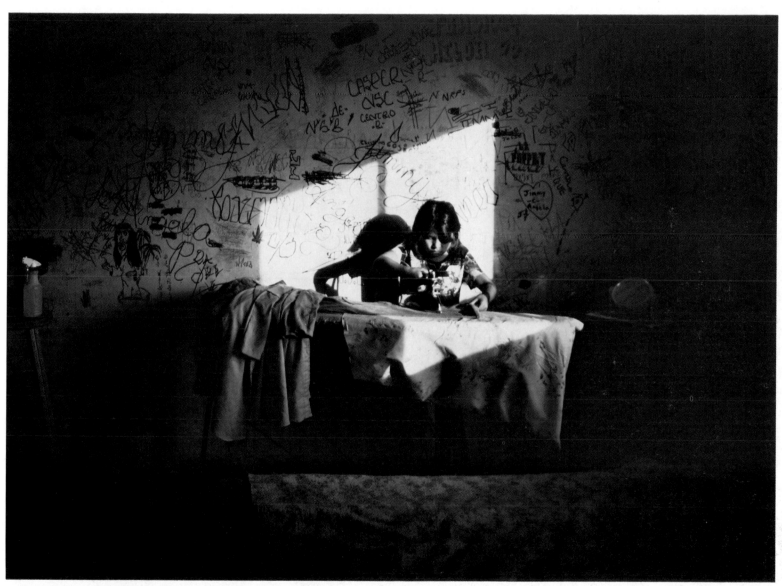

Bedroom, Brawley, California, 1978

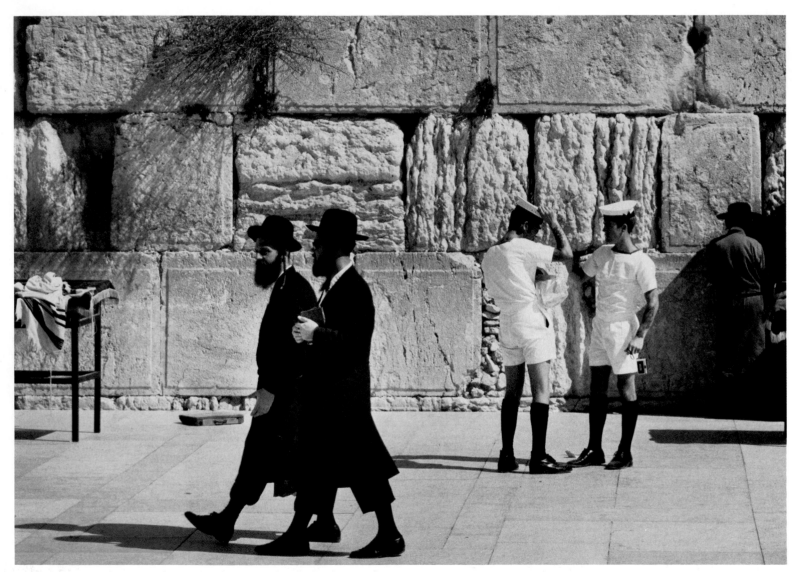

Wailing Wall, Men's Section, 1979

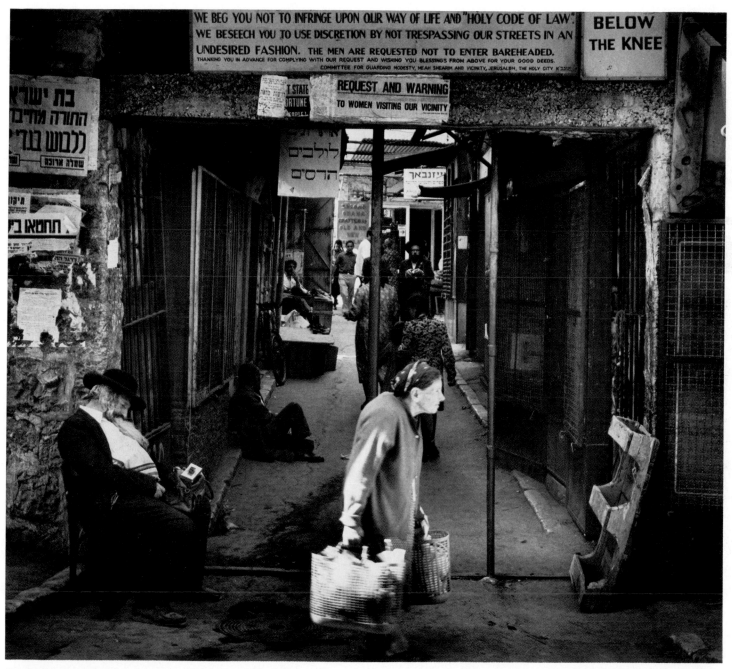

Ultra Orthodox Quarter, 1979

Sphinx, 1979

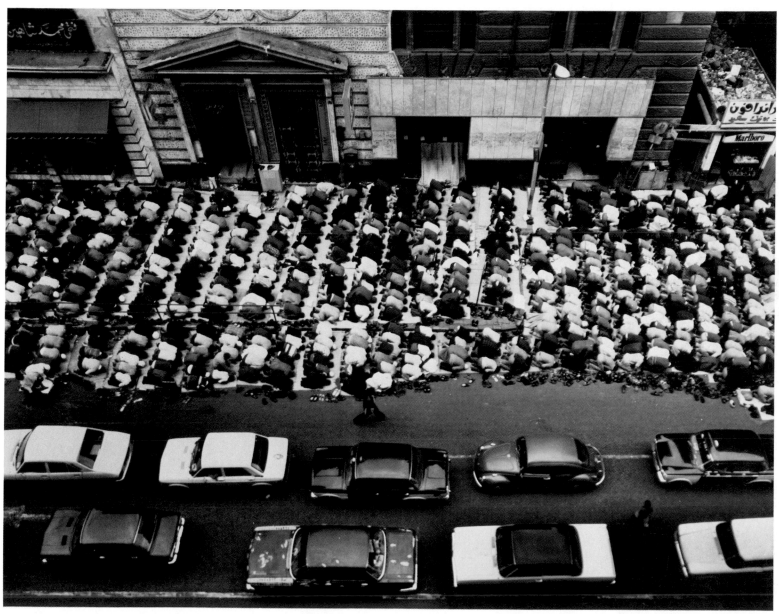

Noon Prayer, 1979

Rajasthan: Land of Legend

A corner of India rich in myth and resonant with a thousand years of history inspires a moving photographic testament from a prodigal son

RAJASTHAN: INDIA'S ENCHANTED LAND
Photographs and introduction by Raghubir Singh. Foreword by Satyajit Ray. Thames and Hudson, New York. 112 pages. 80 plates. Hardcover, $27.50.

Rajasthan is a state in northwestern India. Raghubir Singh was born in its capital, Jaipur, into an affluent family that lost much of its economic standing in the sweeping reforms that followed India's independence in 1947. "The horses were sold off," Singh recalls in the introduction to his book. "The carriages and weapons began gathering dust. The many servants we had were reduced to a few." When members of his extended family went their separate ways, his elder brothers divided the family home into apartments furnished "in the western style."

Singh now lives in Paris, but he says, "I never considered myself an expatriate; every year I returned to travel to different parts of India, though not at first to Rajasthan. In time, the magnetic pull of the land of my birth began to assert itself." He grew nostalgic for the summers spent on his brother's farm, where daybreak brought the sharp calls of partridges and parakeets, and nightfall brought the leopard's cough: "Sometimes we saw its eyes, two tiny torches gleaming in the distance." Between the wheat harvest and the monsoon, villagers "had time on their hands," Singh writes, "to tell ghost stories, and to dance and sing."

The 80 photographs in *Rajasthan — India's Enchanted Land* are the fruit of visits made over the course of four years. They capture the shifting quality of light, the rich and startling colors of both city and countryside, and the reverberations of bygone centuries. Formerly known by the more melodic name Rajputana, Rajasthan — "a place of kings" — was the scene of epic battles between Rajputs and Moguls. Here, saints and outlaws lived, and women flung themselves on the funeral pyres of fallen warriors. "In the history of India," Singh writes, "the story of the Rajputs is a roaring fire." An almost mythical atmosphere permeates many of Singh's photographs: It is present in a scene of the lonely ramparts of the 15th Century Kumbhalgarh Fort at Mewar *(page 216)* and in a portrayal of a Bhil tribesman made up as a tiger *(page 208)* for a dance drama to honor an ancient goddess.

But Singh sees the present as clearly as he does the past. By showing us a trio of magenta-stained cloth dyers working their trade in a Jaipur street *(page 215)* or a bedraggled family that has waded across the flooded Luni River *(page 212),* he conveys the hardships of living in an unforgiving terrain — whether urban or rural. With the same acuteness of eye, he catches the spirit of fairs, festivals and other celebrations in images that tell more about the people of Rajasthan than poverty statistics and population studies ever can.

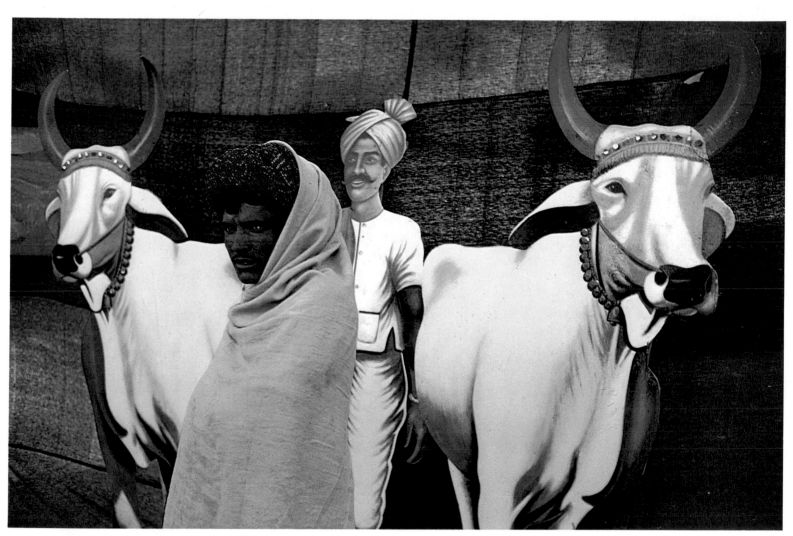

A villager before a cardboard cutout of a smiling farmer

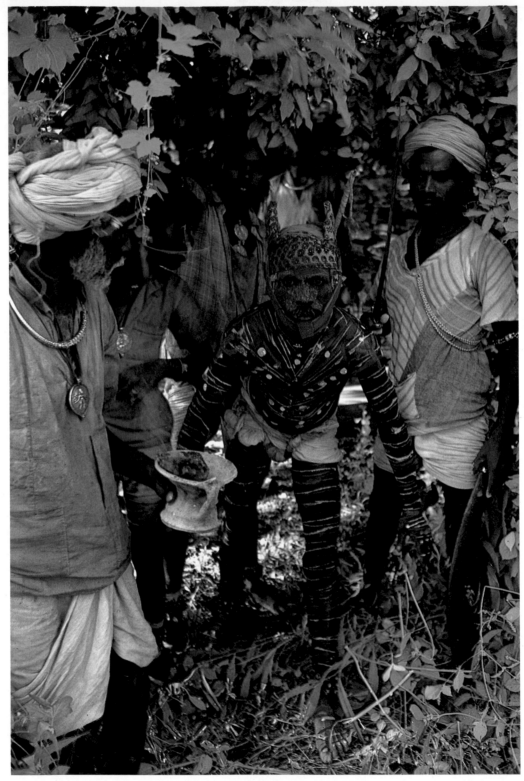

A Bhil tribal dancer made up as a tiger to participate in the drama honoring Gauri, the goddess of abundance

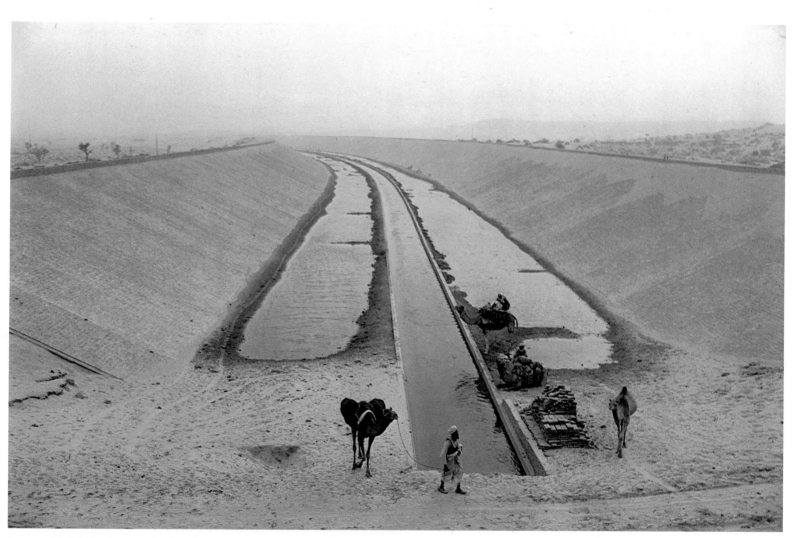

A segment of the Rajasthan Canal, in the Thar Desert

A traditional singer entertaining wedding guests

A temple dedicated to Karni Mata, the popular deity of the Bikaner area

A family who waded through the flooded Luni River

A tree, cattle and camels in the summer drought

Centennial celebrations at Mayo College in the town of Ajmer

Cloth being dyed in a Jaipur street

The ramparts and battlements of the 15th Century Kumbhalgarh Fort in the Mewar region

Rajput landowner with a visitor

217

Other Books

The editors recommend the following additional photography books published during 1981.

Current Work

EARTH WATCH

By Charles Sheffield. Macmillan Publishing Co., Inc., New York. 160 pages. 75 photographs. Hard-cover, $24.95. Computer-enhanced color photographs of Great Salt Lake, the Nile and other notable landmarks, taken from 570 miles up by the Landsat satellite.

FALKLAND ROAD: PROSTITUTES OF BOMBAY

By Mary Ellen Mark. Alfred A. Knopf, Inc., New York. 112 pages. 65 photographs. Hard-cover, $25. Soft-cover, $12.95. A compassionate documentation remarkable for the warm colors of the images and for the rapport established with initially hostile subjects.

MAN AS ART: NEW GUINEA

Photographs by Malcolm Kirk. Introduction by Andrew Strathern. The Viking Press, New York. 143 pages. 93 photographs. Hard-cover, $45. Elaborate face and body painting, headdresses, masks and other adornments of the people of Papua New Guinea, in color and black and white.

NEW AMERICAN NUDES: RECENT TRENDS AND ATTITUDES

Edited by Arno Rafael Minkkinen. Morgan & Morgan, Inc., Dobbs Ferry, New York. 128 pages. 110 photographs. Soft-cover, $19.95. Contemporary nudes selected from nearly 3,500 images taken by more than 450 photographers nationwide. Published in conjunction with a show at the Massachusetts Institute of Technology.

PHOTOGRAPHS

By Elliott McDowell. David R. Godine, Publisher, Inc., Boston. 88 pages. 40 photographs. Hard-cover, $30. A miniature chair perched on the keys of a piano, the Mona Lisa hung on a tree trunk and other whimsical images from a Santa Fe photographer with a unique sense of the absurd.

UNDERSTANDINGS: PHOTOGRAPHS OF DECATUR COUNTY, GEORGIA

Photographs by Paul Kwilecki. Introduction by Alex Harris. The University of North Carolina Press, Chapel Hill. 118 pages. 102 photographs. Hard-cover, $24.95. One corner of rural Georgia presented with understated power by a lifelong Decatur County resident.

Historical

AMERICAN FRONTIERS: THE PHOTOGRAPHS OF TIMOTHY H. O'SULLIVAN 1867-1874

By Joel Snyder. Aperture, Inc., Millerton, New York. 120 pages. 96 photographs. Hard-cover, $35. Arresting, unsentimental landscapes by a geological-survey photographer who recorded the American West.

EYEWITNESS: 25 YEARS THROUGH WORLD PRESS PHOTOS

Edited by Harold Evans and The World Press Foundation. Text by Harold Evans. William Morrow and Company, Inc., New York. 192 pages. 238 photographs. Hard-cover, $10.95. A violent and bloody quarter-century of front-page pictures.

NEW ENGLAND PAST: PHOTOGRAPHS 1880-1915

Edited by Jane Sugden. Text by Norman Kotker. Harry N. Abrams, Inc., New York. 296 pages. 236 photographs. Hard-cover, $37.50. Social history of life in an area that by the turn of the century had come to be considered quaint and old-fashioned.

ORDINARY MIRACLES: THE PHOTOGRAPHY OF LOU STOUMEN

By Lou Stoumen. Introduction by William A. Ewing. Hand Press, Los Angeles. 102 pages. 69 photographs. Hard-cover, $30. A retrospective of the photographer's life and work.

PARIS/MAGNUM: PHOTOGRAPHS 1935-1981

Text by Irwin Shaw. Introduction by Inge Morath. Aperture, Inc., Millerton, New York. 112 pages. 90 photographs. Hard-cover, $30. Images of one of the world's great cities by 28 photographers.

A PHOTO JOURNAL

By Ruth Orkin. The Viking Press, New York. 152 pages. 165 photographs. Hard-cover, $35. More than 40 years of images from Hollywood to Israel, interspersed with autobiographical text.

PICTURES FROM THE NEW WORLD

By Danny Lyon. Aperture, Inc., Millerton, New York. 143 pages. 169 photographs. Hard-cover, $39.50. Photographs of the U.S. and Latin America, more than half of them shot during the early 1960s by a photographer and film maker who was active in the civil rights movement.

PORTRAIT: THEORY

Edited by Kelly Wise. Lustrum Press, Inc., New York. 176 pages. 100 photographs. Soft-cover, $19.95. Portraits and essays by the photographers: David Attie, Chuck Close, Jan Groover, Evelyn Hofer, Lotte Jacobi, Gerard Malanga, Robert Mapplethorpe and James Van Der Zee.

PRAIRIE FIRES AND PAPER MOONS: THE AMERICAN PHOTOGRAPHIC POSTCARD 1900-1920

By Hal Morgan and Andreas Brown. Foreword by John Baskin. David R. Godine, Publisher, Inc., Boston. 208 pages. 304 photographs. Hard-cover, $25. Examples of such postcard categories as notorious criminals, natural disasters, novelty studio poses.

SLAVE TO BEAUTY: THE ECCENTRIC LIFE AND CONTROVERSIAL CAREER OF F. HOLLAND DAY, PHOTOGRAPHER, PUBLISHER, AESTHETE

By Estelle Jussim. David R. Godine, Publisher, Inc., Boston. 310 pages. 259 photographs. Hard-cover, $35. A bid to rescue from obscurity an American artist who was acclaimed as the creative equal of Stieglitz.

STEICHEN AT WAR

By Christopher Phillips. Harry N. Abrams, Inc., New York. 256 pages. 200 photographs. Hard-cover, $40. A history of the Naval Aviation Photographic Unit that documented World War II under the command of Edward Steichen.

Technical

ARTISTIC PHOTOGRAPHIC PROCESSES

By Suda House. American Photographic Book Publishing, New York. 144 pages. Soft-cover, $14.95. Nonsilver processes, including cyanotype, vandyke brownprinting, gum bichromate and Kwik-Print, as well as even less conventional image making and transfer methods.

THE DARKROOM HANDBOOK

By Michael Langford. Alfred A. Knopf, Inc., New York. 352 pages. Hard-cover, $25. Nearly half devoted to techniques of creative manipulation of images, including a how-to chapter on old processes.

DYE TRANSFER MADE EASY

By Mindy Beede. American Photographic Book Publishing, New York. 160 pages. Soft-cover, $16.95. Patient, step-by-step description of a process that is both challenging and rewarding.

INTO YOUR DARKROOM STEP-BY-STEP

By Dennis P. Curtin with Steve Musselman. Curtin & London, Inc., Somerville, MA, and Van Nostrand Reinhold Company, New York. 90 pages. Soft-cover, $11.95. A manual designed to lie flat next to the enlarger or developing trays for on-the-spot guidance to black-and-white processing.

THE PHOTOGRAPHIC ART MARKET

By Peter H. Falk. Falk-Leeds International, Inc., New York. 118 pages. Soft-cover, $29.95. A detailed guide for investors and collectors by a leading analyst of the photographic art market.

Critical

BEAUTY IN PHOTOGRAPHY: ESSAYS IN DEFENSE OF TRADITIONAL VALUES

By Robert Adams. Aperture, Inc., Millerton, New York. 112 pages. Hard-cover, $12.50. A photographer's insights into the meaning of his art.

CAMERA LUCIDA: REFLECTION OF PHOTOGRAPHY

By Roland Barthes. Translation by Richard Howard. Hill and Wang, New York. 120 pages. Hard-cover, $10.95. A posthumous collection of scholarly musings on the nature of photography.

PHOTOGRAPHY IN PRINT: WRITINGS FROM 1816 TO THE PRESENT

Edited by Vicki Goldberg. Simon and Schuster, New York. 574 pages. Hard-cover, $22.50. Commentary and analysis by critics, humorists and photographers.

Marketplace/7

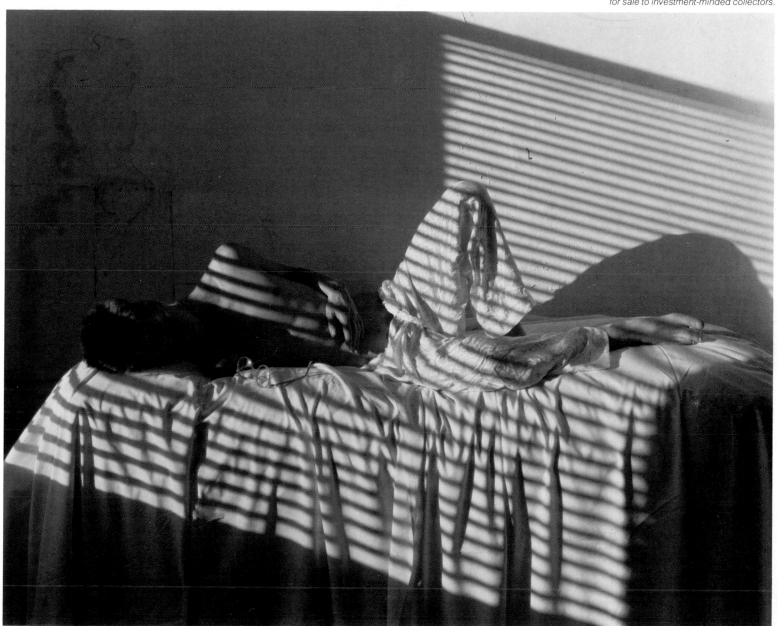

MARSHA BURNS: *Untitled*, 1979

Portfolios: A Profitable Package

Publishing photographs in limited-edition portfolios makes financial sense to contemporary photographers—and to collectors as well

Fifty-five years ago, Albert Bender, a well-known West Coast art patron, saw some prints by a young photographer whose work was virtually unknown at the time. Struck by his talent, and believing his work should be presented as fine art, Bender urged the young man to put together a portfolio. The photographer agreed, and Bender wasted no time calling a dozen or so of his friends to drum up interest in the project. In this, he was eminently successful—partly, no doubt, because he told each of them, "I'm taking 10 of Ansel Adams's portfolios."

Published in 1927, the portfolio was entitled *Parmelian Prints of the High Sierras*. (The publisher had advised that the prints not be characterized as photography, a word she did not think would sell. Hence, "parmelian," which comes from the Greek word *melas,* meaning black.) Adams made 100 sets of 18 prints, each set contained in an eye-catching box covered in black silk and gold satin, with a fancy—albeit fake—crest on top. The price per set: $50.

Ansel Adams—or perhaps more accurately, Albert Bender—was several decades ahead of his time. The market for original prints would not come into its own until the early 1970s, when the public began to recognize photography as an art. Still, Adams continued to make occasional portfolios, despite the modest financial reward: As recently as 1963 the issuing price of his *Portfolio IV* was $150. But in 1979, fifty years after its publication, a set of his *Parmelian Prints* was sold by Christie's, the New York auction house, for $9,000 (and now is probably worth twice that). His *Portfolio VI* was issued in 1976 for an astounding $10,000, and fetched a more astounding $45,000 at a 1979 auction held by Sotheby Parke Bernet.

Not every photographic portfolio, of course, commands such a lofty price. The

JEWEL STERN: *Project Skyline.* Published by Daniel Wolf Press, Inc., New York. Ten 16 x 20 prints in an edition of 30 sets. $2,600.

seven recent ones shown below and on the following pages were issued at an average price of $3,000. (Photographs from them appear on pages 226-240.) Buyers consider such portfolios a good investment. Not only are they expected to appreciate but they also qualify for favorable tax treatment: They can be given to a museum after a holding period of one year and their market value then deducted from income— although the Internal Revenue Service requires proof that the value of the donated photographs has not been artificially inflated. As an incentive to collectors and investors, prepublication prices are 25 to 50 per cent lower than prices for later sets in an edition, and portfolios are priced so that each print in the set costs less than it would if sold singly.

Today, more photographers than ever before are putting portfolios together. Lee Witkin, of Manhattan's Witkin Gallery, estimates that in the 1960s photographers published about 15 portfolios; in the 1970s the number rose to about 165. And the trend of the 1980s is dramatically upward: In 1981, according to the newsletter *The Photograph Collector,* photographers assembled some 50 portfolios.

Despite wide stylistic variations in the prints themselves, the format for most recent portfolios is relatively standard— and much like Ansel Adams' 1927 example. The images, ranging in size from 5 x 7 to 22 x 28 inches, are usually matted, although some are slipped instead into plastic sleeves. The finished prints are presented in custom-made boxes that can cost the publisher up to $200 apiece and often are covered in fine linen from Germany, Italy or the Netherlands. Paul Ickovic's haunting portfolio *Prague, 1980,* for example, is wrapped in a warm-gray

MARSHA BURNS: *Dreamers.* Published by the artist. Twelve 8 x 10 prints in an edition of 60 sets. $3,000.

WILLIAM LARSON: *Aprille.* Published by the artist. Ten 16 x 16 dye-transfer prints in an edition of 12 sets. $3,500.

linen, and Olivia Parker's *Lost Objects* is covered in beige linen, with the title embossed in gold on black leather. The linen-covered box for Jewel Stern's *Project Skyline* offers an unusual inside pocket that holds 10 mylar prints traced in ink from the original blueprints of the buildings shown in the portfolio's photographs.

Most of the boxes open like books (among the largest is William Larson's 44 x 26-inch *Aprille),* and many are lined with imported paper. Both Marsha Burns and Christopher James use handmade paper from France—which some photographers also use for the title page, a preface or introduction, and the contents page. Photographers who prefer the unconventional have packaged their portfolios in boxes made of aluminum or plastic—or even silver lamé.

A consistent feature of portfolios is that they are published in limited quantities. Typically, an edition consists of 25 to 50 sets, each with 10 to 25 prints numbered and signed by the artist. (At 250 sets, Eliot Porter's *Glen Canyon,* page 225, is an exceptionally large edition.) The notion of a limited edition can be misleading, however, since another collection of the same prints may be assembled later, the only difference being that the prints are another size.

Photographers who publish portfolios themselves usually find the venture frustrating, tedious and expensive. Indeed, a major obstacle to doing the job alone is the hefty investment required, generally anywhere from $10,000 to $75,000. By publishing and selling their portfolios themselves, of course, photographers get to enjoy the full fruits of any success. Many of them, however, prefer to share the

CHRISTOPHER JAMES: *Portfolio One.* Published by the artist and the Halsted Gallery, Inc., Birmingham, Michigan. Ten 5 x 7¼ hand-dyed and enameled prints in an edition of 15 sets. $3,600.

OLIVIA PARKER: *Lost Objects.* Published by the artist. Ten 8 x 10 selenium-toned contact prints in an edition of 35 sets. $3,500.

burden and risk with a gallery or a packager (someone who may make his living in another field and puts together portfolios as a sideline). Normally the artist does the printing or at least supervises the procedure. The gallery or packager puts up the money, manages the production of the portfolios, sells the finished products— and takes a healthy cut of the profits.

Financial arrangements between the gallery or packager and the photographer vary widely. For the artist, the least rewarding arrangement is one in which the publisher pays the artist for the prints on delivery and retains all or most of the profits from sales of the portfolios. The photographer may receive as little as $1/10$ of the market value of the prints. Because the value of original prints has been rising, however, photographers have been demanding a stake in the future sales of their work. Many galleries and packagers now pay little if anything for the prints, and instead give the photographer from 40 to 50 per cent of the profits.

Whether or not they do their own publishing, photographers usually must invest a great deal of time and energy in the production of a portfolio. Alice Steinhardt of Los Angeles spent more than a year hand-coloring about 300 prints for *Taos,* her 1981 portfolio of scenes from the Southwest (one of the images may be seen on page 20 of the Trends section). Marsha Burns, who needed 720 prints for her 60-set edition of *Dreamers,* was equally sedulous: She printed each of the 12 images from 85 to 160 times to get enough good ones. "I now have so much sympathy for anyone who tries to manufacture something of quality in quantity," Burns says. Most of her colleagues in this burgeoning field would undoubtedly agree.

PAUL ICKOVIC: *Prague.* Published by Odéon Editions, Boston. Ten 11 x 14 silver prints in an edition of 25 sets. $2,000.

ELIOT PORTER: *Glen Canyon.* Published by Daniel Wolf Press, Inc., New York. Ten 12½ x 16 dye-transfer prints in an edition of 250 sets. $4,000.

JEWEL STERN: *Greystone Hotel,* 1977

MARSHA BURNS: *Untitled,* 1979

WILLIAM LARSON: *Untitled,* 1979

WILLIAM LARSON: *Untitled,* 1979

CHRISTOPHER JAMES: *Fairmont, San Francisco,* 1980

CHRISTOPHER JAMES: *Field, Carmel*, 1980

233

OLIVIA PARKER: *Site I,* 1980

OLIVIA PARKER: *Whelks,* 1979

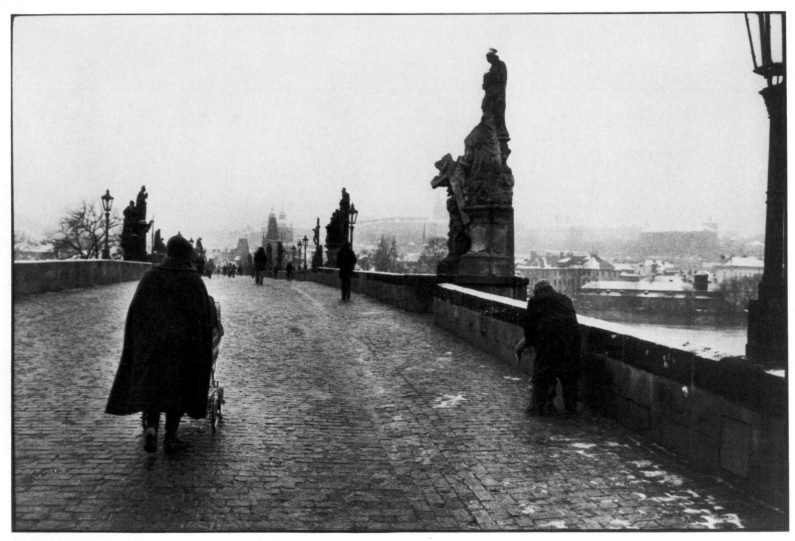

PAUL ICKOVIC: *Untitled*, 1980

PAUL ICKOVIC: *Untitled,* 1980

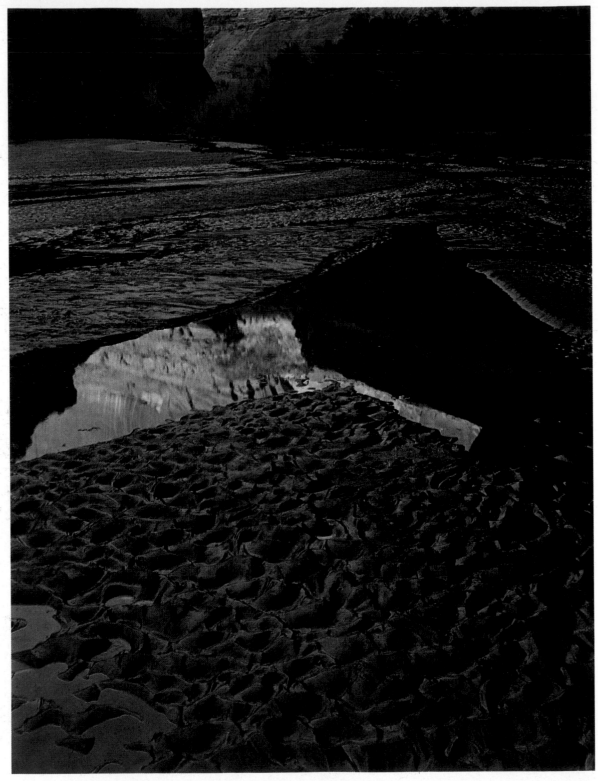

ELIOT PORTER: *Escalante River Outwash, Glen Canyon,* 1962

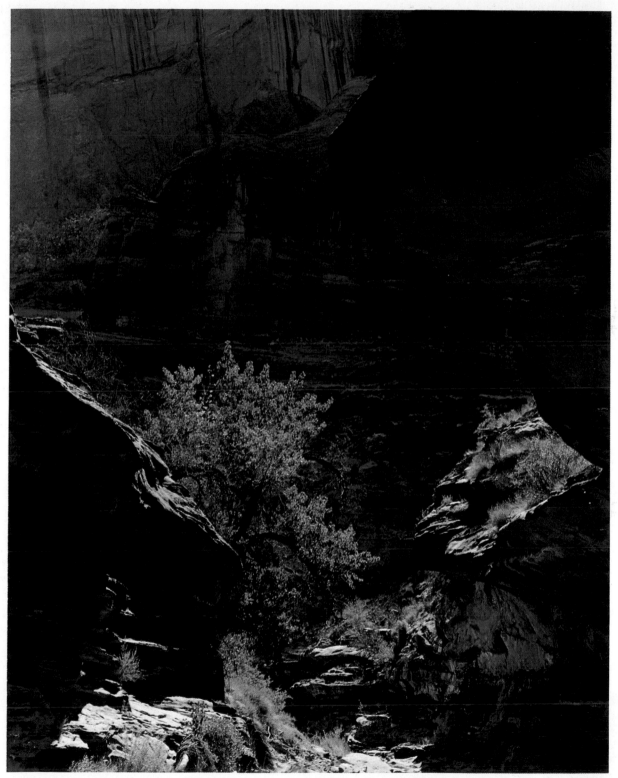

ELIOT PORTER: *Coyote Gulch, Escalante River,* 1971

ELIOT PORTER: *Redbud in Bloom, Hidden Passage, Glen Canyon,* 1963

Roundup/8

Having come from all over the world for a special project in Australia (page 245), more than 100 photographers gather on the Sydney Opera House steps for a group portrait. The big mirror at lower right enabled the photographer who took the picture to include himself in it.

Miscellany / GREGORY HEISLER: *Hello From Sydney, 1981*

Miscellany

The building of Lord Nelson's Column, 1845 — a rediscovered salt print by Fox Talbot

New Home for Edward Weston's Archive

Nearly a quarter of a century after Edward Weston's death, his archive has found a permanent home. In April 1981 the Center for Creative Photography, established in 1975 at the University of Arizona, acquired 2,500 silver and platinum prints and about 10,000 negatives of both the commercial and the creative works of this pivotal figure in 20th Century photography.

Some of the platinum prints date back as far as 1903; other prints, representing Weston's own selection of 800 of his finest photographs, were made in 1955 by his son Brett, who is a photographer in his own right, after the elder Weston was found to be suffering from Parkinson's disease. In addition, the archive incorporates Weston's letters, daybooks, camera equipment and memorabilia, together with his collection of works by other photographers.

The center announced that it would make no prints for sale or display from the negatives now in its possession, although it may produce contact prints for study purposes. Cole Weston, the youngest of the photographer's four sons and the executor of his father's estate, retains the right to make prints from these negatives, something he began doing in the last years of his father's life. Cole expressed the family's "relief and pleasure" that his father's work had been passed along to the center, which also houses the complete archives of several other master photographers, including Ansel Adams, Wynn Bullock and Harry Callahan.

Buried Treasure in New York

Scattered throughout the research libraries of the New York Public Library are nearly two million photographic images of practically every imaginable subject. In terms of photographic technology, they range all the way from 19th Century daguerreotypes and calotypes (the first positive-negative process) to the latest color print process. Yet until recently, much of this treasure had been effectively buried for lack of adequate cataloguing.

With the help of private donations and government grants, however, librarian Julia van Haaften has been spearheading an effort to retrieve the pictures from their unfortunate obscurity. In December 1981, a selection of rediscovered photographs was included in "96 Images: Talbot to Steiglitz," an exhibit that ran at the main library for nearly 12 weeks. As van Haaften noted in the introduction to the accompanying book, the images "all reflect the library's 19th Century origins and nearly universal collecting policy."

To find these "lost" photographs required some determined detective work, including a search of every division in the library. Many original photographs had been pasted into scrapbooks and travel albums whose catalogue descriptions indicated only that they were illustrated. There was, for example, no catalogue entry under "Bisson," although a scrapbook in the general stacks includes several albumen prints made by the Bisson brothers, Louis Auguste and Auguste Rosa-

Construction of the Statue of Liberty, c. 1880, from a French photo album in the New York Public Library

lie, during an ascent of Mont Blanc in 1861. The French photographers were renowned for their Alpine views.

As photographs are found, the next consideration is to guard them against damage. Time Inc. has donated staff time, labor and materials to copy the more important — and fragile — originals. The copies will become the base of an archive of study prints in the Photograph Section of the library's Art, Prints and Photographs Division. The library will also be able to produce fresh prints from the copy negatives. In return, Time Inc. will retain copy prints of all the images it photographs for its own picture collection.

A Photographic Blitz of Australia

The "photo-fantasy of the century," one participant called it: On March 6, 1981, more than 100 photographers from all over the world engaged in a 24-hour blitz of picture taking, from which would emerge a stunning visual chronicle of a nation and its people — *A Day in the Life of Australia,* published in Sydney in the autumn of 1981.

Making the fantasy real was not easy. American photographer Rick Smolan, who had worked on *Life's* 1974 "A Day in the Life of America" project, and his Australian partner, Andy Park, spent two years trying to drum up corporate sponsorship. "Every time we would approach a company," said Smolan later, "its pocketbook simply wouldn't match its enthusiasm." But after the partners were endorsed by Australian Prime Minister Malcolm Fraser — himself a camera buff — financial support began to materialize.

Assembling the international cast for the photographic shoot-out Down Under was no less arduous. "I don't know how Smolan did it," commented participant Dave Harvey of the *National Geographic.* "I can't even get my friends at the *Geographic* together for lunch." The bait, however, was well-nigh irresistible: a chance to shoot the vast, photogenic Australian continent, in the company of some of the world's best photographers. Meeting colleagues he had known only by reputation was "like a dream come true," said freelancer Greg Heisler. Sarah Krulwich of *The New York Times* agreed. "We are all awed at being in the same place at the same time," she said in the course of the project, "and we are all very nervous."

Nerves were put to the test beginning at 12:01 a.m. on D-Day. Each photographer had been given some 25 rolls of film and a free-form assignment — that is, no rules governed how a subject was to be handled, although Smolan begged everyone to avoid what he called the kangaroo-and-aborigine syndrome. Assignments ranged from the deceptively simple "Sydney police beat" given to the Boston *Herald's* Stanley Forman, to the hectic task handed to Han Juche of the People's Republic of China: "tourists, shopping mall, Southport Olympic Pool, Star of the Sea Convent School, Tamaris beachfront, disco dancing, Mad Mary's penthouse disco."

By midnight, the photographers had exposed 2,384 rolls of film. Smolan and a handful of professional picture editors whittled the 70,000 pictures down to 326 images for the book — a job that, as Smolan reported, left them with their eyes "popping out of their heads." Most of the photographers, however, are eager to repeat the assignment elsewhere; and Smolan, armed with a thick notebook of mistakes not to make next time, is preparing to tackle a day in the life of another country — as yet unnamed.

Embarrassing Victorian Fakes

The British magazine *Connoisseur* embarrassed and angered the antique-photo market in May 1981 with an article describing how the magazine had fooled several experts with faked Victorian calotype prints. In a letter to *The Times* of London about the flap caused by the hoax, *Connoisseur* editor Paul Atterbury denied that the magazine was guilty of a mere journalistic stunt: "The purpose of the article was to point out the sands upon which the market has been built, which at the moment allow for, and even encourage, malpractice and exploitation."

In March of 1981, *Connoisseur* had commissioned advertising photographer Howard Grey to fake a set of three calotypes in order to determine how readily dealers and collectors would accept 20th Century counterfeits as the real thing from the 1840s. Only a few months earlier, Grey had been acquitted of fraud charges stemming from just such a hoax, perpetrated in 1974 on a private collector and on the National Portrait Gallery in London. Grey, who had taken the photographs in question, claimed to have been an innocent dupe of artist Graham Ovenden, who in turn argued — at least half successfully, for the jury was unable to reach a verdict in his case — that the whole thing had been an elaborate prank to make fools of the experts.

This time around, *Connoisseur* took the bogus calotypes not only to the Portrait Gallery but to the Victoria and Albert Museum, to two auction houses, Sotheby's and Christie's, and to a prominent private dealer, Robert Hershkowitz. All accepted the calotypes as authentic 19th Century work, putting their total value at anywhere from $60 to $1,200.

The calotype, or salt-print, process was patented by Fox Talbot of Great Britain in

A demure Victorian, posing in 1981

1841 and rendered obsolete in the next decade by the introduction of collodion-albumen printing. Like every other known photochemical technique of the 19th Century, the calotype process can be duplicated without great difficulty in the lab of any modern photographer. Contemporary forgers can also convincingly fake antique daguerreotypes, but that process renders only a one-time positive image, whereas the calotype process creates a negative from which salable forgeries can be mass produced. There is little chance of detection if a counterfeiter takes the requisite time and trouble, using genuine antique paper and avoiding anachronisms in pose, subject matter or technical capability — for example, greater depth of field than Victorian photographers achieved.

"The results of our tests proved quite conclusively," Atterbury wrote in a letter to the London *Times,* "that the level of specialist knowledge required is simply not adequate.

Judgments and attributions are still made on aesthetic rather than technical grounds, and no scientific tests have been devised that can rapidly and easily identify the date of early photographs."

A Four-part Salute to Atget

In 1981, Springs Mills, Inc., a South Carolina-based textile firm, expanded its longtime support of photographic projects at New York's Museum of Modern Art to include the underwriting of books to accompany photographic exhibitions. The first two exhibitions that benefited from the new program were "American Children" and "American Landscapes," which opened in January and July, respectively. The third — and the most ambitious — will be a four-part series covering the lifework of France's Eugène Atget, who died in 1927 at the age of 70. Atget was a commercial photographer who worked in and around Paris for more than 30 years; until recently, his work was known to very few.

In his lifetime, Atget made perhaps 10,000 photographs — delicate, sometimes moody studies of French life captured through its landscapes, architecture and working people. On his death, some 5,000 prints and 1,000 negatives were preserved by Berenice Abbott, the American photographer, who spent the next 40 years trying to publicize his work. In 1968 she sold the collection to the Museum of Modern Art, which has been cataloguing and studying it since then.

The first of the four Atget exhibits — "Old France" — opened in October. The remaining three — "The Art of Old Paris," "The Ancien Regime" and "Modern Times" — will open at the museum at yearly intervals, and all four will travel extensively after their New York run. Books of the same titles, underwrit-

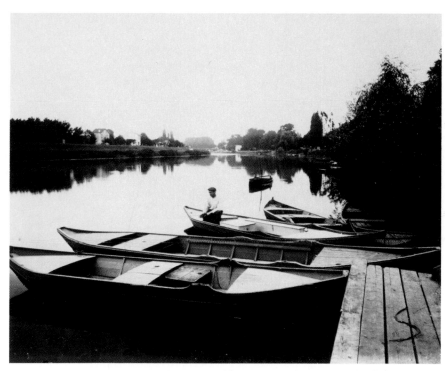

Atget's Bords de la Marne, 1903, from the opening round of a four-part exhibit at the Museum of Modern Art

ten by Springs Mills, will be published with the opening of each show. Altogether, the set of four will contain 500 full-page plates and a similar number of smaller illustrations.

Kodak in Court

Eastman Kodak Company officials may remember the year 1981 more for developments in the courtroom than in the darkroom. In 1981 the giant corporation, long dominant in the amateur photography market, finally managed to extricate itself from an eight-year-old antitrust action by agreeing to pay a multimillion-dollar settlement to a small competitor, Berkey Photo. In addition, Polaroid's instant-photography patent infringement suit against Kodak came to trial after five years of

legal preliminaries. And in 1981 an amateur photographer who had sued Kodak and a photo shop over the loss of his film during processing won a liability decision that the company had fought long and hard.

The liability suit was initiated in 1972 by Indianapolis lawyer John R. Carr Jr. after four rolls of film shot on his family's European vacation disappeared. Carr argued that the replacement cost of the photographic images that he had entrusted to Kodak through the shop far exceeded the cost of the film alone. Kodak countered that it was protected by the notice of limited liability printed on its film packages and on the receipt for exposed film given to customers when they hand in their film for processing. The corporation

claimed that it owed Carr only the price of the film, since it had accepted only the film, not the images thereon, for processing.

After nine years of legal wrangling, an Indiana appeals court turned down Kodak's defense, finding that Kodak and its dealers "must be aware that when film is given to them to be developed it has photographic images on it and that in almost every case these images will be more valuable than the unexposed film." It is not yet clear how much leverage the decision will give to photographers in future conflicts over lost film. The court awarded Carr only $1,013.60, plus interest and legal costs, rather than the $6,400 he sought in damages from Kodak, and its verdict appeared to leave the company the option of altering the wording on its receipts in order to escape future damage claims.

While Carr decided to again appeal the court's award, Berkey Photo— which initially had also won at least part of its claims against Kodak— opted to settle out of court after a series of unfavorable rulings. Berkey's antitrust suit charged that Kodak had conspired to create competitive disadvantages for other companies and had used its dominant market position to overcharge for film and photographic paper.

The case had been under way since 1973, and an initial verdict had assessed Kodak $112.8 million in damages. But the sum was substantially reduced on appeal, and another court, dismissing most of the conspiracy charges outright, had ruled that the rest of the case should be retried. Instead, Kodak and Berkey reached a settlement. Under the terms of the agreement, Kodak paid Berkey $6,750,000 in cash and merchandise credits, and the smaller company dropped its antitrust claims.

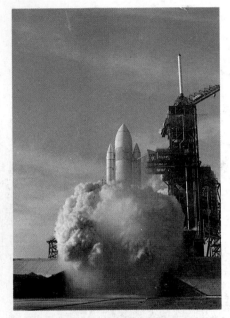

A salvaged image of the shuttle's first launch

Billowing steam about to engulf the camera

The blasted remnants of Morse's sacrificial equipment

Just 12 days after the announcement of the Berkey settlement, Polaroid and Kodak squared off in court for a patent-infringement battle. Polaroid maintains that Kodak's marketing of instant cameras and film in 1976 trespassed on Polaroid patents. If Kodak loses the case, it will have to pay Polaroid royalties to stay in the field, for almost 30 years Polaroid's exclusive turf.

Win or lose, Kodak is faced with the irony that instant photography has not proved as lucrative as they had hoped. After years of research, development and marketing efforts, Kodak is still a distant second to Polaroid in instant photography and has yet to turn a profit in that branch of its corporate empire.

Lost Gamble at Cape Canaveral

The April 1981 launch of the space shuttle *Columbia* was a challenge that brought out the gambler in *Time* photographer Ralph Morse. Although nobody, not even NASA engineers, could predict the destructive force of *Columbia*'s thrust, Morse set up six motor-driven cameras within 600 feet of the space craft's blast-off point, risking the loss of his equipment in pursuit of an image that would convey the space shuttle's awesome power.

The prize Morse sought was an exclusive close-up of mighty jets of flame lifting *Columbia* while 400,000 gallons of water sluiced over the launch pad to cool the platform and to protect the delicate instruments aboard the space shuttle from acoustical damage. He hedged his bets by using old, expendable cameras for the risky shot and by aiming two back-up cameras at the launch pad from the safer distance of 1,400 feet.

For the six cameras in the danger zone, Morse rigged an elaborate remote-control system of timers and activating devices sen-

sitive to the sound, vibration and light flash of the shuttle's launch.

After frustrating delays, *Columbia* finally lifted off on April 12—and Morse lost his gamble. The blast, stronger than anyone had expected, wiped out his equipment in a matter of seconds, destroying film, sandblasting lenses, and scattering charred camera fragments for half a mile. Six frames shot by one of the light-activated cameras were the only images to survive. Two of the phoenix-like frames appear at left, along with a look at Morse's cameras as they appeared after being subjected to *Columbia's* fiery blast.

A Fluctuating Print

Photography auctions and gallery sales continued to pull investors, but hard-to-decipher price fluctuations made 1981 a puzzling year for collector and seller alike.

Ansel Adams' popular classic, *Moonrise, Hernandez, New Mexico,* with at least 800 16 x 20-inch prints in existence, is considered by some a barometer for the market as a whole. In February a 35 x 55-inch print of *Moonrise* was sold by a dealer for $71,500, a record price for a single photograph. At auctions later in the year, however, bidding was erratic. The Adams favorite—along with a surprising number of works by other well-known photographers—went for much less than expected; several photographs failed to attract even their minimum bids and were withdrawn from the sales.

Some analysts consider tight money to be the chief reason for the recent tapering off of investment in collectibles of all kinds. In the photographic field, speculators and novice investors have grown wary, and serious collectors are becoming more selective. If committed collectors remain active, however, the

The $71,500 Moonrise, Hernandez, New Mexico, Ansel Adams' marketplace record-breaker

result may well be a less volatile market for photographs, one characterized by gradual increases rather than spectacular leaps.

The year 1981 saw the arrival of two guides that should make it easier for the collector to follow the market. One is *The Photographic Art Market,* by Peter H. Falk, a dealer turned investment counselor. The book comes in two parts: Falk's analysis of the market, with suggestions on how to invest; and a 61-page compilation of the results of the 1980-1981 auction year. Falk plans to update the auction section annually. The other guide is the "Comparative Auction Index," introduced in the July issue of the monthly newsletter *The Photograph Collector.* The index, to be published twice a year, after each autumn and

spring auction series in New York, tracks the sale prices of selected photographs, comparing them with 1975 prices and measuring the increase or decline against the stock market's Dow Jones Industrial Average.

On yet another information front, New York State's new Art Multiples Disclosure Law requires dealers to provide vital facts about the photographs they sell—including the number of prints in a limited edition, whether the artist approved the edition if it was unsigned and whether a print was made posthumously. Although some dealers already were offering buyers more information than the law requires, its passage is likely to attract new money to photography by protecting the novice investor's interests.

Milestones

Max Waldman, 1919-1981

In the small studio on New York's 17th Street where he died on March 1 at the age of 61, Max Waldman regularly achieved minor miracles of photographic interpretation. International stars of dance, theater and athletics came at his behest to that room, and within its homely framework of whitewashed walls and a linoleum floor, they gave some great performances. "Baryshnikov never leaped higher or with more precise elegance than when he leaped for Max," wrote Philip B. Kunhardt Jr., the managing editor of *Life*. "Makarova turned into a swan for him, her tutu turning to feathers, her arm a long, sensuous neck." Professional football players, too, worked themselves into a lather for Waldman, and Kunhardt wrote of the resulting picture essay published in *Life*, "There was never a story about sheer dazzling Sunday muscle like it before or since."

Waldman's own ferocious intensity was the key to his memorable pictures. It elicited a matching intensity and perfectionism, which he captured in a dark, brooding photographic style that he once described as a "midnight-to-six look."

Originally, Waldman worked as an advertising photographer. However, in the mid-1960s he turned his full attention to the subjects that brought him fame. Although he also lectured and wrote on photography — and his work has frequently been shown in museums in New York — he is perhaps best remembered for two striking books of his photographs: *Waldman on Dance* and *Waldman on Theatre*.

Olivier Rebbot, 1949-1981

The danger-scorning career of Olivier Rebbot, a 31-year-old French freelancer, was cut short by a sniper's bullet in El Salvador, where he was covering the civil war for *Newsweek*. He sustained a chest wound on January 15 and was evacuated to a hospital in Florida; he died there on February 9.

Rebbot had made his mark in photojournalism by recording a variety of natural and man-made disasters, among them an earthquake in Guatemala, civil strife in Lebanon and Nicaragua, the Iranian revolution and the plight of Cambodian refugees. The hazards were considerable. On an assignment to photograph turmoil in Bolivia in 1980, he was arrested at the border for carrying a Cuban passport, and was jailed and beaten before being expelled from the country.

A resident of Manhattan since 1971, Rebbot also found worthy challenges close at hand. For example, he spent several years preparing a photo essay on child prostitution around Times Square. The essay inspired a 1980 television documentary, "Mom, I Want to Come Home Now."

Frank J. Scherschel, 1907-1981

Frank J. Scherschel, who spent World War II recording one dramatic event after another for *Life*, died in May at the age of 74 in Madison, Wisconsin. The genial and well-liked Scherschel joined *Life* in 1942 after a stint on the Milwaukee *Journal* and was with the magazine for 20 years. During the War, he was noted for daring assignments: He photographed a convoy run to Murmansk (standing his ground on the deck of an American ship as it was strafed by German torpedo planes); he covered the Normandy invasion and the liberation of Paris; and in the Pacific he flew in a dive-bomber strike against the Japanese at Munda Island.

After leaving *Life*, Scherschel joined the United States Information Agency; he was chief of its photographic laboratory when he retired in 1972. He then opened a camera store in Baraboo, Wisconsin, near Madison.

Chris von Wangenheim, 1942-1981

Chris von Wangenheim, a fashion photographer best known for his startling juxtapositions of the erotic and the savage, was killed at the age of 39 in a car crash March 9 on the island of St. Martin in the Caribbean.

Born in Breslau, Germany, von Wangenheim came to the United States in 1965 and launched a career that frequently earned him comparison with his close friend Helmut Newton. Along with Newton, he furthered a trend in fashion and advertising pictures that emphasized sexual violence. One notable example: an Italian *Vogue* cover photo of a woman whose head and bare torso were bound in a sadomasochistic leather harness.

Though that sort of picture became his trademark, von Wangenheim experimented with a variety of styles, and he bridled at being stereotyped. He also had an answer for those who expressed shock at his photographs: "The violence is in the culture, so why shouldn't it be in our pictures?"

Bibliography

Bourdon, David, "Altered Photographs." *National Arts Guide*, Vol. 1, No. 5, 1979.

Bown, Jane, *The Gentle Eye: 120 Photographs by Jane Bown*. The Observer (London), 1980.

Cahn, Robert, and Robert Glenn Ketchum, *American Photographers and The National Parks*. The Viking Press, 1981.

Focal Encyclopedia of Photography. Focal Press, 1965.

Freeman, Roland, *Southern Roads/City Pavements: Photographs of Black Americans*. International Center of Photography, 1981.

Galassi, Peter, *Before Photography: Painting and the Invention of Photography*. The Museum of Modern Art, 1981.

L'Informazione: Il fotogiornalismo in Italia 1945/1980. Edizioni Dedalo, Bari, Italy, 1981.

Langford, Michael, *The Darkroom Handbook*. Alfred A. Knopf, 1981.

Minkkinen, Arno Rafael, *New American Nudes*. Morgan & Morgan, Inc. 1981.

Nilson, Lisbet, "Seeing the Light." *American Photographer*, September, 1981.

O'Neill, John P. (editor), *After Daguerre: Masterworks of French Photography (1848-1900) from the Bibliothèque Nationale*. The Metropolitan Museum of Art, 1981.

Papageorge, Tod, *Walker Evans and Robert Frank: An Essay on Influence*. Yale University Art Gallery, 1981.

Picture Magazine. December, 1980.

Pirovano, Carlo (editor), *Inventario di una psichiatria*. Electa, Milan, 1981.

Riboud, Marc, *Visions of China: Photographs by Marc Riboud 1957-1980*. Pantheon Books, 1981.

Shames, Laurence, "Susan Meiselas." *American Photographer*, March, 1981.

Szarkowski, John (introduction), *The Portfolios of Ansel Adams*. New York Graphic Society, 1981.

Witkin, Lee D. and Barbara London, *The Photograph Collector's Guide*. New York Graphic Society, 1979.

Acknowledgments

The index for this book was prepared by Mel Ingber. The editors also wish to thank:

In the Americas—Jacques and Anne Baruch, Baruch Gallery, Chicago; Janet Borden, Robert Freidus Gallery, New York City; Michael and Marsha Burns, Seattle; Sean Callahan, *American Photographer*, New York City; David Cohen, Contact Press Images, New York City; Jay Crouse, Atlanta Gallery of Photographers, Atlanta; Renato Danese, Ted Tamada, Light Gallery, Los Angeles; Susan Dwyer, Thames and Hudson, Inc., New York City; Kathleen Ewing, Kathleen Ewing Gallery, Washington, D.C.; William Ewing, Ruth Lester, International Center of Photography, New York City; David Fahey, Thea Piegdon, G. Ray Hawkins Gallery, Los Angeles; Peter Hastings Falk, Falk-Leeds International, Inc., New York City; Frances Fralin, Corcoran Gallery of Art, Washington, D.C.; Jean Gardner, *Picture Magazine*, Los Angeles; Andrea Gray, New York City; Ursula Gropper, Grapestake Gallery, San Francisco; Len Hartnett, Len Hartnett Archival Products, Inc., North Kingstown, Rhode Island; Jim Hughes, *Camera Arts*, New York City; Robert Flick, University of Southern California, Los Angeles; Jeffrey Gilbert, Gilbert Gallery, Chicago; Julia Van Haaften, New York Public Library, New York City; Susan Hager, Harry H. Lunn Jr., Lunn Gallery Inc., Washington, D.C.; Samuel Hartison, Robert Samuel Gallery, New York City; Marvin Heiferman, Castelli Photographs, New York City; David Holtz, Michael Moore, Eastman Kodak Co., Rochester, New York; Anne Horton, Sotheby Parke

Bernet, New York City; Jean Hunnicutt, Heery Interiors, Atlanta; Bruce Johnson, Polaroid Corporation, Cambridge, Massachusetts; Tamarra Kaida, Mesa, Arizona; Robert Glenn Ketchum, National Park Foundation, Washington, D.C.; Carole Kismaric, Aperture, Inc., New York City; Susan Kismaric, Museum of Modern Art, New York City; Janice Liverance, Ruder & Finn Fine Arts, New York City; John Loengard, Melvin L. Scott, *Life*, New York City; Sophie McConnell, The Viking Press, New York City; A. David Meyer, Buschmann, Carr & Meyer, Indianapolis, Indiana; Richard Misrach, Berkeley, California; Arno Rafael Minkkinen, Massachusetts Institute of Technology, Cambridge, Massachusetts; Peter Morrin, The High Museum, Atlanta; Don Owens, *Photo Show*, Los Angeles; Robert S. Persky, *The Photographic Collector*, New York City; The Photographic Resource Center, Boston; Davis Pratt, Fogg Art Museum, Cambridge, Massachusetts; Dr. Marvin Rappaport, New York City; Fred Ritchin, *New York Times Magazine*, New York City; Chuck Rynd, Equivalents Gallery, Seattle; Gerd Sander, Sander Gallery Inc., Washington, D.C.; Dr. Dietrich Schultze, Agfa-Gevaert, Teterboro, New Jersey; Brent Sikkema, Brent Sikkema Inc., Boston; Mary Kay Simqu, Philadelphia; William F. Stapp, National Portrait Gallery, Washington, D.C.; Dale Stulz, Christie, Manson & Woods International, New York City; Gary Lee Super, NEXUS, Inc., Atlanta; Karen Truax, Northridge, California; Lee Witkin, Witkin Gallery, New York City; Daniel Wolf, Daniel Wolf Gallery, New York City; Cordie Worth,

Photograph Gallery, New York City; Jack Zimmer, Ilford Inc., Paramus, New Jersey.

In Europe—Juan Ramon Anguera, Barcelona; Isabelle Anscombe, London; Mario Apolloni, Rome; Paul Atterbury, *The Connoisseur*, London; Albert Champeau, Ufficio dell'Arte, Paris; Lanfranco Colombo, *Il Diaframma*, Milan; Paolo Crepet, Rome; Dr. James Doyle, D. J. Nield, Basildon, Essex, England; Ute Eskildsen, Museum Folkwang, Essen, West Germany; Franco Fontana, Modena, Italy; Agathe Gaillard, Paris; Galerie Zabriskie, Paris; Luigi Ghirri, Modena, Italy; Pierre Gassman, Paris; Professor L. Fritz and Renate Gruber, Cologne; Isabelle Jammes, Paris; Fritz Kempe, Hamburg, West Germany; Jean-Claude Lemagny, Bernard Marbot, Bibliothèque Nationale, Paris; Angelika Lemmer, Bonn, West Germany; Bernd Lohse, Bergisch-Neunkirchen, West Germany; Uliano Lucas, Milan; Jean-Pierre Mahaim, *Double-Page*, Paris; Romeo Martinez, Paris; Jean-Luc Monterosso, Paris Audiovisuel, Paris; Daniela Mrazkova, Prague; Claude Nori, Paris; Miguel Oriola, Madrid; José Luis de Pablos, Madrid; Daniela Palazzoli, Milan; Vladimir Remeš, Prague; Christiane Roger, Société Française de Photographie, Paris; Gerd Sachsse, Bonn, West Germany; Alain Sayag, Centre National Georges Pompidou, Paris.

In Asia and the Far East—Christine Godden, Australia Center for Photography, Paddington, New South Wales, Australia; Goro Sakamoto (Horijin), Yokohama, Japan; Koen Shigemori, Tokyo College of Photography, Yokohama, Japan.

Picture Credits
Credits from left to right are separated by semicolons, from top to bottom by dashes.

COVER—Masato Sudo, Tokyo; Fil Hunter, courtesy Polaroid Corporation.

Trends: 11: © 1979 Susan Felter, courtesy Robert Samuel Gallery. 13: Hubert Grooteclaes, courtesy Kathleen Ewing Gallery, copied by Henry Beville. 14: Collection of the Art Museum University of New Mexico in Albuquerque. 15: Wallace Nutting, courtesy Karen Truax. 16: Dan Weaks. 17: Bill Turner. 18: Carl E. Kurtz. 19: Seta Injeyan, courtesy *Picture Magazine*. 20: Alice Steinhardt, courtesy G. Ray Hawkins Gallery, copied by Doug M. Parker. 21: © 1981 Christine Osinski. 22: Katherine Fishman. 23: Rita Dibert, courtesy Xochipilli Gallery. 24: © 1979 Karen Truax. 25: © 1979 Peter de Lory. 26, 27: Gail Skoff. 28: Connie J. Ritchie, courtesy Equivalents Gallery. 29: Jane Tuckerman. 31: Robert Mapplethorpe, courtesy Robert Miller Gallery, Inc. 32: Tom Shillea, courtesy Daniel Wolf, Inc. 33: Lynn Davis, courtesy Robert Samuel Gallery. 34: Shelby Lee Adams. 35: © 1980 Toba Tucker. 36: © 1981 Arnold Kramer, courtesy Sander Gallery, Inc. 37: Lucas Samaras, courtesy The Pace Gallery, copied by Al Mozell. 38: Richard Misrach. 39: Joel Meyerowitz. 40: Marsha Burns. 41: © 1979 Judith Black. 42: Philippe de Croix, Paris.

The Major Shows: 45: Jan Saudek, courtesy Jacques Baruch Gallery, copied by Luis Medina. 47: Eadweard J. Muybridge, courtesy National Park Foundation and The Viking Press. 48: Richard Misrach, courtesy National Park Foundation and Grapestake Gallery. 49: William Henry Jackson, courtesy National Park Foundation and The Viking Press. 50: Ansel Adams, courtesy National Park Foundation and The Viking Press. 51: Brett Weston, courtesy National Park Foundation and The Viking Press. 52: Charles V. Janda, courtesy National Park Foundation and The Viking Press. 53: Edward Weston © 1981, courtesy Center for Creative Photography, Arizona Board of Regents. 54: Harry Callahan, courtesy Light Gallery. 55: Boone Morrison, courtesy National Park Foundation and The Viking Press. 56: Laura Gilpin, courtesy Amon Carter Museum. 57: Imogen Cunningham, courtesy Imogen Cunningham Trust. 58: Lee Friedlander, courtesy Robert Friedus Gallery. 59: Jerry N. Uelsmann, courtesy National Park Foundation and The Viking Press. 61-69: Jan Saudek, courtesy Jacques Baruch Gallery, copied by Luis Medina. 71-79: From *Inventario di una psichiatria*, published by Electa, Milan. Photos by Raymond Depardon, Paris; Luciano D'Alessandro, Naples; © Carla

Cerati, Milan; © Luciano D'Alessandro(3); © Gianni Berengo Gardin, Milan(2); Mary Ellen Mark from Magnum; Paolo Lucignani, Rome; Mazzolari, Cremona. 81: © 1955 Hiroshi Hamaya, Tokyo. 82: Maurice Tabard, courtesy Sander Gallery, Inc. 83: Silvano Lucca from Publifoto, Milan. 84: Marie Cosindas, courtesy the Cincinnati Art Museum, Cincinnati Art Museum Centennial Commission. 85: August Kreyenkamp, courtesy Agfa-Gevaert, Leverkusen, Federal Republic of Germany. 86: Jane Bown, London. 87: George Krause, courtesy Mancini Gallery. 88: © Orlan, Paris. 89: Walker Evans, courtesy Lunn Gallery—Robert Frank, courtesy Lunn Gallery. 90: A.A.E. Disdéri from Photo Bibliothèque Nationale, Paris. 91: A. Collard, courtesy Samuel J. Wagstaff Jr. collection, courtesy The Museum of Modern Art. 92: Marc Riboud, courtesy Photograph Gallery. 93: Roland L. Freeman. 94: Lisette Model, courtesy Sander Gallery, Inc.

The Annual Awards: 97: © Jim Brandenberg. 99: © George Wedding from *The San Jose Mercury News*. 100: Frédéric Brenner, Paris. 101: Jacques Bondon, Paris. 102: Bryce Flynn from *The Providence Journal Bulletin*. 103: Mike Wells from Aspect, London. 104: Larry C. Price from *The Fort Worth Star Telegram*. 105: Taro M. Yamasaki from *The Detroit Free Press*. 106, 107: Hiroji Kubota from Magnum/PPS, Tokyo. 108: Nobumitsu Sakuma, Tokyo. 109: Steve McCurry for *Time*. 110: August Sander, courtesy Sander Gallery, Inc., Gunther Sander, Rottach-Egern and Schirmer-Mosel Verlag, Munich. 111: Peter Keetmann, Breitbrunn/Chiemsee, Federal Republic of Germany. 112: © Willy Ronis, Paris.

The New Technology: 115: Fil Hunter, courtesy Polaroid Corporation. 117: John Neubauer. 118, 119: Fil Hunter, art by Robert Herndon. 120: Ilford Limited, Essex, England(2); Fil Hunter(2). 121, 122: Fil Hunter. 123: Fil Hunter, art by Fred Holz. 124, 125: Fil Hunter, art by Mechanics Inc. 127: Susan V. Kelly. 128, 129: Fil Hunter, art by Mechanics Inc. 130: Courtesy Keystone Camera Corporation—courtesy Minox USA; courtesy Canon USA Inc. 131: Courtesy Ricoh of America, Inc.—courtesy Cosina America Inc. 132: Courtesy Canon USA Inc.—courtesy Bell & Howell/Mamiya Company. 133: Courtesy Ricoh of America, Inc. (2)—courtesy Plaubel USA Inc. 134: Courtesy Canon USA Inc.—courtesy Tokina Optical Corporation. 135: Courtesy Berkey Marketing Companies. 136: Courtesy 3M. 137: Courtesy Berkey Marketing Companies—Polaroid

Corporation. 138: Courtesy Agfa-Gevaert, Inc.—courtesy Eastman Kodak Company; courtesy Sony Corporation of America.

Discoveries: 141: Masato Sudo, Tokyo. 143: Masato Sudo, Tokyo; Robert Giard, courtesy Robert Samuel Gallery—Sally Mann; Caroline Adams. 145-151: Tom Zetterstrom, courtesy Daniel Wolf, Inc. 153-163: Masato Sudo, Tokyo. 165-171: Robert Giard, courtesy Robert Samuel Gallery. 173-178: Sally Mann.

The Year's Books: 181: © 1981 Raghubir Singh, Paris, courtesy Thames and Hudson, Inc. 182: © 1981 Alon Reininger from Contact Press Images. 183-191: © 1981 Susan Meiselas from Magnum. 193-205: Max Yavno. 207-217: © 1981 Raghubir Singh, Paris, courtesy Thames and Hudson, Inc.

The Marketplace: 221: Marsha Burns. 222: Jewel Stern, courtesy Daniel Wolf, Inc., copied by Fil Hunter. 223: Marsha Burns, copied by Fil Hunter; William Larson, courtesy Light Gallery, copied by Fil Hunter. 224: Christopher James, copied by Fil Hunter; Olivia Parker, courtesy Brent Sikkema Incorporated, copied by Fil Hunter. 225: Paul Ickovic, courtesy Daniel Wolf, Inc., copied by Fil Hunter; Eliot Porter, courtesy Daniel Wolf, Inc., copied by Fil Hunter. 226, 227: Jewel Stern, courtesy Daniel Wolf, Inc., copied by Henry Beville. 228, 229: Marsha Burns. 230, 231: William Larson, courtesy Light Gallery, copied by Herbert Orth. 232, 233: Christopher James, copied by Henry Beville. 234, 235: Olivia Parker, courtesy Brent Sikkema Incorporated, copied by Henry Beville. 236: Paul Ickovic, courtesy Daniel Wolf, Inc., copied by Henry Beville. 237: Paul Ickovic, courtesy Daniel Wolf, Inc., copied by Herbert Orth. 238-240: Eliot Porter, courtesy Daniel Wolf, Inc., copied by Herbert Orth.

Roundup: 243: Gregory Heisler. 244: William Henry Fox Talbot, from the Rare Books and Manuscripts Division, The New York Public Library, Astor, Lenox and Tilden Foundations. 245: Albert Fernique, from the Rare Books and Manuscripts Division, The New York Public Library, Astor, Lenox and Tilden Foundations. 246: Howard Grey, courtesy *The Connoisseur*, London. 247: Eugène Atget, courtesy The Museum of Modern Art, New York, Abbot-Levy Collection, partial gift of Shirley C. Burden. 248: Ralph Morse for *Time*(2)—Tony Ruta for *Time*. 249: Ansel Adams.

Index
A numeral in italics indicates a photograph or drawing of the subject mentioned.

Time-Life Books, inc. offers a wide range of fine recordings, including a GREAT PERFORMERS series. For subscription information, call 1-800-621-8200, or write TIME-LIFE RECORDS, Time & Life Building, Chicago, Illinois 60611.

Printed in U.S.A.